Nectar and Illusion

Onassis Series in Hellenic Culture

The Age of Titans: The Rise and Fall of the Great Hellenistic Navies
 William M. Murray

Sophocles and the Language of Tragedy
 Simon Goldhill

Nectar and Illusion: Nature in Byzantine Art and Literature
 Henry Maguire

Onassis
Foundation (USA)

Nectar and Illusion

NATURE IN BYZANTINE ART AND LITERATURE

Henry Maguire

OXFORD
UNIVERSITY PRESS

OXFORD
UNIVERSITY PRESS

Oxford University Press is a department of the University of Oxford. It furthers the
University's objective of excellence in research, scholarship, and education by publishing worldwide.

Oxford New York
Auckland Cape Town Dar es Salaam Hong Kong Karachi
Kuala Lumpur Madrid Melbourne Mexico City Nairobi
New Delhi Shanghai Taipei Toronto

With offices in
Argentina Austria Brazil Chile Czech Republic France Greece
Guatemala Hungary Italy Japan Poland Portugal Singapore
South Korea Switzerland Thailand Turkey Ukraine Vietnam

Copyright © 2012 by Oxford University Press

Published in the United States of America by Oxford University Press
198 Madison Avenue, New York, NY 10016

www.oup.com

Library of Congress Cataloging-in-Publication Data
Maguire, Henry, 1943–
Nectar and illusion : nature in Byzantine art and literature / Henry Maguire.
 p. cm. — (Onassis series in Hellenic culture)
Includes bibliographical references and index.
ISBN 978-0-19-976660-4
1. Nature in art. 2. Nature in literature. 3. Arts, Byzantine—Themes, motives.
4. Byzantine literature—Themes, motives. 5. Nature—Religious aspects—Christianity.
I. Title. II. Title: Nature in Byzantine art and literature.
NX650.N38M34 2012
700'.4609495—dc23 2011043945

9 8 7 6 5 4 3 2 1

Printed in the United States of America
on acid-free paper

For Anna and Pierre

Pied Beauty

Glory be to God for dappled things—
 For skies of couple-color as a brinded cow;
 For rose-moles all in stipple upon trout that swim;
Fresh-firecoal chestnut-falls; finches' wings;
 Landscape plotted and pieced—fold, fallow, and plough;
 And all trades, their gear and tackle and trim.

All things counter, original, spare, strange;
 Whatever is fickle, freckled (who knows how?)
 With swift, slow; sweet, sour; adazzle, dim;
He fathers-forth whose beauty is past change:
 Praise him.

—Gerard Manley Hopkins

CONTENTS

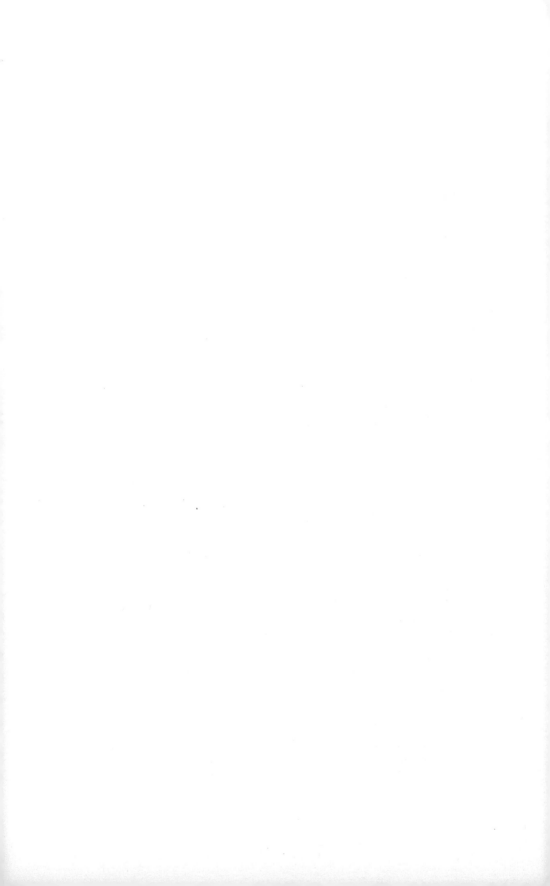

LIST OF ILLUSTRATIONS

Color Plates

Black-and-White Figures

PREFACE

This book and its associated lectures have been sponsored by the Alexander S. Onassis Public Benefit Foundation (USA) and by Oxford University Press in their series "Onassis Lectures in Hellenic Culture." I am very grateful to both institutions and in particular to Maria Sereti at the foundation and to Stefan Vranka and Sarah Pirovitz at Oxford for their assistance and advice. I would also like to express my thanks to colleagues at the University of Pennsylvania and Stanford University, where I gave a series of prepublication lectures and seminars, especially to Renata Holod, Ann Kuttner, Robert Ousterhout, and Brian Rose in Philadelphia and to Bissera Pentcheva in Palo Alto. At both institutions I received warm hospitality, in addition to informed criticism, that has been invaluable in shaping the chapters that follow. In addition, much of the second chapter was initially included as a lecture in the seminar on "Défini-tions philosophiques et définitions rhétoriques de la rhétorique" at the Centre Léon Robin in Paris. I am very grateful to the director, Dr. Barbara Cassin, for the opportunity to present this material before a receptive and discriminating audience.

I am thankful to many individuals for assistance in the increasingly difficult task of finding photographs for publication, especially to Genevra Kornbluth, Ioannis Spatharakis, and David Wright. Gunder Varinlioglu at Dumbarton Oaks and Joanne Bloom at the Fine Arts Library of Harvard responded to repeated requests. At Johns Hopkins University I have been indebted to Ann Woodward and to Jessica Bailey for their continuing assistance in the Visual Resources Collection.

The material presented here is the product of over forty years of research, reflection, and interactions with friends and colleagues. It is impossible to make a complete list of people to acknowledge for their advice and kindnesses, for there are too many. Nevertheless, I would like to express my appreciation here to Nancy Ševčenko, because she also has a special interest in the theme of nature in Byzantine art and because she generously encouraged me to proceed with this project when I was faltering. I would also like to thank Joachim Wolschke-Bulmahn, formerly director of studies in landscape architecture at Dumbar-ton Oaks, with whom I organized a colloquium on the topic of Byzantine Garden Culture in 1996 (Littlewood, Maguire, and Wolschke-Bulmahn, 2002). Also at Dumbarton Oaks, Alexander Kazhdan guided me to many relevant texts, including the remarkable encomium of St. Patapios by Andrew of Crete.

More recently, I am indebted to the hospitality of Charalambos and Demetra Bakirtzis, who enabled me to revisit the painted churches of Cyprus. Finally, as ever, I am deeply grateful to Eunice Dauterman Maguire, with whom I have discussed the material in this book so often over the years. Without her this study could never have been written.

Nectar and Illusion

Introduction

In the early Renaissance, the Venetian painter Giovanni Bellini portrayed the Virgin and child in front of a deep red curtain being drawn open to reveal a distant landscape, where we can see bare wintry trees, green hills, a town, and far-off snow-capped mountains (plate I). This drawing back of the curtain behind the sacred icon to reveal a study of the terrestrial world around us exemplifies the close attention paid by Renaissance artists to natural phenomena and their incorporation of the diversity of earthly creation into religious painting. In the art of medieval Byzantine churches, however, the drapes remained closed, with only occasional chinks opening here and there to show views of observed nature. This was certainly not because the Byzantines were oblivious to the charms of creation—far from it—but their delight was always mingled with distrust. Byzantine attitudes toward the wealth of terrestrial nature were complex and ambivalent. On one hand, in their literature, and more rarely in their art, the Byzantines celebrated nature as a reflection of the glory of its Creator; on the other hand, they viewed the bounty of the natural world as fleeting and corruptible and suspected it as a distraction from spiritual reality and the permanent rewards of their faith. The chapters that follow explore the consequences of the contradictory Byzantine reception of nature, in both the verbal and the visual arts.

This book is intended to be neither an encyclopedia of Byzantine depictions of the terrestrial world nor a study of the practical engagement of the Byzantines with nature through agriculture, hunting, fishing, medicine, and the like. It also does not engage with such modern interests as evolution, genetics, biodiversity, and ecology. Although concerns over food supply have been constant throughout human history and are certainly reflected in Byzantine art, especially in its early period, our topic is not environmental history as such.[1] Rather,

[1]On agriculture, see M. Decker, *Tilling the Hateful Earth: Agricultural Production and Trade in the Late Antique East*, Oxford, 2009. On medicine, see J. Scarborough, ed., *Symposium on Byzantine Medicine*

the book aims to study the changing Byzantine attitudes toward the place of terrestrial nature in Christian art and literature. It will attempt to account for the relative weight given to nature-derived and anthropomorphic images in Byzantine art of different times and contexts and to show how the Byzantines embraced or distanced nature through the manner of its representation, whether verbal or visual.

In the early Byzantine period, from the fourth to the seventh centuries, Christian homilists sought to appropriate the wonders of creation for their faith by composing commentaries on the *Hexaemeron*, which glorified the first six days (*hexaemera*) of creation. At the same time, the decoration of Christian churches also celebrated the created world through a diverse imagery of personifications and depictions of animals and plants, which were portrayed throughout the buildings, on floors, walls, ceilings, vaults, and furnishings. To some extent, these motifs were simple expressions of the power of God—an attempt to counter paganism by inscribing all of nature under a Christian worldview. But in addition, the nature-derived subjects often were seen as symbols of spiritual concepts, especially when such interpretations, as in the case of the vine or the lamb, had precedents in scripture. Because, with a few notable exceptions, these nature motifs did not last on the walls of early Christian churches but are preserved only in mosaics on their floors, they tend to be overlooked or even discounted by modern observers, and their importance is underestimated.[2]

After iconoclasm, from the tenth century onward, nature-derived images played a much smaller role in the decoration of Byzantine churches, as is witnessed by the replacement of figured tessellated pavements with more abstract compositions in opus sectile. Partly as a result of these changes, anthropomorphic images, or icons, acquired a much more prominent role in the visual appearance of posticonoclastic churches. The contrast between preiconoclastic and posticonoclastic church decoration can be exemplified by two buildings, San Vitale in Ravenna, dating to the sixth century, and the Panagia tou Arakos at Lagoudera on Cyprus, dating to the twelfth century. Apart from some limited restorations, the sanctuary of San Vitale preserves its mosaics intact (figure Intro-1). One of the most striking features of these mosaics is the sacred figures embedded in a rich framework of nature-derived motifs, which cover the walls, arches, and vault. In the apse we find Christ enthroned on the cosmic globe in a paradisal landscape containing variegated flowers watered by the four streams of Paradise. On either side there are peacocks, with tails furled. A composition of crossed cornucopias, evocative of terrestrial bounty, decorates the arch that encircles the apse. On the great arch that forms the entrance to the

(*Dumbarton Oaks Papers*, 38), Washington, DC, 1984. On the environment, see I. Anagnostakis, T. G. Kolias, and E. Papadopoulou, eds., *Animals and Environment in Byzantium*, Athens, 2011.
 [2]See the remarks of B. Brenk, *The Apse, the Image and the Icon*, Wiesbaden, 2010, 27–28.

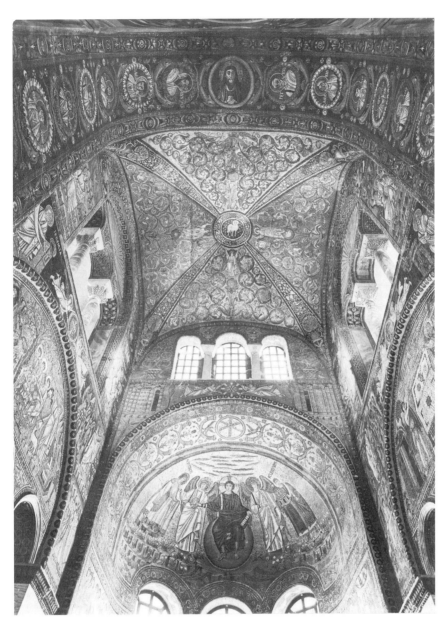

INTRO-1. Ravenna, San Vitale, sanctuary mosaics.

sanctuary, we find dolphins with linked tails framing the portraits of Christ and his saints. Fruiting vines inhabited by birds flank the windows and the openings to the galleries. Richest of all is the vault, which displays the Lamb of God at the center, surrounded by a whole spectrum of birds and beasts, against a backdrop of different fruits, flowers, and scrolling plants (figure Intro-2). Among the flowers we can recognize roses and lilies and among the fruits pears and

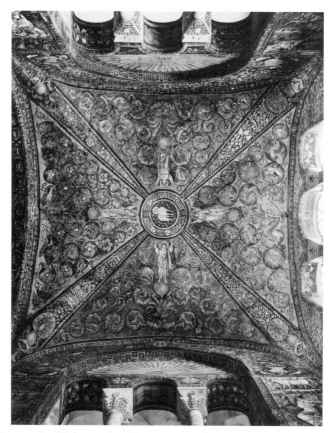

INTRO-2. Ravenna, San Vitale, mosaics of the sanctuary vault.

apples. Among the birds we can identify a white dove, a green parrot, an owl, a cock, a quail, a swallow, a duck, and a wader with a snake caught in its beak. The beasts include a hare in flight, a running antelope, a fawn, a white ram, a billy goat, panthers running and springing, and possibly a lion. At each of the four corners of the vault, a splendid peacock unfurls its tail, its shimmering feathers reflecting the variety of divine creation.[3]

The medieval church at Lagoudera could not present a greater contrast. Here, also, the painted decoration is well preserved, but, with the exception of the postmedieval choir screen, the profusion of plants and animals has virtually disappeared (plate II). Instead, we are presented with an austere gallery of sacred portraits. The center of the vault is occupied not by the symbol of the Lamb but by a severe image of Christ the all-ruler, who is surrounded by

[3]F. W. Deichmann, *Frühchristliche Bauten und Mosaiken von Ravenna*, Baden-Baden, 1958, plates 311–353.

his court of angels. The windows are flanked not by fruiting vines but by portraits of the prophets as sources of spiritual illumination. On the lower walls and vaults of the church we find portraits of the Evangelists and other saints, together with scenes from the New Testament. Apart from the Nativity, there are no animals to be seen anywhere in the paintings of the church, and plant ornament is deployed extremely sparingly.[4] A sparse decoration of trefoil-shaped leaves appears in a few limited areas of the frescoes,[5] but otherwise the rich evocation of nature that we found in San Vitale is lacking. In the twelfth-century church we are removed from the terrestrial world and placed in a program that is almost entirely anthropomorphic.

The watershed that divided Byzantine attitudes toward nature was the iconoclastic period of the eighth and ninth centuries, when the place of images in Christian worship came under intense scrutiny.[6] The attacks of the iconoclasts forced the proponents of the sacred portrait icons to focus on the pagan and magical connotations of nature-derived imagery, with the result that portrayals of nature personifications and animals became increasingly problematic, even, or indeed especially, for those who accepted images of Christ and his saints.

An important factor in the Byzantine view of the terrestrial world was the connection drawn by the Byzantines between the charms of nature and the allure of rhetoric. The Byzantines both admired rhetoric as a means of bringing grace and harmony to their speech and condemned it as an agent of deceit and trickery. Yet the Byzantines' ambivalence concerning rhetoric also applied to nature, which was abundant and delightful but also illusory compared with eternal truths. Rhetoric and nature came together in the ancient rhetorical technique of ekphraseis, a vivid description involving the close observation of terrestrial phenomena, which frequently graced the compositions of church writers, both before and after iconoclasm.[7] In addition, the hymns and sermons of the Byzantine church embraced a rich store of nature-derived metaphors, especially in praise of the Virgin, which, like the ekphraseis, continued to flourish after iconoclasm. In posticonoclastic art, however, the visualization of the nature-derived imagery that ekphraseis and metaphor provided was limited to certain contexts. The visual arts had less freedom than the spoken word. This

[4]D. Winfield and J. Winfield, *The Church of the Panaghia tou Arakos at Lagoudhera, Cyprus: The Paintings and Their Painterly Significance*, Washington, DC, 2003.

[5]Notably in the reveals of the windows in the dome and framing the medallions in the band at the center of the vault over the west arm and in the soffits of the wall arches on the north and south sides of the naos; Winfield and Winfield, *Church of the Panaghia tou Arakos at Lagoudhera, Cyprus*, plates 11 (d–f), 23–24, fig. 90.

[6]On iconoclasm, see R. Cormack, "Art and Iconoclasm," in E. Jeffreys, J. Haldon, and R. Cormack, eds., *The Oxford Handbook of Byzantine Studies*, Oxford, 2008, 750–757.

[7]For a recent treatment of ekphraseis, see R. Webb, *Ekphraseis, Imagination and Persuasion in Ancient Rhetorical Theory and Practice*, Farnham, 2009.

was only to be expected in a society that placed the legitimacy of the visual image in Christian worship under a high degree of scrutiny.

The abstraction of motifs from nature in Byzantine art raises a complex set of questions. Especially in monumental art, portrayals of animals and plants tended to become less naturalistic after iconoclasm, and there was less concern to differentiate individual species. This was not simply due to a general tendency to abstraction and schematization in medieval art, because the lack of definition was selective. Portraits of saints, for example, could be highly differentiated, even as the motifs from nature became less so. Moreover, naturalism in the portrayal of flora and fauna was greater in certain contexts, such as in the pages of manuscripts or in high-status ivory carvings.

The relative decline of nature-derived symbolism in medieval Byzantine art gave a greater potential value to symbols that were inorganic, especially the framing of sacred figures with various kinds of buildings or with gold grounds. While a gold ground is a familiar symbol of the sacred, the use of architectural settings to convey spiritual values has received much less attention.[8] The increased importance of architectural symbolism is an important part of the transformation that took place in Byzantine art after iconoclasm.

The first chapter of the book explores the role of the iconoclastic controversy as a divide between the early Byzantine and the medieval Byzantine periods. During the iconoclastic crisis, both the supporters and the opponents of images of Christ and the saints accused the other side of "worshipping the creature rather than the Creator." This secondary debate—the debate over the portrayal of living things other than human beings—has attracted little attention from scholars compared with the dispute over the sacred icons. Nevertheless, it was a debate that had a profound effect on the subsequent decoration of Byzantine churches, and, like the debate over icons proper, its roots reached back into the early Byzantine period.

The second chapter is devoted to the abiding Byzantine ambivalence between the acceptance and denial of the techniques of rhetoric, especially insofar as they were applied to the glorification of the earthly world. The preiconoclastic sermons and commentaries devoted to the *Hexaemeron*, that sung the praises of nature, frequently incorporated self-contained ekphraseis of particularly noteworthy elements of creation, such as the River Nile or the peacock. But conversely, in other contexts, early Byzantine writers could criticize the world of nature as transient and evanescent. The conflicting views of nature continued in posticonoclastic texts. On one hand, nature was seen as corruptible

[8]Discussion of this topic has tended to center on perspective and the construction of space rather than more specifically on the symbolism of the depicted buildings themselves. For a recent analysis of space in Byzantine painting, see C. Antonova, *Space, Time, and Presence in the Icon: Seeing the World with the Eyes of God*, Farnham, 2010.

and false, but another, more positive view was that nature had been redeemed and sanctified through the incarnation of Christ. This concept gave an avenue for elaborate ekphraseis of nature to survive in the literature of the Byzantine church. After iconoclasm, Byzantine artists occasionally echoed these literary descriptions in their portrayals of nature, but they also found ways to reprove the earth-bound rhetoric of ekphraseis and to put it in its place. In both their writing and their art, Byzantines of the Middle Ages relegated nature to a subordinate position, even while they were still prepared to deploy their eloquence in acknowledgment of its charms.

The third chapter discusses the repetition of nature-derived metaphors in Byzantine art, with a focus on images that evoked the Virgin. These metaphors were reiterated in sermons and hymns until the end of Byzantium. Many of the same images also accompanied the Virgin in her portrayals in Byzantine art, but much less frequently than they appeared in literature, and not during all periods. There was a disjunction between constantly repeated verbal and written metaphors on one hand and sporadically appearing visual imagery on the other. The same disjunction applied to representations of paradise, the depictions of which lay between metaphor and reality.

The most striking examples of artistic poverty in the face of the luxuriant nature-derived metaphors of the texts come in the painted cycles of the *Akathistos*, the early Byzantine hymn in honor of the Virgin that was frequently illustrated in the fourteenth and fifteenth centuries. Here, the richness of the animal and even the horticultural imagery in the poem was largely ignored. For the most part, the illustrations of the *Akathistos* are rigorously anthropomorphic, with very little attention paid to the nature-derived allusions of the poem. The only metaphors illustrated in the *Akathistos* cycles are inorganic, such as the "lamp full of light." On the other hand, the *Akathistos* paintings can be contrasted with other contemporary cycles of scenes depicting the Virgin, such as the mosaics portraying her infancy in the Kariye Camii (the church of the Chora Monastery) in Istanbul, which are richly framed by plants and animals.

The fourth chapter, on nature and abstraction, looks at some of the changes in Byzantine art described in the preceding chapters through a different lens, that of aesthetics. In particular, it considers the question of the extent to which the unfigured opus sectile floors of medieval Byzantine churches and palaces were read by the Byzantines as abstract depictions of the earth and its rivers. Such pavements were frequently described by Byzantine writers as the earth or as colorful flowering meadows, and their marbles were compared to rivers or to seas. Were such descriptions merely conventional metaphors, or did they convey a more fundamental association of the floor with terrestrial creation? And if so, can the abstraction of the images be interpreted as disengagement—that is, as a visual defense against their use in idolatry? There was an ideological opposition between two tropes frequently expressed by Byzantine writers: first that sacred figures were distinguished by a spotless pallor; and second that nature

was characterized by a variety of colors, as might be seen in plants or in the polychromatic stones of a pavement.

The final chapter discusses the role of representations of architecture in Byzantine art. The reduction in nature-derived imagery in Byzantine churches after iconoclasm, and its replacement by a more strictly anthropomorphic gallery of sacred figures, gave a new prominence to the architectural backgrounds that framed the holy portraits. In many contexts, depictions of architecture came to substitute for the old portrayals of animals and plants as conveyors of Christian meaning. Architecture was not merely an inert backdrop to sacred iconography, but it acquired a symbolic charge in place of the motifs from nature, assuming a greater significance in posticonoclastic Byzantine art as an expression of spiritual values. The decline of nature symbolism and the rise of architectural symbolism were closely linked.

In their attitudes toward nature and its depiction, the Byzantines of the Middle Ages were in constant dialogue with neighboring cultures of Western Europe and Islam. They reacted against the mosques, which excluded all portrayals of the human figure, allowing only images of plants. And they reacted against Western churches, which eventually allowed the curtain to be drawn, revealing the terrestrial world in all of its variety. Byzantine art remained in a state of creative tension between the spiritual, represented by the sacred portraits, and the earthly, represented by the world of nature.

1 }

Nature and Idolatry

Nature in Early Byzantine Church Art

In a recent book, Ingvild Gilhus refers to the transition from paganism to Christianity as a "change from a sacrificial cult, where the animal body had been a key symbol, to the Christian cult, where the human body became the new key symbol." She goes on to characterize this shift as "one of the dramatic changes in the history of religions."[1] In churches, the change from an art that was embedded in nature to one that was anthropocentric was certainly dramatic, but it did not take place overnight; it was a slow and sometimes violent process that took several centuries.

The engagement of the art of Christian churches with nature begins with one of the earliest surviving decorations from a Christian church, namely, the early fourth-century floor mosaics of the double basilica at Aquileia. These pavements present a few explicitly Christian subjects, such as the story of Jonah, surrounded by a rich variety of motifs derived from the world of nature, including sea creatures of various kinds in their watery environment, together with birds, beasts, fruits, and plants (figure 1-1). There are also personifications, such as the season of summer.[2]

After this initial flourishing of nature in the pavements of Aquileia, church floors of the mid- and later fourth century, a period of increasing tensions between Christianity and paganism, exhibit a general reluctance to admit plants, animals, and personifications, although a few such images did appear

[1] I. S. Gilhus, *Animals, Gods and Humans: Changing Attitudes to Animals in Greek, Roman, and Early Christian Ideas*, London, 2006, 2.

[2] G. Brusin and P. Zovatto, *Monumenti Paleocristiani di Aquileia e di Grado*, Udine, 1957, 20–125; J.-P. Caillet, *L'Evergétisme monumental chrétien en Italie et à ses marges d'après l'épigraphie des pavements de mosaïque (IVe-VIIe s.)*, Rome, 1993, 123–141; H. Maguire, "Christians, Pagans, and the Representation of Nature," *Begegnung von Heidentum und Christentum im spätantiken Ägypten* (= *Riggisberger Berichte* 1), Riggisberg, 1993, 131–60, esp. 132–137.

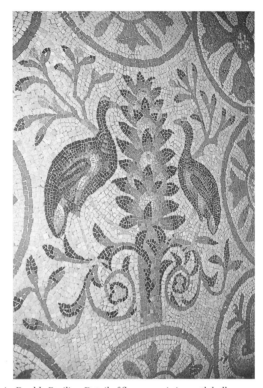

FIGURE 1.1. Aquileia, Double Basilica. Detail of floor mosaic in north hall.

at this time, especially birds and plants. The floors of many late fourth and early fifth-century churches show a still greater austerity, sometimes being completely aniconic. Then, in the course of the fifth century, figured motifs returned, culminating by the sixth century in a repertoire that was even richer than that at Aquileia.[3]

The reversion from unfigured back to figured mosaics is strikingly demonstrated at Huarte in Syria. Here the mosaics that were laid at the turn of the fourth and the fifth centuries in the nave and aisles of the "Ancient Basilica" were primarily geometric.[4] But the mosaics that were put down later in the fifth century in the narthex and baptistery of the same church depicted wild beasts chasing and attacking each other.[5] Then, according to an inscription, in 483 all of these mosaics were covered over by the pavement of a larger basilica, during the office of the Bishop Photios. The pavements of this church were richly figured, especially the nave, which displayed a great carpet portraying

[3]Maguire, "Christians, Pagans," 132–145.

[4]P. Canivet and M. T. Canivet, *Huarte, sanctuaire chrétien d'Apamène* (IVe-VIe s.), Paris, 1987, 115–118, 237–246, 315, fig. 77, plates 145–150.

[5]Ibid., 43, 116, 119, 246–254, 315, fig. 77, plates 151–7.

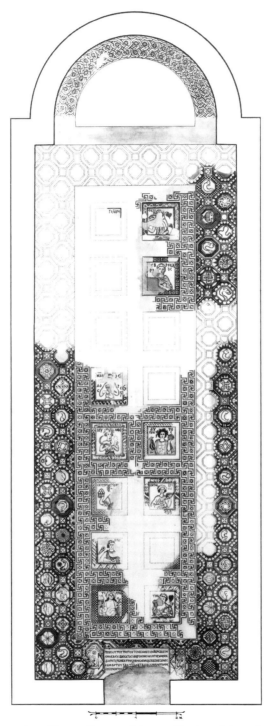

FIGURE 1.2. Tegea, Basilica of Thyrsos, floor mosaic in nave. Months and rivers of paradise surrounded by sea creatures.

a variety of beasts pursuing and pouncing upon each other among trees and other plants.[6]

Together with a broader variety of animal subjects, nature personifications returned to church pavements during the second half of the fifth century. Moreover, the range of personifications seems to have increased. By the sixth century we discover on the floors of churches not only personified months and seasons, as at Aquileia, but also the earth and the ocean, together with springs and rivers. Included among the personifications that grace late fifth- and sixth-century pavements are the splendid series of twelve months in the basilica of Thyrsos at Tegea in Greece (figure 1-2);[7] the earth, inscribed "Ge" from the church of the Priest John at Khirbet el-Mukhayyat, in Jordan (figure 1-3);[8] the half-naked body of the sea, identified as "Thalassa," who rises from fish-filled waters at the center of the nave of the church of the Apostles at Madaba in Jordan, dated by inscription to 578–579 (figure 1-4);[9] and, finally, the rivers of paradise, "Geon," or the Nile, "Phison," "Tigris," and "Euphrates," which are displayed in four panels of the mosaic of the East Church at Qasr-el-Lebia in Libya, dated by inscription to 539–540 (figures 1-5 and 1-6). At Qasr-el-Lebia the four rivers are accompanied by the oracular spring Castalia, either the spring at Delphi or at Daphne near Antioch.[10] The nude personification of the pagan oracle is included as one of the waters of the world converted by the power of Christ.[11]

During the later fifth and the sixth centuries, not only did the floors burgeon with a rich life of plants and animals; as we saw in the introduction, in many churches also the walls and vaults were decorated with vegetation and creatures of all kinds. San Vitale in Ravenna is one of the few buildings that preserve such a decoration intact today (figures Intro 1-2), but other churches once displayed similar motifs. In the fifth-century church of the Acheiropoietos at Thessaloniki, both the walls and arches originally displayed mosaics of animals and plants. From this decoration there survives a fragment of mosaic from the western end of the south wall of the nave, which displays a fountain surrounded by a plant scroll containing birds and beasts (Plate III).[12] The undersides of the arches dividing the nave from the aisles, the narthex, and the galleries still preserve their mosaics whose motifs include wreaths containing fruits and flowers

[6]Ibid., 49–50, 119–126, 193–206, fig. 63, plates 93–110.

[7]A. K. Orlandos, "Palaiochristianika kai byzantina mnemeia Tegeas-Nykliou," *Archeion ton Byzantinon Mnemeion tes Hellados*, 12 (1973), 12–81, esp. 27–43, figs. 6–12, plate A.

[8]M. Piccirillo, *Madaba, le chiese e i mosaici*, Milan, 1989, 190–192.

[9]Ibid., 98–107.

[10]E. Alföldi-Rosenbaum and J. Ward-Perkins, *Justinianic Mosaic Pavements in Cyrenaican Churches*, Monografie di Archeologia Libica XIV, Rome, 1980, 124–126, plates 7.1–7.4, 11.1.

[11]H. Maguire, *Earth and Ocean: The Terrestrial World in Early Byzantine Art* (Monographs on the Fine Arts Sponsored by the College Art Association of America XLIII), University Park, 1987, 50–55.

[12]*Byzanz: Pracht und Alltag*, exhibition catalogue, Kunst-und Ausstellungshalle der Bundesrepublik Deutschland, Bonn, 2010, 337–338, no. 450.

FIGURE 1.3. Khirbet el-Mukhayyat, Church of the Priest John, floor mosaic in nave, detail. Personification of Ge (Earth).

and a great variety of birds.[13] Nor was it only the floors and walls of churches that glorified the variety of nature. Their furniture also proclaimed the wealth of creation, as can be seen on the great carved marble pulpits that survive from Ravenna, such as the sixth-century ambo of Bishop Agnellus in the Cathedral.[14] Here we find a catalogue of the creatures, arranged in square panels covering the whole façade of the pulpit. The animals are arranged by rows in an ascending hierarchy, with fish at the bottom, followed by water-fowl, land birds, stags, peacocks, and finally lambs. Richer still is the remarkable vine scroll, carved in ivory, which frames the portrayals from the New and Old Testaments on the sixth-century throne of Archbishop Maximian, a work that was probably created in Constantinople.[15] This vine scroll takes up a surface area equal to that of the panels that it frames, so it becomes a dominant element of the chair's decoration. Its grape-bearing tendrils enclose a wonderful variety of creatures, big and small, from songbirds to peacocks, from hares to lions (figure 1-7).

[13]S. Pelekanidis, *Palaiochristianika mnemeia Thessalonikes. Acheiropoietos, Mone Latomou*, Thessaloniki, 1949; Pelekanidis, *Gli affreschi paleocristiani ed i più antichi mosaici parietali di Salonicco*, Ravenna, 1963, 41–47, figs. 10–11.

[14]F. W. Deichmann, *Ravenna, Hauptstadt des spätantiken Abendlandes*, vol. 1, *Geschichte und Monumente*, Wiesbaden, 1969, 73, figs. 96–97.

[15]W. F. Volbach, *Early Christian Art*, New York, n.d., 356, plates 226–235.

FIGURE 1.4. Madaba, Church of the Apostles, Personification of Thalassa (the Sea) at the center of the nave mosaic.

The return of these nature-derived images to churches in the fifth and sixth centuries was enabled by a new attitude on the part of Christian viewers. This attitude is expressed by a sermon of the second quarter of the fifth century, which was delivered by the Archbishop of Ravenna, St. Peter Chrysologus. In the course of his homily, which is devoted to baptism, Peter Chrysologus quotes the following words from Psalm 28:

> The voice of the Lord is over the waters;
> the glory of God thunders,
> the Lord over many waters.
> The voice of the Lord is powerful,
> The voice of the Lord is full of majesty. . . .
> The lord sits enthroned over the flood;
> The Lords sits enthroned as king for ever.
> May the Lord give strength to his people!
> May the Lord bless his people with peace!

In his commentary on this passage, Peter relates the triumphant words of the psalm to Christ's baptism. "Today," he says, "the Lord is *over* the waters. And he is rightly said to be *over* the waters, and not *under* the waters, because Christ in his baptism does not serve, but rules over the sacraments." Peter then goes on to ask how it was that the Jordan did not flee at the presence of the Trinity during the baptism of Christ, as it had formerly fled, or drawn back, to allow the passage of the Ark of the Covenant in the time of Joshua. The reason, says the preacher, is that the river was changed. In Peter's words, "The one that has submitted to reverence begins not to be in fear."[16]

In this passage, an early Christian preacher in Ravenna describes the submission and conversion of water, the most fundamental element of terrestrial nature. We can still see the same ideas expressed visually in the art of Ravenna, most strikingly in the mosaic that survives in the dome of the baptistery attached to the Arian Cathedral, which dates to the late fifth or early sixth century (plate IV).[17] On the right of the image, John baptizes Christ, who stands naked in the stream, beneath the dove of the Holy Spirit. On the left is the personification of the river Jordan, who is portrayed in the same manner as pagan river gods, with a cloth draping the lower half of the body, long flowing strands of beard and hair, and an upturned vase signifying the source of the water. However, the personification of the Jordan has an additional attribute not normally associated with rivers, for on top of his head he sports a pair of red claws. The claws usually accompany portrayals of Ocean in ancient art, as can be seen in a late fourth or early fifth-century floor mosaic discovered at Ain Témouchent, near Sétif in Algeria (figure 1-8).[18]

[16]*Sermo CLX*, ed. J.-P. Migne, Patrologiae cursus completus, Series Latina LII, cols. 621–62; cited by F. W. Deichmann, *Ravenna, Hauptstadt des spätantiken Abendlandes*, vol. 2, *Kommentar*, part 1, Wiesbaden, 1974, 35.

[17]F. W. Deichmann, *Frühchristliche Bauten und Mosaiken von Ravenna*, Baden-Baden, 1958, plates 251–254, Deichmann, *Geschichte und Monumente*, 209–212; Deichmann, *Kommentar*, part 1, 254–255. On the personification of the Jordan in art, see, most recently, R. M. Jensen, *Living Water: Images, Symbols, and Settings of Early Christian Baptism*, Leiden, 2011, 117–123, 134–136.

[18]K. M. D. Dunbabin, *The Mosaics of Roman North Africa*, Oxford, 1978, 151–152, plate 143. On the attribute of the claws, see F. Barry, "The Mouth of Truth and the Forum Boarium: Oceanus, Hercules, and Hadrian," *Art Bulletin* 93 (2011), 7–37, esp. 7–10.

FIGURE 1.5. Qasr-el-Lebia, East Church, floor mosaic in nave.

FIGURE 1.6. Qasr-el-Lebia, East Church, floor mosaic in nave, detail. Personification of Geon (the Nile)

FIGURE 1.7. Ravenna, ivory throne of Maximian, detail. Vine and creatures.

FIGURE 1.8. Ain-Témouchent, floor mosaic. Ocean.

The attribute of the claws expands the significance of the personification of the Jordan River to encompass all of the terrestrial waters. In the baptistery at Ravenna, the figure of Jordan/Ocean raises his left hand to acknowledge his master, the true God, Christ.

Another work that may be contemporary with the Arian Baptistery, or possibly slightly later, and that portrays a similar idea is the mosaic in the apse of the church of Hosios David in Thessaloniki. Here a splendid vision of Christ enthroned in his glory fills the apse (figure 1-9). The Lord is seated on a rainbow in a radiant aureole of light, supported by the four winged symbols of the Evangelists. This theophany is flanked by two unidentified figures with haloes, one sitting in contemplation on the right, the other raising his hands in a gesture that perhaps indicates his awe as he witnesses the vision. The identity of these two figures is uncertain. They are usually identified as prophets, apostles, or Evangelists; in the later Middle Ages they were identified as Ezekiel and Habakkuk. The feet of Christ rest on a hill from which flow the four rivers of paradise, which, in their turn, become a fish-filled stream running along the bottom of the mosaic. Below this stream, in the lower border of the mosaic, is an inscription, the beginning of which identifies the water as the water of life: "A life-giving source, accepting and nourishing the souls of the faithful [is] this most venerable house." The same words are repeated on the book held by the unidentified figure sitting in the rocky landscape to the right of the vision. But on close examination of the life-bringing stream, just to the left of Christ's feet, a shadowy form can be seen (figure 1-9, lower left). This is the defeated, or

converted, figure of the old deity, who is depicted in a white grisaille against the blue ground of the water. The god emerges from the current, with the naked torso, long hair, and flowing beard of the pagan river gods. He raises both arms, spreading his palms in astonished acknowledgment of the heavenly vision above him, recognizing Christ as his master. In spite of his shaggy and uncouth appearance, the god of the waters makes the same gesture as the nimbed holy man standing on the shore at the left.[19] Thus, here, in the very fountain of life, the converted ghost of the pagan past joins in acclamation of the Christian vision.

Turning from Greece to Egypt, in the sixth century we begin to find texts that treat the River Nile as a subject of Christ. Thus, the poet Dioscorus of Aphrodito, in an epithalamium for a wedding, bound the power of the river to Christ to convey a blessing upon the bride and groom. Dioscorus proclaimed, "Easily protecting . . . the Nile with his many children, may God grant a noble marriage free from the destructive envy of others."[20] On a sixth-century papyrus from Antinoe in Egypt we find a hymn addressed to the Nile that begins in a manner reminiscent of the pagan invocations but ends with an appeal to the Christian God:

O most fortunate Nile, smilingly have you watered the land;
Rightly do we present to you a hymn . . .
You are full of wonders in all Egypt, a remedy for men and beasts;
[you have brought] the awaited season . . .
the fruit of your virtue is very great . . .
you have displayed to us a strange miracle;
you have brought the benefits of the heavens . . .
True illumination, Christ, benefactor [save] the souls of men,
now and
[forever].[21]

Most of this poem contains nothing explicitly Christian. Only at its close does it appeal to Christ, the true source of the river's power. It is as if the supplicant is praying to the river as Christ's agent, al most in the same manner as one might call upon a saint. Sometimes, the association of the elements of creation with the power of Christ was made explicit in an inscription. For example, the personification of the sea that occupies the center of the pavement in the nave of the church of the apostles at Madaba in Jordan, mentioned before, is surrounded by an invocation that calls on the "Lord God, who made the heaven and the earth" to give life to the donors and the artist of the mosaic (figure 1-4).[22]

[19]J.-M. Spieser, "Remarques complémentaires sur la mosaïque de Osios David," *Hetaireia Makedonikon Spoudon, Makedonike Bibliotheke* 82 (1995), 295–306.

[20]Translation by L. S. B. Mac Coull, *Dioscorus of Aphrodito: His Work and His World*, Berkeley, CA, 1988, 111–112.

[21]M. Manfredi, "Inno cristiano al Nilo," in P. J. Parsons and J. R. Rea, eds., *Papyri Greek and Egyptian Edited by Various Hands in Honour of Eric Gardner Turner*, London, 1981, 49–69, esp. 56.

[22]Piccirillo, *Madaba*, 105.

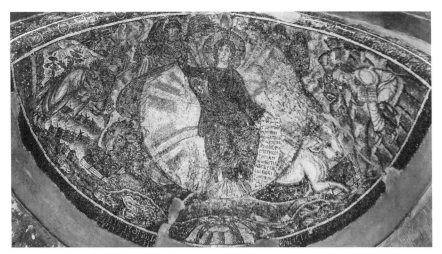

FIGURE 1.9. Thessaloniki, Hosios David, apse mosaic. Holy man and water god acclaim Christ.

The Christian rehabilitation of the cults of the rivers was aided by the fact that the four rivers of paradise were often identified with the four major rivers of the terrestrial world, which were thought to have their source in the fountain in paradise. Many people believed that the Tigris, the Euphrates, the Nile, and a fourth river, sometimes identified with the Ganges or the Danube, all had their origins in the terrestrial paradise, somewhere in the east, beyond the great ocean that encircles our inhabited world.[23] Thus, mortals who lived in the early Byzantine period were fortunate to have a direct link to paradise, provided by the water that flowed in these four great rivers. According to the early sixth-century poet Avitus, the Phison, which he identifies with the Ganges in India, steals the wealth of paradise and conveys it to our place of banishment.[24] The very association of the four rivers with paradise allowed a fusion of their spiritual and their physical values; these rivers nourished souls at the same time as they nourished fields and crops. In some surviving early Christian baptisteries we find the four rivers depicted in the mosaics of the pavement surrounding the font. For example, they appear, together with their names, at the four corners of the font in a fifth-century baptistery found at Ohrid. In this case the rivers are portrayed as masks with water streaming from their mouths, while between them there are representations of paradisal fountains flanked by birds and deer.[25]

[23]Maguire, *Earth and Ocean*, 17–28.

[24]*Poematum de mosaicae historiae gestis*, ed. Migne, Patrologia Latina LIX, col. 330.

[25]V. Bitrakova-Grozdanova, *Monuments paléochrétiens de la région d'Ohrid*, Ohrid, 1975, 55–65, plate 4.

Opposition to Portrayals of Nature

The sheer abundance of nature imagery in fifth- and sixth-century churches might lead one to assume that these motifs posed no problems to Christians; either they were purely decorative, or else, if they did express some kind of appeal to the natural forces portrayed, these forces were now safely under the control of Christ. However, this assumption would be wrong. From the fourth until the eighth centuries the depiction of nature continued to raise difficulties for Christian viewers, as both surviving texts and works of art make abundantly clear. The overriding issue was the danger of worshipping creation rather than the Creator. In the words of St. Augustine, "Superstition is whatever is instituted by men with regard to the making and worshipping of idols, or worshipping as God either creation or any part of creation."[26]

In the fourth century many church writers attacked cults or magical practices that centered on elements of nature, and their hostility must partly explain the relative avoidance of such subjects in the floors of mid- and later fourth-century churches.[27] The *Speech against the Pagans* by Athanasius of Alexandria provides an example. Athanasius visited Aquileia in the year 345,[28] and in all likelihood he saw part, at least, of the mosaic pavements of the old cathedral. Athanasius castigated the contradictory cults of the pagans: the Egyptians venerate the bull of Apis, he said, while others sacrifice the same animal to Zeus; the Libyans consider the ram, whom they call Ammon, to be a god, but the same animal is immolated by others as a victim.[29] Later, Athanasius speaks of pagans who worship the stone or wooden forms of irrational birds, reptiles, and four-footed beasts.[30] His polemic tells us that in the fourth century portrayals of animals were still associated in the minds of some Christians with paganism. Another evidence of this association is the episode of the bull device that Julian the Apostate depicted on the reverse of his coins, minted at Antioch. Some Christians, probably erroneously, read this animal as a symbol of the many pagan sacrifices that the emperor performed.[31] Toward the end of the fourth century Gregory of Nazianzus spoke derisively of pagan idols and of

[26]*De doctrina christiana II*, 30.

[27]See D. Michaelides, *Cypriot Mosaics*, Nicosia, 1987, 5–6, on the impact of antipagan legislation during this period.

[28]M. M. Roberti, "Osservazioni sulla basilica postteodoriana settentrionale di Aquileia," *Studi in onore di Aristide Calderini e Roberto Paribene*, III, Milan, 1956, 863–875, esp. 866.

[29]*Oratio contra gentes*, 24; ed. J. P. Migne, Patrologiae cursus completus, Series Graeca XXV, col. 48.

[30]*Oratio contra gentes*, 27; ed. Migne, Patrologia Graeca XXV, col. 52.

[31]Sokrates said that Julian had the bull placed on his coins because of his many pagan sacrifices; *Historia ecclesiastica*, 3, 17. Modern interpretations include the Apis bull, Julian's supposed natal sign (Taurus), and the symbol of the emperor as guardian of his people. See F. D. Gilliard, "Notes on the Coinage of Julian the Apostate," *Journal of Roman Studies* 54 (1964), 135–141, esp. 138, plate 10; J. P. C. Kent, *The Roman Imperial Coinage*, vol. VIII, London, 1981, 47.

the "honors paid to snakes and wild animals—the general competition in disgrace, in which each initiation and festival has its own character but all share in diabolical inspiration."[32]

Even plants and their products came under suspicion when viewed in the context of the threat of paganism. Athanasius in his *Speech against the Pagans* criticizes the role of wine in pagan cults: "the Indians venerate Dionysos," he says, "whom they refer to in symbolic form as wine, which others offer as a libation to other gods."[33] Antipagan legislation at the end of the fourth century explicitly prohibited the use of wine in pagan ritual.[34] But the connotations of wine were ambivalent, since it was employed both in pagan and in Christian cults. The same held true for depictions of the vine. A mosaic that survives from the pavement of the original Christian basilica at Paphos Chrysopolitissa, on Cyprus, may contain a reference to the role of wine in pagan practices. The mosaic, which probably dates to the fourth century, depicts a vine with large bunches of grapes, accompanied by a prominent inscription: "I am the true vine" (figure 1-10).[35] The late Roman houses of Paphos also contained fine examples of pavements portraying vines, but in pagan settings; for example, in the dining room of the so-called House of Dionysos, a large fruiting vine was associated with the portrayal of a Dionysiac procession.[36] In this context, the choice and display of the quotation from St. John's Gospel (15:1) above the vine portrayed in the Christian church appears defensive: it tries to distinguish between the Christian vine, which is true, and the pagan vines, which are not.

Such an inscription would not have satisfied a puritanical Christian such as St. Nilus of Sinai, who early in the fifth century wrote a letter to the prefect Olympiodorus when he was about to build a church. The prefect had proposed decorating his church with pictures of different birds, beasts, reptiles, and plants, together with animal hunts, including the chasing of hares and gazelles with dogs. For an example of the kind of decoration that Olympiodorus had in mind, we may cite again the floors of the Ancient Basilica of Huarte, in Syria, where, as we have seen, by the mid-fifth century, there were mosaics of birds, plants, and wild beasts pursuing and attacking each other. In his letter, however, Nilus rejects this kind of decoration as childish and distracting to the faithful. Instead, he recommends that Olympiodorus fill his church with crosses. "Whatever is unnecessary," says Nilus, "ought to be left out."[37]

[32] *Oratio XXXIX*, 6; translation by B. E. Daley, *Gregory of Nazianzus*, Abingdon, 2006, 130.

[33] *Oratio contra gentes*, 24; ed. Migne, Patrologia Graeca XXV, col. 48.

[34] *Codex Theodosianus*, 16.10.12.

[35] Michaelides, *Cypriot Mosaics*, 34–35, fig. 37.

[36] Ibid., 16–17, figs. 10–11.

[37] *Epistulae*, 4.61; ed. Migne, Patrologia Graeca LXXIX, cols. 577–580. Translation by C. Mango, *The Art of the Byzantine Empire, 312–1453*, Englewood Cliffs, NJ, 1972, 33. On the text, see H. G. Thümmel, "Neilos von Ankyra über die Bilder," *Byzantinische Zeitschrift* 71 (1978), 10–21.

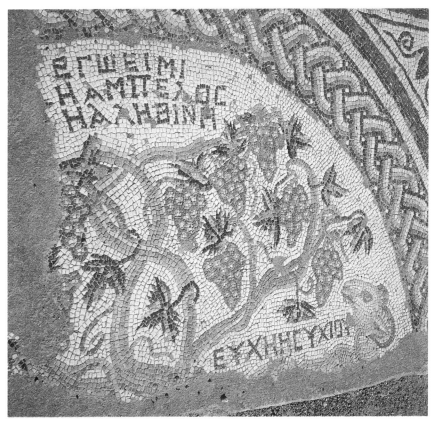

FIGURE 1.10. Paphos, Basilica of Chrysopolitissa, floor mosaic of nave, detail. The true vine.

If pictures of animals and plants were to be denied, portrayals of larger cosmic entities were no less suspect. Once again, Athanasios lays out the issues in his *Speech against the Pagans*. He says that some will boast that they do not venerate the stone or wooden forms of birds, reptiles, or beasts, but instead they worship the sun, the moon, the heavens, and also the earth and the waters. But these people, says Athanasius, are no less in error, because they make gods of what has been created rather than worshipping the Creator, whom the created elements confess. In and of themselves, he said, the elements of nature have no powers; the earth, for example, is powerless to give fruits without rain, nor does the great ocean move without the driving force of the winds.[38] We encounter similar ideas in the ninth homily on Genesis by St. John Chrysostom. Speaking of the earth, John Chrysostom says that it has been made our nurse and our mother. We feed from it, and in every other way we have the benefit of it. However, we should ascribe all of these benefits no longer to the

[38] *Oratio contra gentes*, 27; ed. Migne, Patrologia Graeca XXV, cols. 52–56.

nature of the earth itself but rather to the power of the creator who made it.[39] Likewise, St. Augustine, in the *City of God*, proclaimed, "We do not call even the earth herself creator, although she was seen to be the fruitful mother of all the things . . . for we read: 'God gives it a body as he has chosen and to each kind of seed its own body' (1 Corinthians 15:38)."[40]

The mentality that these churchmen were attempting to combat, namely, the belief that such natural entities as the earth and the ocean had powers in and of themselves, found expression in floor mosaics. A good example is the pavement discovered at Ain-Témouchent, with its frontal mask of Ocean characterized by enlarged eyes (figure 1-8). An inscription at the bottom of the mosaic invokes the staring mask's powers against the hostile forces of envy.[41] More remarkable still was a pavement in the baths of a Roman house at el Haouria in Tunisia (figure 1-11).[42] Here a floor mosaic could be found that originally depicted a frontal mask of Ocean. The image was similar to the more complete mosaic of the same subject at Ain-Témouchent. However, at some time after its completion, the face of Ocean was carefully picked out, leaving behind just his curved beard and the claws that had projected from his hair. Only the figures that had framed the mask in the four corners of the mosaic, erotes and hippocamps, were allowed to remain, presumably because whoever erased the central mask considered the supporting cast to be innocuous. In this act of iconoclasm, we can see clearly the anxiety provoked by a water deity in a household that presumably had become Christian.

Christian writers of the fourth century also attacked the cult of rivers. Athanasius argued against people such as the Egyptians who gave special reverence to rivers and springs and "proclaim them to be gods."[43] Another text, the first Mystagogical Catachesis, attributed either to the fourth-century Bishop Cyril of Jerusalem or to his successor, John, opposes the lighting of lamps and incense to springs and rivers and the practice of having recourse to them for the cure of bodily diseases.[44] John Chrysostom, in a homily delivered in Constantinople in 399, condemns the medical use of amulets, castigating women who hung charms inscribed with the names of rivers about their necks.[45]

[39]*In Genesim, Homilia IX*; ed. Migne, Patrologia Graeca LIII, col. 77.

[40]*De civitate Dei*, 12.26. On the related Christian ambivalence toward the celebration of the seasons, see G. M. A. Hanfmann, *The Season Sarcophagus in Dumbarton Oaks*, Cambridge, MA, 1951, 190–192, 196–209.

[41]Invida sidereo rumpantur pectora visu . . .; Dunbabin, *Mosaics of Roman North Africa*, 151–152, plate 143.

[42]L. Poinssot, "Mosaïques d'El-Haouria," *Revue Africaine* 76 (1935), 183–206, esp. 189–195, fig. 3.

[43]*Oratio contra gentes*, 24; ed. Migne, Patrologia Graeca XXV, col. 48.

[44]*Mystagogica catechesis I*, 8; ed. Migne, Patrologia Graeca XXXIII, col. 1072. On the attribution, see J. Quasten, *Patrology*, vol. 3, Westminster, MD, 1986, 364–366.

[45]*In epistulam ad Colossenses, Homilia VIII*, 5; ed. Migne, Patrologia Graeca LXII, col. 358.

FIGURE 1.11. El-Haouria, Roman house, floor mosaic from the baths, detail. Excised mask of Ocean.

We have seen that the four major rivers of the terrestrial world—the Nile, the Phison, the Tigris, and the Euphrates—originated in the gem-encrusted spring of paradise and were therefore accepted into churches. But the fact remained that they had been the focus of pagan cults before the triumph of Christianity, and this stain could never completely be erased. The problem was especially acute in the case of the Nile, for this river, above all other waters, was associated not only with bounty but also with the rites and idolatry that had tried to ensure its annual flood. In the 380s, the pagan orator Libanius taunted the Christians with their acquiescence in the Nile festivities because of their concern for the food supply: he writes, "The eager supporters of abolition [of pagan rites] have refrained from abolishing them [that is, feasts to the Nile], but have allowed the river to be feasted in the time-honored ritual for the customary reward."[46] We know in fact from a papyrus from Oxyrhynchus that the Nile Festival was being celebrated as late as 424.[47]

[46]*Oratio XXX*, 35; translation after A. F. Norman, *Libanius, Selected Works*, vol. 2, Cambridge, MA, 1977.

[47]Z. Weiss and R. Talgam, "The Nile Festival Building and Its Mosaics: Mythological Representations in Early Byzantine Sepphoris," in J. H. Humphrey, ed., *The Roman and Byzantine Near East*, vol. 3, Portsmouth, RI, 2002, 55–90, esp. 70.

In response to the continuing popularity of the cult of the Nile, Christian orators developed an antithesis, between on one hand the waters of the Nile, which they vilified as corrupt and corrupting, and those of the baptismal font on the other, which brought eternal life. This theme is evident in Firmicus Maternus's *Errors of Pagan Religions*, composed in the mid-fourth century. According to Firmicus, "The inhabitants of Egypt adore water, implore water, and venerate water in the superstitious routine of their offerings." He goes on to associate the Nile with the unsavory cult of Osiris, whose body was dismembered and dispersed along the banks of the river, and with the dog-headed Anubis. "In vain do you suppose," says Firmicus, addressing the Egyptians, "that this water can bring you any advantage. But there exists another water by which men are renewed and reborn. . . . This water of fire, which you scorn, is ennobled by the majesty of the venerable spirit."[48] The association of the Nile with idolatry occurs again in the work of the sixth-century poet Romanos. His hymn on the Holy Innocents declares that when Christ arrived at the Land of Egypt and of the fruitful Nile, he overthrew there all of their idols.[49]

Against this background of suspicion, Christians were careful about how they represented the Nile in their churches. For the most part, they avoided personifying the Nile on its own, without the company of the other three rivers of paradise to act as chaperons. We have already seen the four rivers appearing together in the mosaic at Qasr-el-Lebia (figures 1-5 and 1-6). Another example survives in Greece, in the nave mosaic of the already mentioned basilica of Thyrsos at Tegea in the Peloponnese (figure 1-2). Here we see a map-like composition, showing the earth and the surrounding ocean. The ocean is represented by the border around the mosaic, which portrays sea creatures in octagons. The earth is evoked by the personifications of the twelve months, depicted in bust form in the central rectangular panel of the mosaic, each holding its seasonal attributes. In the four corners of the central panel we find the four rivers of paradise, identified as Gehon, or the Nile, and Phison, nearest to the sanctuary; and the Tigris and Euphrates, nearest to the entrance.[50]

The fear was that an isolated image of the Nile in human form might encourage idolatry by tempting viewers to venerate the created rather than the creator. A concern of this kind may be expressed in a sixth-century encomium addressed to Marcian, the bishop of Gaza, by the orator Choricius. Describing the now lost church of St. Stephen in that city, which the bishop had been instrumental in building, Choricius came to the scenes depicted in the aisles of the basilica,

[48] *De errore profanarum religionum*, 2.1–5; see A. Hermann, "Der Nil und die Christen," *Jahrbuch für Antike und Christentum* 2 (1959), 30–69, esp. 47–48.

[49] Strophe 15, ed. J. Grosdidier de Matons, *Romanos le Mélode, Hymnes*, vol. 2, Sources chrétiennes CX, Paris, 1964, 222.

[50] Orlandos, "Palaiochristianika kai byzantina mnemeia Tegeas-Nykliou," 12–81, esp. 27–43, figs. 6–12, plate A.

FIGURE 1.12. Gerasa, Church of St. John the Baptist, floor mosaic in nave, detail. Nilotic motifs.

which portrayed the animals and plant life of the River Nile. The river, he said with approval, was "nowhere portrayed in the way painters portray rivers"—that is, the Nile was not shown by a personification. Instead, said Choricius, the Nile was "suggested by means of distinctive currents and symbols, as well as by the meadows along its banks" where "various kinds of birds that often wash in that river's streams dwell in the meadows."[51] In other words, in St. Stephen at Gaza, as in many surviving early Byzantine churches, the Nile was evoked only by means of its typical flora or fauna. An illustration of the kind of scenes that Choricius was describing is provided by the beautiful floor mosaics in the transepts of the church of the Multiplying of the Loaves and Fishes at Tabgha, which date to the second half of the fifth century, where we see water birds and lotus plants but no Nile personification.[52] Similar motifs from the Nile, together with representations of its principal cities, such as Alexandria, occur on the sixth-century pavement of the church of St. John the Baptist at Gerasa (figure 1-12).[53]

[51]*Laudatio Marciani II*, 50–51; ed. R. Foerster and E. Richsteig, *Choricii Gazaei opera*, Leipzig, 1929; translation by Mango, *Art of the Byzantine Empire*, 72.

[52]R. Hachlili, *Ancient Mosaic Pavements*, Leiden, 2009, 97, figs. V 2a–b.

[53]C. H. Kraeling, *Gerasa, City of the Decapolis*, New Haven, CT, 1938, 324–329, 480, plates 66–70; M. Piccirillo, *The Mosaics of Jordan*, Amman, 1993, 286–289, figs. 535–545. On the iconography of the Nile in Early Christian art, see H. Maguire, "The Nile and the Rivers of Paradise," in M. Piccirillo and E. Alliata, eds., *The Madaba Map Centenary, 1897–1997*, Jerusalem, 1999, 179–184.

The floor mosaics of Antioch in ancient Syria provide an interesting example of the sensitivity of some Christians concerning the appropriateness of nature-related personifications. This example of iconoclasm occurs at the "House of the Sea Goddess," which lies on the slope of a hill above Antioch's port city of Seleucia.[54] By the time that the excavators worked on it, in the 1930s, a portion of the building had already been washed away down the hillside, but the archaeologists were able to expose a wide corridor paved with mosaics, which ran in front of an ornamental pool. The mosaics can be dated to the end of the fifth century. In the section of the corridor facing the pool the composition comprised two large panels. One of the panels depicts a marine deity, portrayed as a woman sitting in the midst of the sea, naked except for two narrow strips of seaweed draped over her torso (figure 1-13). With her right hand she holds onto the neck of a sea dragon, whose coils wind around her legs. Below her is a large fish, while on the right a naked Eros approaches her riding on the back of a dolphin. The other panel frames a large cross-shaped guilloche, which is outlined by the braiding together of two ornamental bands (figure 1-14). In the spaces between the arms of the cross and the corners of the panel there are four medallions, which originally contained the busts of four personifications. These personifications, which are still identified by their inscriptions, were *Ktisis*, that is, Foundation or Creation; *Ananeosis*, or Renewal; *Euandria*, or Manliness; and *Dynamis*, or Strength. At some time, while the villa was still occupied, the faces of these four personifications were carefully removed and replaced by small square slabs of plain marble. It is evident that this was a deliberate act of erasure, but the question remains: why did the inhabitants of the house meticulously take out the heads of these four personifications? And why did they permit the naked sea deity to remain untouched? At the time of excavation the sea goddess had suffered some damage, but this was due to natural causes, not human intervention.[55]

To find answers, it is necessary to consider the meanings that these personifications, especially *Ktisis* and *Ananeosis*, may have held for the citizens of Antioch. Both pagans and Christians could associate the portrayal of Foundation with the safety of their house and household. In the original mosaic, before the erasures, Foundation was shown holding her usual attribute of the measuring rod (figure 1-14, upper left). This instrument indicated a soundly

[54] D. Levi, *Antioch Mosaic Pavements*, Princeton, NJ, 1947, 349–350, fig. 142, plates 82c, 132b–132c, 133a.

[55] The loss that can be seen at the upper right of the panel with the sea deity is due to the accidents of preservation; enough of the goddess's head is preserved to show that it was never deliberately removed.

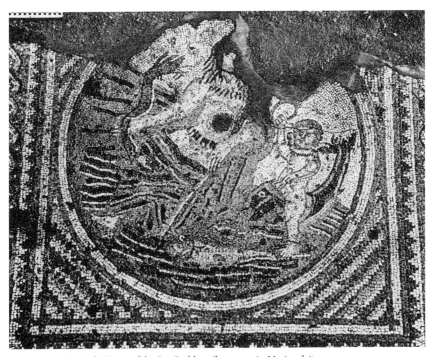

FIGURE 1.13. Antioch, House of the Sea Goddess, floor mosaic. Marine deity.

FIGURE 1.14. Antioch, House of the Sea Goddess, floor mosaic. Cross with erased personifications.

constructed building, a concept that was comforting in a city such as Antioch that was always in danger from earthquakes.[56]

For Christians, however, the personification of *Ktisis* took on a new significance, namely, the creation of the world by God.[57] For this reason the personification *Ktisis* found her way onto the pavements of some sixth-century churches, such as the basilica at Qasr-el-Lebia in Libya. Here a woman identified as *Ktisis* appears at the head of the pavement, no longer grasping her measuring rod but instead proffering a wreath and a branch in her right hand (figure 1-5, top row, second panel from the right). Now she evokes not only the secure foundation of the church building but also the whole of God's creation. The content of the other panels in the floor mosaic, most of which illustrate the varied creatures of land, sea, and air together with the four rivers of paradise, demonstrates that here *Ktisis* stands for earthly creation.[58]

Ananeosis, or renewal, was another important concept in Christian thought. She also is personified on the pavement at Qasr-el-Lebia, in a prominent location at the center of the second row from the top (figure 1-5). She is portrayed as a richly dressed woman staring out from between parted curtains and holding a brimming basket (figure 1-15).[59] In this mosaic *Ananeosis* is situated at the center of a complex web of allegories, one of which is suggested by the panel immediately below her, showing an eagle holding a deer in its talons. Early church writers linked the image of the eagle and its prey both with the eucharist and with baptism.[60] The designer at Qasr-el-Lebia, therefore, associated the personification of Renewal with the idea of Christian renewal through the rites of baptism and of the mass, symbolized by the eagle with the body of its victim.

The pavement at Qasr-el-Lebia demonstrates that by the sixth century the personifications of Creation and Renewal had been adopted by Christians and their images had appeared in churches. This Christianization may have been the cause of their erasure from the House of the Sea Goddess at Seleucia. From the late fifth century until the invasion of the Arabs in the seventh century, Antioch was a stronghold of Monophysites, some of whom believed that representations of Christ and of the saints should not be permitted. One of the Monophysites, Philoxenus the Bishop of Mabbug, was reported to have engaged in acts

[56]Maguire, *Earth and Ocean*, 48.

[57]Ibid., 48–50.

[58]Alföldi-Rosenbaum and Ward-Perkins, *Justinianic Mosaic Pavements*, 123–133, plates 6–16.

[59]Alföldi-Rosenbaum and Ward-Perkins, ibid., p. 124, identify the contents of the basket as fruit; however, S. Stucchi, *Architettura cirenaica*, Monografie di Archeologia Libica XI, Rome, 1975, 401-402, identifies the contents as bread.

[60]H. Maguire, "An Early Christian Marble Relief at Kavala," *Deltion tes Christianikes Archaiologikes Etaireias* 16 (1991–1992), 283–295, esp. 290–294.

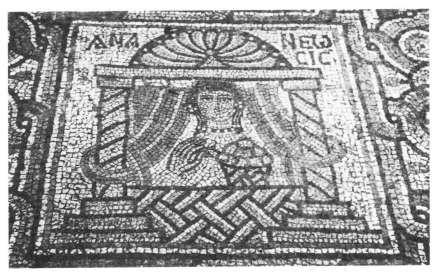

FIGURE 1.15. Qasr-el-Lebia, East Church, floor mosaic in nave, detail. Personification of *Ananeosis* (Renewal).

of iconoclasm, destroying images of angels and concealing images of Christ.[61] The Monophysites even took issue with animal symbols, such as the dove representing the Holy Ghost, as we discover from a passage from the *Ecclesiastical History* of John Diakrinomenos that was cited in the acts of the second council of Nicaea:

> It is an infantile act to represent the most-holy and venerable Ghost in the likeness of a dove seeing that the text of the Gospel teaches not that the Holy Ghost became a dove, but that it was once seen in the form of a dove, and that since this happened only once by reason of dispensation and not essentially, it was in no way fitting for believers to make for it a bodily likeness.[62]

This excerpt suggests that the problem went beyond the mere childishness of the representation. The Monophysites were worried about the embodiment of the spiritual and the consequent confusion between the bird as a symbol and as an object of worship in its own right. Similar concerns motivated Severus, the Monophysite patriarch of Antioch from 512 to 518, who, according a complaint recorded in the acts of a council held in 536, melted down the sacred

[61]J. Cramer, ed., *Anecdota graeca e codd. manuscriptis Bibliothecae Regiae Parisiensis*, vol. 2, Oxford, 1839, 109; G. Mansi, *Sacrorum conciliorum nova et amplissima collectio*, Florence, 1759–1798, vol. XIII, col. 181; Mango, *Art of the Byzantine Empire*, 43–44.

[62]Mansi, *Sacrorum conciliorum nova collectio*, vol. XIII, col. 181; Mango, *Art of the Byzantine Empire*, 43–44.

vessels and "appropriated . . . the gold and silver doves representing the Holy Ghost that hung above the sacred fonts and altars, saying that the Holy Ghost should not be designated in the form of a dove."[63] One such silver dove, which evidently escaped iconoclasm of the type perpetrated by Severus, is preserved as part of the Attarouthi treasure from northern Syria, now in the Metropolitan Museum of Art in New York.

The original decoration in a Monophysite church from this period at Kartmin, in northern Mesopotamia (now southeast Turkey) is still preserved, albeit in a damaged condition. The mosaics date to the year 512 and cover the vault and the two side walls of the sanctuary of the church.[64] The vault is adorned with a vine scroll springing from four silver vases placed in the corners. At the center of the ceiling, the vines enclose a medallion containing a splendidly jeweled cross.[65] Each of the side walls of the sanctuary presents basically the same composition, of a domed ciborium resting on four columns, under which is placed an altar carrying three vessels, a bread basket flanked by two chalices (figure 1-16).[66] A striking feature of the mosaics is that they show no human figures; even beasts and birds are absent. The compositions at Kartmin, like the floor at Qasr-el-Lebia, refer to the Eucharist, but by entirely different means. The mosaics of Qasr-el-Lebia portray the allegory of the eagle and the corpse beside the personification of *Ananeosis* (figures 1-5 and 1-15); those at Kartmin show only the vases and the vine, together with the inanimate ciborium, the table, and the liturgical vessels; all living creatures are rigorously excluded.

We may suggest, then, that the person who excised the personifications of Renewal and Creation from the house of the Sea Goddess was troubled by the Christian connotations that these figures had acquired. Like Philoxenus of Mabbug, this iconoclast felt that Christian images should not be shown. If this interpretation of the evidence is correct, and the removal of the personifications from the mosaic in the House of the Sea Goddess was an erasure of Christianized imagery, then it is possible to understand why the sea deity was allowed to remain; she did not evoke any Christian concepts but merely stood for the pleasures of the pool and the waters beside which she was placed. The sea goddess was an adornment of the ornamental pool and was not expressive of the religious orientation of the owner of the house.

[63]Mansi, *Sacrorum conciliorum nova collectio*, vol. VIII, col. 1039; ibid., vol. XIII col. 184; translation by Mango, *Art of the Byzantine Empire*, 44.

[64]E. Hawkins and M. Mundell, "The Mosaics of the Monastery of Mar Samuel, Mar Simeon, and Mar Gabriel near Kartmin," *Dumbarton Oaks Papers* 27 (1973), 279–296.

[65]ibid., 283–289, fig. 7.

[66]Ibid., 289–291, figs. 33–34, 40–41.

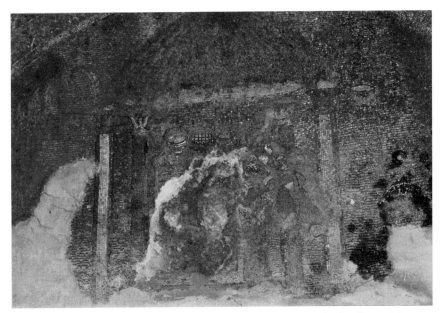

FIGURE 1.16. Kartmin, Monastery of Mar Samuel, Mar Simeon, and Mar Gabriel, wall mosaic in sanctuary. Altar and ciborium.

Nature and the Iconoclastic Crisis

The erasures in the House of the Sea Goddess at Antioch were a prelude to an episode of iconoclasm that is much more widely known and discussed. During the eighth century, many of the depictions of animals, personifications, and human beings engaged in pursuits that exploited nature, such as agriculture, hunting, and fishing, were excised from the pavements of churches in Palestine.[67] The floor of the church of St. Stephen at Umm al-Rasas, which was set in 718, provides a *terminus post quem* for this wave of destruction (figure 1-17).[68] Because the erasure of the offending motifs from the Palestinian mosaics was accomplished with some care, so as not to disturb the surrounding compositions,

[67]Concerning the erasures in Palestinian churches, see R. Schick, *The Christian Communities of Palestine from Byzantine to Islamic Rule: A Historical and Archaeological Study*, Princeton, NJ, 1995, 210–219; Schick, "Archaeological Sources for the History of Palestine: Palestine in the Early Islamic Period: Luxuriant Legacy," *Near Eastern Archaeology* 61–62 (1998), 74–108, esp. 87–88; S. Ognibene, "The Iconophobic Dossier," in M. Piccirillo and E. Alliata, *Mount Nebo: New Archaeological Excavations 1967–1997*, Jerusalem, 1998, 373–389; L. Brubaker and J. Haldon, *Byzantium in the Iconoclast Era (ca. 680–850): The Sources—An Annotated Survey*, Aldershot, 2001, 35–36; G. Bowersock, *Mosaics as History: The Near East from Late Antiquity to Islam*, Cambridge, MA, 2006, 100.

[68]M. Piccirillo and E. Alliata, *Umm al-Rasas/Mayfa'ah*, vol. 1, *Gli scavi del complesso di Santo Stefano*, Jerusalem, 1994, 134–240; Brubaker and Haldon, *Byzantium in the Iconoclast Era*, 32–34; Ognibene, "Iconophobic Dossier," 383–384.

most specialists now believe that the interventions were executed by the Christians themselves rather than by their Muslim rulers.[69] And since the Christians in Palestine were eliminating portrayals of animals as well as human beings from the floor mosaics of their churches, it is often proposed that they were motivated by a desire to reach an accommodation with the iconophobia of their dominant Muslim neighbors, who banned representations of all living creatures, including animals, from their religious buildings.[70] There is some sporadic evidence that in the early Islamic period Muslims occasionally used Christian churches for prayer,[71] and it has been suggested that this practice increased the pressure on Christians to make their places of worship follow Muslim prohibitions. While the extent to which Muslims and Christians shared their places of worship on a consistent basis is uncertain, there is no doubt that the presence of their Arab neighbors must have affected the ways that Christians thought about the decoration of their churches.[72] Muslim attitudes to images of living beings in sacred places surely caused the Christian communities to reassess their own practices; the Arab invasions gave new urgency to the debates about the acceptability of nature-derived imagery that had taken place earlier within the Christian community itself.

A key text in the debate concerning the status of imagery from the natural world in churches was St. Paul's Epistle to the Romans 1:23–25. This passage reads, "And they exchanged the glory of God, who is incorruptible, with the likeness of an image of man who is corruptible, or of birds, quadrupeds, or reptiles, and they paid respect to and worshipped the creature rather than the

[69]Schick, *Christian Communities of Palestine*, 210; Schick, "Archaeological Sources for the History of Palestine," 87; Ognibene, "Iconophobic Dossier," 384–385; Brubaker and Haldon, *Byzantium in the Iconoclast Era*, 36.

[70]A. Grabar, *L'iconoclasme byzantine*, Paris, 1984, 122; Schick, *Christian Communities of Palestine*, 218–219; Schick, "Archaeological Sources for the History of Palestine," 87–88; Ognibene, "Iconophobic Dossier," 385; Bowersock, *Mosaics as History*, 104–111; Brubaker and Haldon, *Byzantium in the Iconoclast Era*, 35–36; L. Brubaker, "Eighth-Century Iconoclasms: Arab, Byzantine, Carolingian, and Palestinian," in J. D. Alchermes, ed., *ΑΝΑΘΗΜΑΤΑ ΕΟΡΤΙΚΑ: Studies in Honor of Thomas F. Mathews*, Mainz am Rhein, 2009, 73–81, esp. 80–81. S. Fine, "Iconoclasm and the Art of Late-Antique Palestinian Synagogues," in L. I. Levine and Z. Weiss, eds., *From Dura to Sepphoris, Studies in Jewish Art and Society in Late Antiquity*, Portsmouth, 2000, 183–194, esp. 192–194, attributes the Jewish iconoclasm to the rise of Islam rather than to competition with the Christians, in opposition to C. Barber, "The Truth in Painting: Iconoclasm and Identity in Early-Medieval Art," *Speculum* 72 (1997), 1019–1036, esp. 1023, who suggests that by the late sixth century the Jews already had turned away from figural imagery. See also S. Fine, *Art and Judaism in the Greco-Roman World: Toward a New Jewish Archaeology*, Cambridge, 2010, 123–124.

[71]S. Bashear, "Qibla Musharriqa and Early Muslim Prayer in Churches," *The Muslim World* 81 (1991), 267–282; Bowersock, *Mosaics as History*, 109–110, 122.

[72]S. H. Griffith, "Crosses, Icons and the Image of Christ in Edessa: The Place of Iconophobia in the Christian-Muslim Controversies of Early Islamic Times," in P. Rousseau and M. Papoutsakis, eds., *Transformations of Late Antiquity: Essays for Peter Brown*, Aldershot, 2009, 63–83, esp. 69–70.

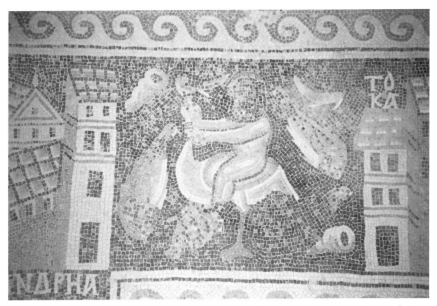

FIGURE 1.17. Umm al-Rasas, Church of St. Stephen, detail of floor mosaics in nave with iconoclastic interventions.

Creator." In their council of 754, the iconoclasts used these verses against the supporters of icons, but they omitted a key phrase, namely, the words "or of birds, quadrupeds, or reptiles."[73] The Orthodox council of 787, in its refutation of the proceedings of the iconoclast council, seized on this omission to make a distinction between the Christian worship of sacred icons and the pagan worship of idols. The council of 787 responded:

> One must expressly say that they [i.e., the iconoclasts] are the ones who, like the gentiles, exchanged the glory of God and worshipped the creature rather than the Creator, because they have exchanged and distorted what the apostle meant according to their own desires. For it is quite clear to everyone that, when the apostle says "they exchanged the glory of God who is incorruptible with the likeness of the image of man who is corruptible," he is, obviously, ridiculing the pagans; for he continues: "or of birds, quadrupeds, or reptiles." Even though they [the iconoclasts] cut off a whole phrase deceitfully in order to lure the simpler ones [to believe] that the apostle addresses himself to the issue of iconographic representations of the Church [that is, to icons of Christ and the saints], what follows makes the clarification manifest. For he also makes reference

[73]Mansi, *Sacrorum conciliorum nova collectio*, vol. XIII, col. 285; translation by D. Sahas, *Icon And Logos. Sources in Eighth-Century Iconoclasm*, Toronto, 1986, 111.

to birds, quadrupeds, and reptiles as well as to the fact that "they worshipped the creature rather than the Creator." Thus those who are most experienced in historical books know that in olden times the Egyptians used to honor bulls and other mammals, various kinds of birds, insects, wasps, and even less worthy creatures. The Persians also worshipped the sun and fire, while the Greeks, in addition to these, worshipped the entire creation.[74]

Here, then, the supporters of icons were forced by the iconoclast attack to distinguish *their* kind of image worship, of portraits of Christ and the saints, from the idolatry of the pagans, which involved animals and images of the entire creation, such as the personification of *Ktisis*. This distinction rendered the old manner of church decoration, with its animals and personifications, even more problematic than it had been before, as nature-derived representations suggested the worship of creation rather than the Creator. The erasures on the Palestinian floors were, therefore, as much a response to the debates concerning Christian images as to pressure from Islam. There is no evidence, either in archaeology or in texts, that the Christians of Palestine followed the example of the iconoclasts in Constantinople and destroyed icons of Christ and the saints.[75] But to keep these holy portraits, they had to jettison the profane imagery of the natural world.

For an illustration of this principle, we may examine as an example the Church of the Virgin at Madaba, which was probably constructed toward the end of the sixth century. Originally, a floor mosaic depicting a grid or trellis of florets was laid in the nave and narthex of the church (figure 1-18). In the eighth century the central portion of the original mosaic was replaced by a large square containing an aniconic composition of circles and squares framing an inscription (figure 1-19). The original trellis mosaic survives only around the edges.[76] The inscription begins with these words: "Looking on Mary the Virgin Mother of God and on Christ whom she bore, king of all, only son of the only

[74]Mansi, *Sacrorum conciliorum nova colllectio*, vol. XIII, col. 285; translation by Sahas, *Icon and Logos*, 111–112.

[75]John of Damascus and Theodore Abu Qurrah both wrote in defense of icons; S. H. Griffith, "Theodore Abu Qurrah's 'On the Veneration of the Holy Icons:' Orthodoxy in the World of Islam," *Sacred Art Journal* 13 (1992), 3–19. A synod in Jerusalem condemned iconoclasm in 760; Schick, *Christian Communities of Palestine*, 210–211. The early ninth-century *Life of Stephen the Younger* characterizes the region of Syria and Palestine as not participating in the destruction of holy portrait icons; M.-F. Auzépy, ed., *La vie d'Etienne le Jeune par Etienne le Diacre*, Aldershot, 1997, 121–125.

[76]Piccirillo, *Madaba, le chiese e i mosaici*, 41–66; Piccirillo, *Mosaics of Jordan*, 50; Brubaker and Haldon, *Byzantium in the Iconoclast Era*, 34–35, fig. 25; H. Maguire, "Moslems, Christians, and Iconoclasm: Erasures from Church Floor Mosaics during the Early Islamic Period," in C. Hourihane, ed., *Byzantine Art: Recent Studies*, Princeton, NJ, 2009, 111–119.

God, purify your mind and your flesh and your works."[77] It seems most likely that these words referred to an image of the Virgin and Child somewhere in the church. This may have been a mosaic in the apse, such as the sixth-century mosaics of the Virgin and Child in the apses of the churches at Kiti and Lythrangomi on Cyprus.[78]

The reason for the replacement of the central portion of the original nave mosaic is uncertain, but we know that it was probably not on account of wear and tear, because the floor at the entrance, which would have suffered the most traffic, was not replaced. Nor is it known what occupied the center of the trellis floor that was destroyed when the inscription with its geometric frame was inserted. To judge from other sixth-century pavements in Madaba, however, it is likely that the original focus of the floor was some motif related to nature, such as a personification of the earth or the sea (figures 1-3 and 1-4), or else an animal. A small chapel discovered at Madaba preserves an example of an animal as the focal point of such a composition. Its pavement consists of a trellis of florets, similar to the one at the Church of the Virgin, surrounding a medallion containing a single sheep.[79]

At the Church of the Virgin in Madaba, therefore, there may have been a situation in which an image of Christ and the Virgin was prominently displayed in the church, even while a nature-related motif, or motifs, had been removed from the floor. If this was the case, we can interpret the suppression of the representations from nature as a form of purification by those who wished to preserve the sacred icons of Christ and the saints.

At the very least, we can say for certain that the new aniconic pavement at Madaba cannot have been an example of accommodation with Muslim sensibilities, for the inscription at its center explicitly identifies the Virgin as "Mother of God" and Christ as the "only son of the only God." Both of these concepts would have been unacceptable to Muslims. Indeed, the mosaic inscription in the Dome of the Rock, which was built around 692 in Jerusalem, precisely rejects the claims made by the later inscription at Madaba. Quoting

[77]ΠΑΡΘΕΝΙΚΗΝ ΜΑΡΙΗΝ ΘΕΟΜΗΤΟΡΑ ΚΑΙ ΟΝ ΕΤΙΚΤΕΝ
Χ(ΡΙΣΤΟ)Ν ΠΑΜΒΑΣΙΛΗΑ ΘΕΟΥ ΜΟΝΟΝ ΥΙΕΑ ΜΟΥΝΟΥ
ΔΕΡΚΟΜΕΝΟΣ ΚΑΘΑΡΕΥΕ ΝΟΟΝ ΚΑΙ ΣΑΡΚΑ ΚΑΙ ΕΡΓΑ. . . .
Piccirillo, *Madaba, le chiese e i mosaici*, 49; A. Rhoby, ed., *Byzantinische Epigramme in inschriftlicher Überlieferung*, vol. 1, *Byzantinische Epigramme auf Fresken und Mosaiken*, Vienna, 2009, 394–395. Compare the inscription set into the mosaic pavement of the church at el-Rashidiyah in Jordan, dated 574: "Entering here you will see the Virgin Mother of Christ, the ineffable Logos, dispensation of God, and if you believe, you will be saved. . . ." L. Di Segni, "Varia Arabica. Greek Inscriptions from Jordan," *Liber Annuus* 56 (2006), 578–592, esp. 587–590.
[78]A. Megaw and E. Hawkins. *The Church of the Panagia Kanakaria at Lythrankomi in Cyprus*, Washington, DC, 1977; Michaelides, *Cypriot Mosaics*, 119–120, fig. 69.
[79]Piccirillo, *Madaba, le chiese e i mosaici*, 129–132.

FIGURE 1.18. Madaba, Church of the Virgin, plan.

FIGURE 1.19. Madaba, Church of the Virgin, nave floor mosaic with inscription.

from the Koran, the inscription in the Dome of the Rock declares that Jesus is the prophet, not the son of God, and that it is not for God to take a son.[80]

It may also be observed that the Christians who made the erasures in the floors of their churches were more concerned about removing personifications than they were about destroying animals. This selectivity corresponds more with Christian sensibilities than with Muslim attitudes, for the Muslims, in their places of worship, were careful to remove all the images of animals as well as humans. Their scrupulosity in this regard is well illustrated by the carvings in the Great Mosque of Kairouan, built in the ninth century, which contained carved capitals appropriated from earlier Byzantine buildings, most of which must have been churches.[81] Many of the reused Byzantine capitals were of the two-zone type, with projecting animal protomes at the corners (figure 1-20). The Muslims carefully converted the birds of the protomes into nonfigural volutes, but they allowed the vegetal elements of the capitals to remain. In some cases the wings of the birds were recut to resemble leaves.[82]

[80]O. Grabar, *The Shape of the Holy: Early Islamic Jerusalem*, Princeton, NJ, 1996, 56–66.

[81]K. A. C. Creswell, *Early Muslim Architecture*, vol. 2, Oxford, 1940, 220; N. Harrazi, *Chapiteaux de la grande Mosquée de Kairouan*, Tunis, 1982.

[82]Harrazi, *Chapiteaux de la grande Mosquée de Kairouan*, 150, no. 323.

FIGURE 1.20. Kairouan, Great Mosque, reused Byzantine capital. Bird converted into leaves and volutes.

The differing attitudes of the Christian iconoclasts toward nature person-ifications and animals may be seen in the mosaic that covers the floor of the Chapel of the Martyr Theodore adjoining the atrium of the Cathedral Church at Madaba, in Jordan (figure 1-21). According to an inscription, the chapel and its mosaic were completed in the year 562. Here the central rectangle contains a geometrical interlace creating circles, lozenges, and octagons that framed a variety of subjects, including birds, fishes, baskets of fruit, and farm workers; in the borders there were pastoral and hunting scenes. In a general sense these motifs represented terrestrial bounty. As at Tegea, personifications of the four rivers appeared at the corners of the rectangular composition; once again they were labeled Geon, Phison, Euphrates, and Tigris. Thus, the mosaic appears to have shown the inhabited earth, evoked here by its creatures and its fruits, and watered at its four corners by the rivers of paradise.

When the pavement of the Chapel of the Martyr Theodore suffered icono-clastic interventions in the course of the eighth century, the erasures were directed especially at the human figures in the central panel, in particular the personifications of the rivers of paradise. The iconoclasts allowed most of the

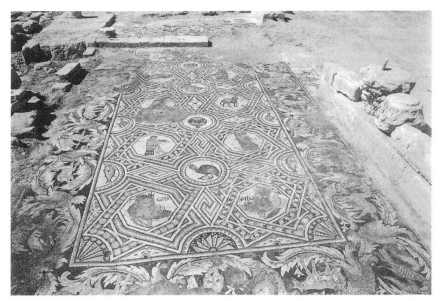

FIGURE 1.21. Madaba, Cathedral Church, Chapel of the Martyr Theodore, floor mosaic. Terrestrial motifs with erased personifications.

portrayals of animals to remain, and for the most part they also spared the images of hunters and pastoralists in the borders.[83]

Another, more remarkable case of such selectivity concerns the Chapel of the Theotokos in 'Ayn al-Kanishah. In this building there was a floor mosaic of the third quarter of the sixth century depicting two confronted lambs in the sanctuary and a vine scroll inhabited by birds and beasts in the nave. In the eighth century many of the animals were partly or wholly erased. After this event, the mosaic was restored. The restoration took the form of a panel with geometric patterns that replaced the two rows of the vine scroll adjacent to the entrance. In the center of this panel was a medallion set in a square. The medallion contained the dedicatory inscription, dating the restoration to the year 762, and naming the church as that of the Theotokos, the Mother of God. In the four corners of the square there were four small vases, each inscribed with one of the names of the four rivers of paradise. At the same time the inscription and the rivers were set, repairs were made to some of the damaged animals in the rest of the vine scroll. The legs of several of the birds were restored, including those of a phoenix in the central row of medallions. The lower part of a doe was also repaired.[84] Here, then, the restorers avoided representing the rivers of paradise as personifications, preferring to show them simply as vases. On the

[83]Piccirillo, *Madaba, le chiese e i mosaici*, 26–28; Piccirillo, *Mosaics of Jordan*, 117, figs. 110–115.
[84]Ognibene, "Iconophobic Dossier," 376–384.

other hand, they did not hesitate to restore the images of the animals in the rest of the mosaic. Again, the deliberate repair of the birds in this mosaic, even as the nature personifications were avoided, appears to correspond more to the Christian scale of values than to the attitudes of the Muslims, who prohibited all representations of animals in their places of worship.

The suppression of the imagery of the natural world in Palestinian floor mosaics foreshadowed the pavements that were laid in Byzantine churches after the crisis of iconoclasm, in the tenth and later centuries, which were usually predominantly made of slabs or strips of marble laid in the opus sectile technique rather than of tesserae.[85] These medieval opus sectile floors were either totally deprived of figural images or they incorporated a very much more limited repertoire than had appeared before the eighth century. Good examples can be seen in the monastery of Hosios Loukas in Greece (plate XIV).[86] The abstraction of the floors at Hosios Loukas contrasts with the wealth of portrait icons displayed in the mosaics of the walls and vaults above. In addition, after iconoclasm personifications of the months, the seasons, and the rivers of paradise no longer appeared in Byzantine churches. They were neither on the floors nor on the walls, although they were occasionally depicted in manuscripts, where their presence was more discreet.[87] It is true that the Sea continued to play a regular role as a personification in scenes of the Last Judgment. But here she was portrayed in a very negative context, being accompanied by carnivorous sea creatures disgorging the bodies of the unfortunates whom they had consumed.[88]

Once the supporters of the sacred portrait icons had cleansed their own places of worship of the tainted subjects, they could turn the tables and accuse the iconoclasts of what they themselves had been accused of by their opponents, namely, honoring the images of created beings. Thus, in the early

[85]On the medieval Byzantine opus sectile floors, see U. Peschlow, "Zum byzantinischen opus sectile-Boden," in R. Boehmer and H. Hauptmann, eds., *Beiträge zur Altertumskunde Kleinasiens. Festschrift für Kurt Bittel*, Mainz, 1983, 435–447; A. G. Guidobaldi, "L'opus sectile pavimentale in area bizantina," *Atti del I Colloquio dell' Associazione Italiana per lo Studio e la Conservazione del Mosaico*, Ravenna, 1993, 643–663. For Turkey, see Y. Demiriz, *Interlaced Byzantine Mosaic Pavements*, Istanbul, 2002.

[86]R. Schultz and S. Barnsley, *The Monastery of Saint Luke of Stiris in Phocis*, London, 1901, 33; Peschlow, "Zum byzantinischen opus sectile-Boden," 444, plate 93.2.

[87]On the depiction of the months in byzantine manuscripts, see A. P. Kazhdan, A.-M. Talbot, A. Cutler, T. E. Gregory and N. P. Ševčenko, eds., *The Oxford Dictionary of Byzantium*, Oxford, 1991, 1403. For a depiction of the fountain of paradise personified as a naked youth, see the miniatures in the two twelfth-century copies of the *Homilies of James of Kokkinobaphos*: A. Grabar, *Byzantine Painting*, Geneva, 1953, 180–181 (Bibliothèque Nationale, MS. Gr. 1208); I. Hutter and P. Canart, *Das Marienhomiliar des Mönchs Jakobos von Kokkinobaphos, Codex Vaticanus Graecus 1162*, Codices e vaticanis selecti LXXIX, Zurich, 1991, fol. 37v.

[88]See, for example, G. and M. Soteriou, *Eikones tes Mones Sina*, Athens, 1956, plate 151; I. Andreescu, "Torcello III: la chronologie relative des mosaïques pariétales," *Dumbarton Oaks Papers* 30 (1976), 247–341, fig. 10. In some later churches the sea was accompanied by a personification of the earth, as, for example, at Asinou on Cyprus; A. and J. A. Stylianou, *The Painted Churches of Cyprus, Treasures of Byzantine Art*, London, 1985, 136.

ninth century Stephen the Deacon, the author of *The Life of Saint Stephen the Younger*, accused the iconoclasts of preserving with honor the "pictures of trees or birds or senseless beasts" that were in the churches while at the same time destroying the "venerable images of Christ or the Mother of God or the saints."[89] Here Stephen the Deacon maintains that what the iconoclasts perpetrated was the opposite of what may have taken place at the Church of the Virgin in Madaba, where the images of Christ and his mother were honored whereas the nature-derived images were removed. In another well-known passage, Stephen the Deacon goes on to claim that the iconoclasts went beyond the mere preservation of mosaics of plants and animals to the creation of new ones. Describing the iconoclastic interventions in the Church of the Virgin at the Blachernai, Stephen states that the emperor Constantine V scraped all of the scenes of Christ's life from the walls, replacing them with mosaics of "trees and all kinds of birds and beasts, and certain swirls of ivy-leaves [enclosing] cranes, crows, and peacocks. . . . " Memorably, he describes the resulting church as a "store house of fruit and an aviary."[90] The original fifth-century wall mosaics of the basilica of the Acheiropoietos at Thessaloniki illustrate the type of early Byzantine decoration that the iconoclasts were accused of preserving, or recreating, at the expense of sacred portrait images (plate III).

Other Byzantine defenders of images repeated the charge made by the *Life of Stephen the Younger*, that the iconoclasts kept the old decorations of flora and fauna while destroying the portrait icons. We find this line of attack in the sometimes contradictory arguments of the early ninth-century patriarch Nikephoros. First the patriarch accused the iconoclasts of failing to make a distinction between idols drawn from nature and the true icons of Christ and the saints, writing, "[the iconoclasts] do not hesitate, when they compare the replica of Christ with those of the things that are in the sky, on the earth, and under the surface of the waters, to count [the image of Christ] among them, not making any distinction between the replica of the Master and Creator and those of his creatures and servants."[91] Then, in effect, Nikepohoros turns the argument around, accusing the iconoclasts of making a distinction between the icons of Christ and of his creatures, but in a manner that bordered upon idolatry. He claims that God prepared humanity for the incarnation and for the depiction of Christ in the form of an icon by first prohibiting idols in the shape of elements of creation, such as animals.[92] Therefore, for the orthodox, images of wild and domestic beasts, birds, and other living creatures that had been

[89]Auzépy, *La vie d'Étienne le Jeune*, 121, 215.

[90]Ibid., 127, 221-222; translation by Mango, *Art of the Byzantine Empire*, 152–153.

[91]*Antirrheticus III*, ed. Migne, Patrologia Graeca C, col. 448; translation in M.-J. Mondzain-Baudinet, *Nicéphore, Discours contre les iconoclastes*, Paris, 1989, 236.

[92]*Antirrheticus III*, ed. Migne, Patrologia Graeca C, cols. 448–449; Mondzain-Baudinet, *Nicéphore, Discours contre les iconoclastes*, 237–238.

depicted on textiles and elsewhere in churches were there solely for aesthetic reasons and not for veneration. But now the iconoclasts, he maintains, were prepared to accept images of beasts in their churches even while they rejoiced in destroying the icon of Christ: "But you [iconoclasts], when you worship in church, are not offended by the images of the ass, the dog, and the pig; yet you rejoice in the burning of the image of Christ in the sacred precinct itself."[93] Elsewhere, Nikephoros accuses the iconoclasts of distorting the position of Nilus of Sinai by claiming that the saint supported zoomorphic decoration in churches rather than the opposite.[94] Thus, the accusation of the iconoclasts that the worshippers of icons were venerating the creature rather than the Creator was effectively turned back on themselves.

Although the defenders of Christian portrait icons accused the iconoclasts not only of preserving the old pre-iconoclastic images of flora and fauna in their churches but also of depicting such subjects anew, it is hard today to determine how much these charges were true and how much they were polemical rhetoric.[95] It can be said, however, that the two church decorations of the iconoclastic period that with certainty have survived from within the bounds of the Byzantine empire—Hagia Eirene at Constantinople and Hagia Sophia at Thessaloniki—are extremely austere and do not lend much credence to the accusations against the iconoclasts. In both churches a simple cross against a gold ground filled the apse, while the organic motifs were restricted to leaves, framing the arch of the apse at Hagia Eirene (figure 1-22),[96] and set in six horizontal rows at the bottom of each side of the barrel vault over the sanctuary at Hagia Sophia.[97] In the latter church, single vine leaves alternate with small crosses within a grid of squares that resembles a trellis fence such as may be seen in front of a garden. In a painting from a fourth-century tomb discovered in Thessaloniki, for example, a similar trellis, with square openings, screens a garden containing a fountain flanked by two peacocks.[98] The composition at Hagia Sophia, however, depicts no birds or fountains but only the six regimented rows of crosses and leaves.

[93] *Antirrheticus III*; ed. Migne, *Parrologia Graeca* C, cols. 464–465. See, on this passage, A. Grabar, *L'iconoclasme Byzantin*, 2d ed., Paris, 1984, 197–199; S. Gero, *Byzantine Iconoclasm during the Reign of Constantine V*, Louvain, 1977, 116, note 17; Mondzain-Baudinet, *Nicéphore, Discours contre les iconoclastes*, 249–250, notes 121–122.

[94] Gero, *Byzantine Iconoclasm during the Reign of Constantine V*, 49, note 63. I am indebted to Jeffrey Featherstone for this reference.

[95] Concerning the problem of whether the decorations described by Stephen were indeed of the iconoclastic period, see Auzépy, *La vie d'Étienne le Jeune*, 222, note 206.

[96] W. S. George, *The Church of Saint Eirene at Constantinople*, Oxford, 1912, 47–56, plates 17, 18, 22; Brubaker and Haldon, *Byzantium in the Iconoclast Era*, 19–20, fig. 1.

[97] R. Cormack, "The Apse Mosaics of S Sophia at Thessaloniki," *Deltion tes Christianikes Archaiologikes Etaireias* 10 (1980–1981), 111–135, plate 19b; Brubaker and Haldon, *Byzantium in the Iconoclast Era*, 23–24, figs. 14–15.

[98] E. Marki, *E Nekropole tes Thessalonikes*, Athens, 2006, 159, fig. 101, plate 12.

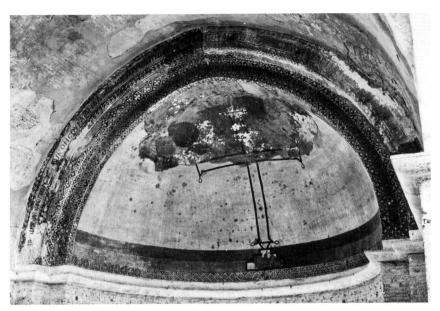

FIGURE 1.22. Istanbul, Hagia Eirene, iconoclastic mosaics in apse.

If these surviving fragments of iconoclastic church decoration are repre-
sentative, then it appears that the iconoclasts were as eager as their opponents
to avoid an excess of nature-derived subjects in their churches and the con-
comitant charge of idolatry. Certainly there is nothing in either Hagia Irene
or Hagia Sophia that corresponds to Stephen the Deacon's description of the
mosaics set by Constantine V in the Blachernai, neither birds nor beasts nor
vine scrolls enclosing cranes, crows, and peacocks. In rhetoric, both the defenders
and the opponents of portrait icons could be accused of worshipping creation
rather than the Creator. In practice, both parties were at pains to avoid depic-
tions that might confirm the truth of the charges against them.

2 }

Nature and Rhetoric

Byzantine Suspicion of Rhetoric

In Byzantine literature, nature and rhetoric were inextricably linked. This chapter will explore that connection, especially the moral ambivalence that both nature and rhetoric shared in Byzantine thought. In her Alexiad, the historian Anna Comnena gives a highly negative portrait of John Italos, the Italian-born teacher who for a relatively brief period toward the end of the eleventh century occupied the chair of philosophy at Constantinople. Anna Comnena acknowledges Italos's unrivaled knowledge of the ancient philosophers, especially Aristotle and Plato, and his mastery of dialectic, but she complains that, in her words:

> In other literary studies his competence was not so obvious: his knowledge of grammar, for example, was defective, and he had not "sipped the nectar" of rhetoric. For that reason his language was devoid of harmony and polish; his style was austere, completely unadorned. His writings wore a frown, and in general reeked of bitterness, full of dialectic aggression, and his tongue was loaded with arguments, even more when he spoke in debate than when he wrote.[1]

In her portrait of Italos, Anna Comnena appears to set up a clear distinction between the techniques of philosophy and rhetoric. In philosophy, Italos had no rivals, but he was utterly devoid of the charms and graces provided by rhetoric. For this reason the character of Italos remained boorish and barbaric, in spite of his erudition.

Although Anna Comnena seems to have viewed the techniques of rhetoric as a necessary component of civilized learning, other Byzantine writers treated rhetoric with more ambivalence. This ambivalence is strikingly evident in the *Chronographia* of Michael Psellos, who preceded Italos in the chair of

[1] *Alexiad*, 5.8.6; ed. B. Leib, vol. 2, Paris, 1943; translation by E. R. A. Sewter, *The Alexiad of Anna Comnena*, Harmondsworth, 1969, 176.

philosophy at Constantinople. On one hand, Psellos expresses admiration for those who were able to use rhetoric to bring elegance to their speech. For example, he praises the character and rhetorical skills of Constantine Lichudes with the following words:

> He [Lichudes] was a man of nobility, outstanding in eloquence, whose language was honed and ready for all the powers of speech, and who possessed a deep knowledge of public affairs. In effect, he combined [knowledge of] the laws of politics with the technique (the word used by Psellos is *techne*) of rhetoric, to which he had conferred greater distinction by making it [even] more persuasive. . . . When delivering a rhetorical speech, he cultivated a style both elegant and pure Attic. . . .[2]

On the other hand, just a few paragraphs earlier, Psellos gives a very different assessment of the techniques of rhetoric, viewing them in a much more negative light as agents of deceit and trickery. This evaluation comes in Psellos's portrayal of the character of Emperor Constantine IX Monomachos. After relating an anecdote revealing the generosity and magnanimity of the emperor's character, Psellos makes a distinction between rhetoric and history. He remarks, "Such are the stories that one could tell about this emperor, if one wished. But if one were to prefer also to compose a panegyric about the man, the most persuasive of the orators would incorporate into his fitting eulogy even the facts that a historical discourse would probably reject."[3] Psellos then proceeds, in a somewhat ironic tone, to describe the emperor's interest in landscape gardening, including his ability to transform, with the greatest speed, barren plains into groves full of warbling nightingales and trees full of chirping grasshoppers. Psellos goes on:

> When I make statements such as this, I am just touching on the technique of rhetoric and persuasion. If one wished to give one's speech the most complete exercise [of the art], one could manipulate every listener and every heart according to one's will. To me, however, such feats are not praiseworthy—I loath the verbal techniques (his word again is *technai*) that pervert the truth.[4]

Here, then, Psellos echoes the words of Socrates in Plato's Gorgias: "It seems, then, that rhetoric produces the kind of persuasion that creates belief, but does not teach about right and wrong."[5] For Psellos, rhetoric is at the same

[2]*Chronographia*, 6.178; ed. E. Renauld, vol. 2, Paris, 1928, 58–59; translation modified after E. R. A. Sewter, *Fourteen Byzantine Rulers: The Chronographia of Michael Psellos*, Harmondsworth, 1966, 248.

[3]*Chronographia*, 6.173; ed. Renauld, 56.

[4]*Chronographia*, 6.176; ed. Renauld, 58.

[5]*Gorgias*, 454e-455a; ed. E. R. Dodds, Oxford, 1959, 81.

time a praiseworthy technique for enhancing the style of one's speech, and even one's character, and a despicable means of deceit.

The same ambivalence concerning rhetoric was expressed by other Byzantine writers. We can take, for example, the description of the Church of the Holy Apostles at Constantinople composed by Nicholas Mesarites at the turn of the twelfth and thirteenth centuries. This ekphraseis, itself a work of rhetoric, concludes with an encomium of the current patriarch, John X Kamateros, as a Christian orator. Mesarites says that the patriarch:

> is not only wise in divine matters ... but is most knowledgeable and exalted in all the wisdom concerning worldly matters, through which his speech is greatly enriched in a most refined and excellent fashion. . . . As a grammarian he is above Histiaios and Theodosios, as a rhetorician he is above Demosthenes and Hermogenes.[6]

The ekphraseis ends with a remarkable play on the word *logos*, which acquires a double meaning of the patriarch's eloquence and of the word of God himself. Speaking of John Kamateros, Mesarites declares:

> He unfolds his tongue like an unfailing spring, a source of satiation for all folk who thirst after upright belief. O streams of *logos*, not like the Nile enriching Egypt with seven mouths, but with one mouth alone besprinkling the whole inhabited earth and enriching it with inexhaustible riches, may we ourselves take our fill of it for the whole span of our lives, so that we may be enriched in our souls as well as in our bodies, and may find eternal blessings as well as those of the present life, in Christ Jesus our Lord, to whom be glory for ever. Amen.[7]

This passage at the close of Mesarites's ekphraseis can be contrasted with another passage toward the beginning of his work, devoted to the school at the Church of the Holy Apostles, which covered both the elementary curriculum and more advanced subjects such as rhetoric.[8] Speaking of the pupils, he describes "those who have attained the higher and more accomplished stages" of their education and who "string together words into webs of thoughts and transform the written sense into a riddle, saying one thing with their tongues, but hiding something else with their minds."[9] Thus, we find in one and the same rhetorical work both a suspicion of rhetoric as a

[6]*Description of the Church of the Holy Apostles at Constantinople*, 43.5; ed. G. Downey, in *Transactions of the American Philosophical Society*, n.s. 47:6 (1957), 918, with translation (modified here) on 896.

[7]*Description of the Church of the Holy Apostles at Constantinople*, 43.9–10; ed. Downey, 897, 918.

[8]*Description of the Church of the Holy Apostles at Constantinople*, 8.3, 42.1; ed. Downey, 866, 894, 899, 916.

[9]*Description of the Church of the Holy Apostles at Constantinople*, 8.3; ed. Downey, 866, 899; Cf. *Iliad*, 9, 313.

means of concealing the truth and a virtual equation of rhetoric with divine wisdom itself.

Nature and Rhetoric in Early Byzantium

The Byzantines drew a connection between the wealth of rhetoric and the wealth of nature. Mesarites, in describing the inexhaustible riches of speech, compared them to the River Nile. Moreover, as with rhetoric, the Byzantines could look upon nature with suspicion; its abundance was seen as fleeting and illusory compared with the truths that were eternal. We shall see that this Byzantine ambivalence toward the interplay of rhetoric and nature was expressed in both written media and in the visual arts.

We begin with rhetoric, nature, and art in the early Byzantine period, before the iconoclastic crisis of the eighth century. Before iconoclasm, the description and depiction of nature played an important role in conveying religious truth. In particular, the natural world was celebrated in the many sermons and commentaries devoted to the *Hexaemeron*, the first six days of the creation. In these works, terrestrial creation was inscribed under the power of Christ. In the *Hexaemeron* sermons, and in the works that they inspired, the marvels of the created world conveyed, by analogy, the greatness of the Creator.[10] Frequently, the authors incorporated into their compositions self-contained ekphraseis, or rhetorical descriptions, of particularly noteworthy elements of creation. Thus, we find, in a poem on Genesis composed in the early sixth century by Avitus, an extended account of the rivers of paradise, including the Nile. Avitus characterizes the river as follows:

> The gentle flow [of the Nile] glides through Egypt, to enrich its territory for an appointed time. For, as many times as the river breaks its banks with its swollen stream and inundates the fields with black silt, the fruitfulness [of the fields] is irrigated by water, and, in the absence of moisture from the sky, the spreading of the river provides a terrestrial rain. Then Memphis lies submerged under a broad flood, and above the landowner sails over his absent fields. The river has no boundary. . . . The happy shepherd sees the familiar grass sink [under the water] and fish swimming in an alien sea take the place of the green field of the flocks. But after the water has wed the womb of the thirsty earth, fertilizing the young shoots with its bountiful potion, the Nile retreats, and gathers in its far scattered waves. The lake subsides, and becomes a river. Then the former shore-line

[10]H. Maguire, *Earth and Ocean: the Terrestrial World in Early Byzantine Art*, Monographs on the Fine Arts Sponsored by the College Art Association of America XLIII, University Park, 1987, 17–20, 31–33, 41–44.

is restored to the river's bed, the billows having been confined within its banks.[11]

As shall be seen, this description was a set piece, which was to be repeated and critiqued by later writers.

In the *Hexaemeron* literature we often encounter descriptions of individual animals, especially spectacular ones such as the peacock. A typical ekphraseis of the peacock is contained in the Second Theological Oration of Gregory of Nazianzus. This sermon, which Gregory delivered in Constantinople in the year 380, incorporates a celebration of the created world that resembles the commentaries on the *Hexaemeron*. As in other texts, the splendors of the peacock reflect the glory of the Creator:

> Whence comes the love of beauty and the love of esteem displayed by the peacock, this swaggering bird of Median origin? To the extent that when he sees someone approaching him (for he is aware of his own beauty), or when he beautifies himself in front of his females, so they say, he stretches up his neck, and makes a circle with his gold-gleaming and star-studded plumage. And with his pompous gait he makes a theatrical spectacle of his beauty to his admirers.[12]

A later writer, George of Pisidia, included in his seventh-century poem on the *Hexaemeron* a similar ekphraseis of the splendors of the peacock:

> How could anyone who sees the peacock not be amazed at the gold interwoven with sapphire, at the purple and emerald green feathers, at the composition of the colors in many patterns, all mingled together but not confused with one another?

But it was not only splendid creatures such as the peacock that the authors of the *hexaemera* admired. Immediately after his ekphraseis of the peacock, George of Pisidia describes the locust and its destructive swarms. Then he exclaims:

> And let not some braggart accuse us of moving the course of our speech with random trivialities concerning what is small and piecemeal. For if someone sees a beautifully adorned house gleaming with gilded forms, but constructed with iron and wood and with the interlocking of humble tiles, he will admire the plain with the magnificent.

So it is, explains George of Pisidia, with God's universe:

[11] *Poematum de Mosaicae historiae gestis*, 1; ed. J.-P. Migne, Patrologiae cursus completus, Series Latina LIX, col. 329.

[12] *Homilia XXVIII*, 24; ed. P. Gallay and M. Jourjon, *Grégoire de Nazianze, Discours 27–31 (Discours Théologiques)*, Paris, 1978, 152.

How should we not fearfully admire all the work of the all accomplishing logos, [including] the ant, the mosquito, and the locust.

Having given insects their due, the poet launches into a second encomium of the peacock:

> Once again, whence comes the beautiful peacock. This bird is refulgent and star-studded in aspect, clad in purple plumage, because of which, swaggering and puffed up in its appearance, it streams alone through all of the other birds. This purple has twined patterns on the bird without its toil, and has mixed a plentiful stream of many colors.[13]

While early Byzantine writers were willing to deploy the techniques of rhetoric, especially ekphraseis, to extol the bounty of terrestrial features such as the River Nile or to praise the beauty of creatures such as the peacock or to marvel at small animals such as insects, they could also criticize the world of nature as fleeting and evanescent. A juxtaposition of two descriptions of landed estates with extensive views illustrates this kind of ambivalence. The first ekphraseis is contained in a letter written in the fourth century by St. Basil, who describes to a friend the pleasures provided by his estate in the Pontus. According to Basil, his property was on a high mountain, covered with a thick forest, and watered by streams. At the base of the mountain was a plain, also well irrigated. The retreat was surrounded by groves of multifarious trees, which formed a hedge around it. Basil emphasized the fine view of the plain below and its swift-flowing river that could be obtained from an outlook near the house, a prospect that, in his words, was "furnishing me and every spectator with a most pleasant sight." He also described the excellent hunting that the estate afforded to his guests: "for besides its other excellences it abounds in game . . . it feeds herds of deer and wild goats, hares, and animals like these."[14]

We can find a repudiation of the topoi incorporated into this rhetorical description in another text, the fifth-century *Life of St. Melania the Younger*. This aristocratic lady sold her estates early in the same century so that she could devote herself to Christ. The *Life* records how the devil tried to divert Melania from her decision by reminding her of her most desirable landed property. In presenting this property, the text deploys the topoi appropriate to the ekphraseis of an estate provided with fine views, like the one praised by St. Basil. It is as if the Devil himself is using the techniques of rhetoric to persuade Melania to abandon her saintly purpose. To quote from the text:

> Again this most blessed one suffered these interventions of the Devil, because he planted in her a doubt. For she had a most excellent property,

[13] J.-P. Migne, ed., Patrologiae cursus completus, Series Graeca XCII, cols. 1529–1532.

[14] *Epistula XIV;* translation by R. J. Deferrari, *St Basil, The Letters*, vol. 1, London, 1926, 106–111.

with a bath below it and a swimming pool in it, so that on one side [views] could be obtained of the sea, and on the other of groves of trees, in which there were various animals and hunts. When, therefore, she bathed in the swimming pool, she saw both the passage of ships and hunting in the woods. But the devil insinuated into her [mind] various thoughts, describing to her the precious marbles and the various adornments [of her house], or her large income and all her wealth. . . . But the saint repulsed these [temptations], piously countering that all these things were as nothing in contrast to what was promised to the servants of God. For these trees can rot, or be consumed by fire, or be dissipated over time.[15]

So here the landscape and its pleasures are shown to be evanescent, while the rhetorical techniques of ekphraseis that the Devil had employed to praise them are exposed as trickery.

An encomium of St. Barbara by the eighth-century author John of Damascus expresses a similar attitude toward the role of rhetoric in glorifying the false allure of physical riches and beauty. This passage entirely rejects the traditional procedures of panegyric, saying that both they and their subjects were fleeting and transient. In a convoluted passage that is itself highly rhetorical, John refers to the construction of an encomium according to the divisions prescribed by rhetorical handbooks such as the third- or early fourth-century treatise of Menander, with its separate praises of the subject's fatherland, of the glory of his family, and of his physical characteristics:[16]

The rhetorical technique of eloquence is apt to praise bodily and fleshly beauty, which is composed of the symmetry and good color of the limbs, through the well-turned composition of words and through refined and fast-talking persuasiveness; and also often to praise bodily strength and luxury, as well as the dignity of being well born and conspicuousness of rank, if there be any, and the notable qualities of the fatherland, and the flowing abundance of wealth. . . . Except that everything that speech has defined and recounted concerning bodily form, being destroyed swiftly and abruptly and altered by time, conspires to undo one after another and in order the painstaking harmony and complexity of the encomium, like the withering and decaying flower of the field and like the deceitful and phantom-like appearance of auspicious dreams.[17]

[15]*Vita Sanctae Melaniae Junioris*, 18; *Analecta Bollandiana* 8 (1889), 33.
[16]Menander's instructions are contained in his *Peri epideiktikon*, 1–2, ed. D. A. Russell and N. G. Wilson, *Menander Rhetor*, Oxford, 1981, 76–94.
[17]*Laudatio S. Barbarae*, 21; ed. P. B. Kotter, *Die Schriften des Johannes von Damaskos*, vol. V, Berlin, 1988, 274–275. The passage is discussed in A. Kazhdan, *A History of Byzantine Literature (650–850)*, Athens, 1999, 85.

Here, then, the Christian author says that an eloquent eulogy, even if it is carefully arranged according to the divisions set out in the manuals, is, like the beauties of nature, fated to be deconstructed by decay.

We have already seen that in church art during the early Byzantine period, as in the literature, there are frequent displays of the elements of creation, such as its rivers and its creatures (plates III–IV; figures Intro-1, Intro-2, 1-1 to 1-7, 1-9, 1-10, 1-12, 1-21). At the same time, we encounter occasional repudiations of such artistic celebrations of the transitory world of nature. Sometimes an orator described a painting or a mosaic portraying features of the terrestrial world, so that his ekphraseis of the work of art was layered over his ekphraseis of nature, as in the case of Choricius of Gaza describing the depictions of the plant and animal life of the Nile in the aisles of the basilica of St. Stephen at Gaza.[18] As we have seen in chapter 1, such riverine motifs from the Nile can still be admired in the floor mosaic of the Church of St. John the Baptist at Gerasa (figure 1-12).[19]

For visual equivalents of the ekphraseis of the peacock as a conspicuous adornment of creation, we can look to the mosaics of San Vitale. Here we find no less that eight portrayals of this bird, four with their long tails furled, flanking the paradisal scene in the vault of the apse and standing beside the base of the great acanthus plant on the west side of the vault over the sanctuary, and four more with their tails spread out in a circle, occupying the corners of the sanctuary vault (figure Intro-2).[20] In these set pieces of display, the mosaicists set out to rival both created nature and the orators who had celebrated it. Each of the peacocks in the four corners of the vault is different. The most impressive one is in the northeast corner. In the tail of this bird, the semicircular lines of gold that surround the eyes are broken by red or green tesserae, so that a motile, coruscating effect is produced, as if the bird were shaking its feathers.

Nor did artists neglect insects, which also were carefully described in the *hexaemera*. A well-known ivory diptych in Florence, which dates to the late fourth or early fifth century, depicts a locust among the animals named by Adam in paradise; it is portrayed just above the source of the four rivers at the bottom of the panel (figure 2-1).[21] A fifth- or sixth-century marble architectural

[18]*Laudatio Marciani II*, 50–51; ed. R. Foerster and E. Richsteig, *Choricii Gazaei opera*, Leipzig, 1929; translation by C. Mango, *The Art of the Byzantine Empire 312–1453*, Englewood Cliffs, NJ, 1972, 72.

[19]C. H. Kraeling, *Gerasa, City of the Decapolis*, New Haven, CT, 1938, 324–329, 480, plates 66–70; M. Piccirillo, *The Mosaics of Jordan*, Amman, 1993, 286–289, figs. 535–545.

[20]F. W. Deichmann, *Frühchristliche Bauten und Mosaiken von Ravenna*, Baden-Baden, 1958, plates 311–313, 342–345.

[21]K. Weitzmann, ed., *The Age of Spirituality: Late Antique and Early Christian Art, Third to Seventh Century* (exhibition catalogue, Metropolitan Museum of Art), New York, 1979, 505–507.

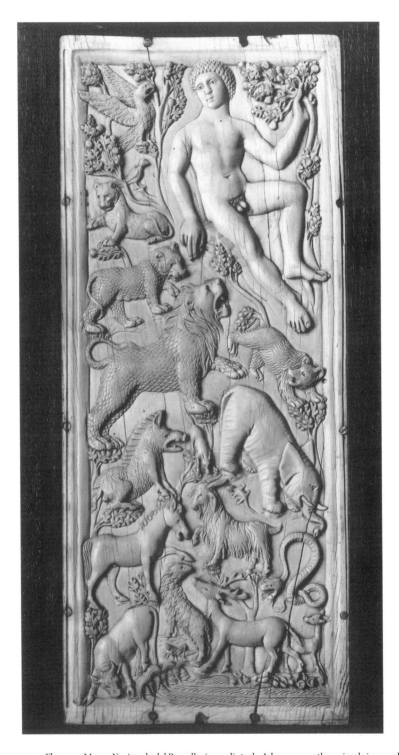

FIGURE 2.1. Florence, Museo Nazionale del Bargello, ivory diptych. Adam names the animals in paradise.

FIGURE 2.2. Thessaloniki, Museum of Byzantine Culture, marble relief from the Church of the Acheiropoietos. Birds, snail, and bees.

relief from the church of the Acheiropoietos in Thessaloniki portrays a vine scroll that harbors several bees, together with birds and a snail (figure 2-2).[22]

Scenes of the hunt similar to those admired by St. Basil can be seen in many early Byzantine churches, including the Chapel of the Martyr Theodore at Madaba (figure 1-21) and the basilica of Dumetios in Nikopolis, which dates to the second quarter of the sixth century. In the latter church, in the borders of the floor mosaic of the south transept naked men spear a variety of animals, including lions, boar, bears, and stags.[23]

Although such celebrations of nature were common on the floors, walls, and ceilings of early Byzantine churches, particularly after the middle of the fifth century, we have found that these motifs also had their critics. The letter of Saint Nilus of Sinai to the Prefect Olympiodorus, discussed in the previous chapter, condemned depictions of plants, animals, and hunts, proposing that they be replaced by simple crosses.[24]

[22]*Thessalonike, Istoria kai Techne* (exhibition catalogue, White Tower, Thessaloniki), Athens, 1986, 41–42, no. II 28a–b.

[23]E. Kitzinger, "Studies on Late Antique and Early Byzantine Floor Mosaics, I: Mosaics at Nikopolis," *Dumbarton Oaks Papers* 6 (1951), 83–122, figs. 20–22.

[24]*Epistula IV*, 61; ed., Migne, Patrologia Graeca LXXIX, cols. 577–580.

Nature and Rhetoric in the Byzantine Middle Ages

In the medieval period of Byzantium, as in the early period, the view of nature continued to be ambivalent, except that now the denigration of nature carried more weight than it had before. After the iconoclastic crisis of the eighth and ninth centuries, the great series of commentaries on the *Hexaemeron* dwindled, although the creation continued to be described in the World Chronicles, most notably in the twelfth-century *Biblos chronike* of Michael Glykas, where the first six days of creation receive an extended commentary.[25] Rhetorically, the most notable medieval treatment of the first six days of creation is the ekphraseis of creation, which opens the verse chronicle written by Constantine Manasses in the mid-twelfth century for his patroness, the Sebastokratorissa Eirene.[26] This ekphraseis contains a description of the four rivers of paradise, including the Nile, to which the author devotes three lines that reference familiar themes:

> . . . the Nile with her white flow Aethiopian land surrounds
> and waters the Egyptian's grounds, their fields of rich black soil,
> [and] with fertile floods entices them to yield a harvest full.[27]

Constantine Manasses also describes the animals created by God, including, of course, the pompous peacock:

> The golden peacock swaggered about, boasting of his feathers:
> shining with a thousand tints, his wings were like pure gold,
> but in his feathers glimmered also deepest purple red;
> each feather held a shining bloom, a golden glittering eye,
> thus in his own plumage the creature planted a garden.[28]

However, the ekphraseis of creation by Constantine Manasses, with its strongly poetic evocation of nature echoing the early *Hexaemeron* commentaries, was an exception in medieval Byzantine literature. In other post-iconoclastic texts, we find two conflicting views of nature. On one hand, nature was seen as corruptible, fleeting, transient, and false. But there was

[25] I. Bekker, ed., *Michaelis Glycae annales*, Corpus scriptorum historiae byzantinae, Bonn, 1836, 3–160.

[26] *Synopsis Chronike*, lines 27–285; ed. O. Lampsidis, *Constantini Manassis Breviarium chronicum*, Athens, 1996, 6–19. For a discussion of this ekphraseis, see I. Nilsson, "Narrating Images in Byzantine Literature: The Ekphraseis of Konstantinos Manasses," *Jahrbuch der Österreichischen Byzantinistik* 55 (2005), 121–146, esp. 129–136, 140–146. Michael Psellos devoted about 60 lines to the *Hexaemeron* at the beginning of a poem on the creation and fall of Adam; ed. E. Kurtz, *Michaelis Pselli Scripta minora*, vol. 1, Milan, 1936, 402–404.

[27] *Synopsis Chronike*, lines 225–227, translation by Nilsson, "Narrating Images in Byzantine Literature," 145.

[28] *Synopsis Chronike*, lines 260–264, translation modified after Nilsson, "Narrating Images in Byzantine Literature," 146.

a competing idea, which held that nature had been redeemed and sancti-
fied through the incarnation of Christ. We find the negative view already
expressed in the encomium of St. Patapios, a work attributed to Andrew of
Crete, whose career, which began in Palestine, was contemporary with the
beginnings of iconoclasm in the eighth century.[29] This text is worth exam-
ining in some detail, since it explicitly combines the denigration of nature
with the denigration of the rhetoric that celebrated it. The speech sets up
an antithesis of the two fatherlands of the saint. The first birthplace is rep-
resented by Egypt, where St. Patapios was brought into the world. This is
the material, earthbound territory of the Nile, with its corruptible riches of
the flesh. The saint's second birthplace is represented by baptism, through
which he was born into the eternal riches of heaven. As we found in chapter
1, Andrew of Crete was not the first author to make this contrast between
the water of the Nile and the water of baptism,[30] but he elaborated the
distinction between the saint's two birthplaces with a series of rhetorical
antitheses:

> Egypt is the generator of darkness and gloom, while the font is the
> mother of immaterial light. One [Egypt] is the nurse of misfortunes, while
> the other [the font] is the orchestrator of righteous acts. One is the guide
> to death, the other the leader to eternal life; one is the manufacturer of
> the earthly passions, the other the teacher of the passionless way of life.
> This one is the place of grief, that one the treasury of joy, this the shady
> abode of evil, that the brilliant abode of virtue.

At this point, the author of the encomium plays the part of a Late Antique
orator of the second sophistic, schooled in the handbook of the rhetorician
Menander. He observes that there are in his audience:

> Certain persons who are not listening to what I am saying with much care,
> because I have said nothing elegant or clever about the saint's fatherland.
> For those who are fond of life, are fond of cloaking their hearing with
> sophistic croaks; I mean those by whom the musical plays performed at
> the evening revels of Bacchus, or the swaggering fables of theatrical per-
> formances, are perceived as something very great and useful. For this rea-
> son, being at that part of the speech, I thought that now I should give a
> little learned discourse about the land of Egypt.

Accordingly, Andrew pretends to comply with the expectation of an en-
comium of the saint's birthplace, as if he were following the instructions of

[29]Migne, ed., Patrologia Graeca, XCVII, cols. 1205–1254. On this text, see Kazhdan, *History of
Byzantine Literature*, 52–54.
[30]See Firmicus Maternus, *De errore profanarum religionum*, 2.1–5; ed. R. Turcan, Paris, 1982, 77–79.

Menander. He parades all of the usual topoi of Nilotic prosperity, only, how-
ever, to undercut them at the end:

> There the earth is rich, the fields fat and fruitful, the cities thickly set and
> the countryside green. In that place there are herds of horses, pastures
> full of flocks, and herds of goats, cattle, and swine, and whatever per-
> tains to food and delight and to [sustaining] this insupportable life. The
> river's waters, like a sea, are encircling the land, and irrigate the whole
> country. . . . For this river, rising regularly in its annual floods, expands
> like an ocean, and makes the land watery and causes the earth, which a
> little while before was green with an abundance of produce, to be given
> over now to heavily laden ships of burden. It permits the ploughs to work
> between the sails [of the boats], and ordains that the aquatic and the
> terrestrial creatures should herd together, whether herbivorous or car-
> nivorous. O the wonder of it! Yesterday a productive field, today a deep
> sea; yesterday a dwelling place of herds of beasts and beasts of burden,
> today the lurking place of fish and swimming creatures. Egypt, plain to
> say, brought forth as its offspring this youth for us [that is, St. Patapios].
> Egypt, the ungrudging supplier of earthly delights, the manufacturer
> of bright garments, the artificer of the passions, the handmaiden of the
> pleasures, the patron of mud and clay, the provider of meats and basins,
> she it is who is called darkness in the scriptures, but shone out with the
> pursuer of darkness.

Having thus effectively undermined his encomium of the saint's terrestrial
birthplace, Andrew concludes by saying that Egypt was sanctified and cleansed
of its accursed idols and the foul rites of its demons only through the arrival
of the light of Christ.[31] Thus, in a sense, the author of the encomium of St.
Patapios corrects the old tradition of the ekphraseis of the Nile and chastises it.

Later medieval Byzantine authors also corrected other types of ekphraseis,
such as the traditional description of a country estate. An example can be found
in the biography of Theodore of Stoudios attributed to the tenth-century offi-
cial Theodore Daphnopates, which makes use of St. Basil's description of his
retreat in the Pontus. Daphnopates borrowed Basil's ekphraseis to describe the
estate at Boskytion, to which Theodore had withdrawn to practice an ascetic
life. The author introduces the ekphraseis of Boskytion with an apologetic dis-
claimer: "Nothing could replace a brief account of the place, nor is the descrip-
tion [of it] disagreeable or superfluous." Daphnopates gives to Boskytion the
same landscape features that Basil had attributed to his estate in the Pontus;
the tenth-century author even uses much of the same vocabulary as had been

[31] *In S. Patapium*, ed. Migne, Patrologia Graeca XCVII, cols. 1217–1222.

employed by the church father. He says that Boskytion, like Basil's estate, featured a mountain peak covered with variegated trees, which surrounded the property. As in Basil's ekphraseis, a well-watered plain was to be found at its base. However, Daphnopates censors some elements of the fourth-century description. He does not mention the sensory pleasures provided by the views of the surrounding terrain, nor does he praise the opportunities for hunting. We are told only that the place "provides tranquility to those living there, who hold converse alone with God, and who maintain a rest from the senses."[32]

The foundation document, or *typikon*, of the Kosmosoteira monastery at Pherrai in Thrace, drawn up by Isaac Comnenus in 1152, contains a similar kind of correction of the ekphraseis of an estate, again from a monastic context. Here one topos is used to undercut another. At the beginning of his *typikon*, Isaac, following a convention of such documents, says that he founded the monastery "in a deserted area, formerly nothing but thickets."[33] At a later point in the document, after his instructions for the maintenance of the cistern and the aqueduct, Isaac inserts an eloquent description of the monastery's site, but he is careful to preface the rhetoric of this ekphraseis by observing that the place had formerly been desolate and thus suitable for habitation by ascetics:

> I think that the charms of the monastery and the site will draw many people to them. There is the spot itself—even if previously it was the dwelling of snakes and scorpions—the river Ainos, the sea with its surf and its calms, the pasturage and grazing land of evergreen meadows to nourish horses and cattle. There is the site on the crest of the hill. . . . There is the fine temperance of the currents of air and the power of strong breezes, with the everlasting reeds rustling in tune with them about the mouth of the river. There is the immense plain, and the panoramic view, especially in summertime, of corn in flower and in ear, which impresses great gladness on those who direct their gaze there. There is the grove of lovely saplings growing so near the monastery, and bunches of grapes are entwined among them. As a joy to the throats of the thirsty, water gushes forth wonderfully beautiful and cold.[34]

Conventional though it is, this description is strongly evocative of the site, as anyone who has visited Pherrai can testify.

[32]*Vita Theodori Studitae*, 6; ed. Migne, Patrologia Graeca XCIX, col. 121.
[33]L. Petit, ed., "Typikon du monastère de la Kosmosotira près d'Aenos (1152)," *Izvestiia Russkago Archeologicheskago Instituta v Konstantinople* 13 (1908), 20; translation by N. Ševčenko in J. Thomas and A. C. Hero, *Byzantine Monastic Foundation Documents*, vol. 2, Washington, DC, 2000, 799; compare the typika of Rila and Mount Menoikeion near Serres in Thomas and Hero, *Byzantine Monastic Foundation Documents*, vol. 1, 129–130, and vol. 4, 1592.
[34]Petit, ed., "Typikon du monastère," 57; translation by Ševčenko in Thomas and Hero, *Byzantine Monastic Foundation Documents*, vol. 2, 833.

In some medieval Byzantine writings, therefore, we have the impression that their authors felt that their rhetorical descriptions of nature needed to be censored, corrected, or at least excused. Another view that we encounter in the medieval texts is more positive; it is the concept of the sanctification of nature through the incarnation. Andrew of Crete himself expressed this idea in his first sermon on the Nativity: "Today the nature that was formerly turned to earth takes on the beginning of deification, and the dust that has been exalted is urged to return to the glory that is on high."[35] A more prolix passage on the same theme can be found in the twelfth-century homilies by the monk James of Kokkinobaphos. This work was probably composed for a female patron, perhaps the same Sebastokratorissa Eirene who commissioned the verse chronicle of Constantine Manasses.[36] In the sermon on the Visitation, James of Kokkinobaphos describes how creation venerated the Virgin as she rested on her way to visit her cousin Elizabeth. He wrote, in his usual overwrought prose:

> For behold, all Creation advances to meet [the Virgin] when she is half way through her journey, and greets her with words of thanksgiving. Earth, as if taking pride in her own offspring, all but cries out as follows: "Behold my most blooming root, behold the fruit of my abundance . . . the fruition of my bounty and of the blessing by which I will be released from my sentence of thorns. . . . The rod that gives birth to the flower of incorruption. . . . Oh sweetest smelling lily of my fields . . . you are the pure stream from which, like drops of rain, the raindrops of the graces are sprinkling."[37]

The manuscript of the homilies in the Vatican, which is probably close in date to their composition, contains an illustration of this passage, in which we see the Virgin resting in a glade of plants and trees, with a steam of water flowing at her feet (figure 2-3).[38] In the lower left corner of the miniature, Earth, depicted in the antique manner as a naked woman, raises her hands in adoration towards the Virgin. In this painting Earth appears almost as a penitent; it is the most direct illustration of the sanctification of nature in Byzantine art.

[35]Migne, ed., Patrologia Graeca XCVII, cols. 809–812; translation by M. Cunningham, *"Wider than Heaven": Eighth-Century Homilies on the Mother of God*, Crestwood, NY, 2008, 75–76. On the concept of the sanctification of the created world through the incarnation, see Cunningham, "The Meeting of the Old and the New: the Typology of Mary the Theotokos in Byzantine Homilies and Hymns," in R. N. Swanson, ed., *The Church and Mary*, Woodbridge, 2004, 52–62.

[36]E. Jeffreys, "Mimesis in an Ecclesiastical Context: The Case of Iakovos Monachos," in A. Rhoby and E. Schiffer, eds., *Imitatio—Aemulatio—Variatio*, Vienna, 2010, 153–164, esp.153–154.

[37]*Oratio in SS. Deiparae Visitationem*, 16; ed. Migne, Patrologia Graeca CXXVII, cols. 676–677.

[38]Vatican Library, MS. Gr. 1162, fol. 147; I. Hutter and P. Canart, *Das Marienhomiliar des Mönchs Jakobos von Kokkinobaphos, Codex Vaticanus Graecus 1162*, Codices e vaticanis selecti LXXIX, Zurich, 1991.

ἀνάστασις τῆς θεοτόκον ἐκ τῆ ᾶ δαι:—

ἡκτίσις αὖοι προσκαρτόσαι, τοῖς χρ
εἰ ψηρίοις προσετωιδ ὀξιοῦται λόγοις

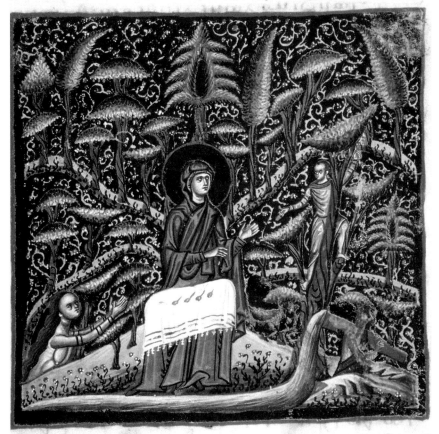

ἡμέρ, ὡς ὁ λειτω προστος σεμειωσε ἐρμ
υ λαφικαστ, τοιαῦτα ϙοδόρ ὄτι υρᾶται
ι Δου τὸ ἀμθηερ τατόμενουτέλεχ· ἰδὸι

FIGURE 2.3. Vatican Library, MS. Gr. 1162 (*Homilies of James of Kokkinobaphos*), folio 147. Earth adores the Virgin.

The concept of the sanctification of nature through the incarnation gave an avenue for descriptions and depictions of nature to continue to flourish in art and literature of the Byzantine church, in spite of doubts concerning the status of both rhetoric and nature within the Christian worldview. The best-known example of such license is the ekphraseis of springtime, with its stereotyped praises of the creatures and plants appropriate to that season. The model was the New Sunday Sermon, composed by Gregory of Nazianzus for delivery on the first Sunday after Easter. In this homily, the rebirth of man through Christ gave Gregory of Nazianzus an excuse for describing the rebirth of nature. The New Sunday Sermon, however, exhibits all of the contradictions that came to characterize the Byzantine reception of both nature and rhetoric. There is a long passage that condemns physical delights received through the senses, starting with Eve seeing and tasting the fruit and concluding with the aural artifices of rhetoric:

> That fruit that brought me death was "lovely to look at and good to eat"; let us flee from beautiful colors, and look only to ourselves! Do not allow lust for beauty to overcome you. Do not become a captive of your eyes— not even, if possible, of a fleeting glance; think of Eve, of the lure of that delicious fruit, of the costly remedy. . . . Let not your throat become your garden of delights, where everything offered to you is simply swallowed up. . . . Does your sense of smell make you soft? Flee from fragrant things! Are you weakened by your sense of touch? Put away things that are smooth and soft. Has your hearing led you astray? Close the door on deceptive and elaborate words.[39]

But then, a few paragraphs later, Gregory begins his own rhetorical description of the burgeoning of nature in the spring, in which he evokes the sensory pleasures of the season in all of their variety:

> Look at all that meets your eyes! The queen of seasons leads the way in the procession for the queen of days, showering from her own treasure every exquisite and delightful gift. Now . . . the sun stands higher and glows more golden; now the moon's orb is more radiant. . . . Now the sea's waves make peace with the shores. . . . Now the springs gush forth with a new sparkle. . . . Now the meadow is fragrant, the shoots burst forth, the grass is ready for mowing, and the lambs skip through the rich green fields. . . . Now the industrious bee lifts up its wing and leaves the hive; revealing her own wisdom, she flies to the meadows and takes her spoil from the flowers. . . . Now too the bird builds up her nest . . . and they fill the grove with song, charming the human hearer with their

[39]*Oratio XLIV, In novam Dominicam*, 6; ed. Migne, Patrologia Graeca XXXVI, col. 614; translation by B. E. Daley, *Gregory of Nazianzus*, Abingdon, 2006, 158.

chattering. . . . Now every race of living thing is laughing, and we all make festival with our senses.[40]

Later Byzantine authors, such as John Geometres in the tenth century and Isidore of Thessalonica in the fourteenth, took their license from the revered church father and incorporated similar descriptions of the springtime into their own sermons composed for the Feast of the Annunciation to the Virgin, which took place on March 25. According to John Geometres, spring was the time when the birds, fishes, and animals bring forth their young, at different times and in different places but all seeming to celebrate the renewal of our nature. In these ekphraseis of the spring we can find a rich display of images from terrestrial creation: the sun in a golden sky, the gentle streams, the leafing trees, the earth producing grass and flowers, the flocks skipping and leaping in the fields, and the nestlings spreading their wings and preparing themselves for variegated song.[41]

The Garden of St. Anne, in which the Annunciation of the conception of the Virgin took place, provided another context for incorporating descriptions of animals and plants into the celebration of the incarnation. In the early fourteenth century, Theodore Hyrtakenos wrote a long description of St. Anne's precinct.[42] Drawing on a variety of sources, including the Byzantine secular romances of the twelfth century, his text elaborates the brief account of the garden that had been given in the apocryphal *Protoevangelion of St. James*.[43] Hyrtakenos describes the varieties of trees that encircled the garden, paying especial attention to the cypresses.[44] He also describes the multifarious birds that flitted about the enclosure, in particular the nightingale, the parrot, the peacock, and the swan.[45] Taking his cue from the Romances, he gives an extensive description of the fountain at the center of the garden, with its colored marbles and its carvings of animals. In his words, "The bowl [of the fountain] was hewn in light green stone. In the middle of the bowl an upright cylinder was soaring aloft. A cone was posted upon the cylinder like a head on a neck." Hyrtakenos adds, "It was possible to perceive the cone as an ornament upon

[40]*Oratio XLIV, In novam Dominicam*, 10–11; ed. Migne, Patrologia Graeca XXXVI, cols. 617–620; translation by Daley, *Gregory of Nazianzus*, 160–161.

[41]John Geometres, *In Annuntiationem*, ed. Migne, Patrologia Graeca CVI, col. 841; Isidore of Thessalonica, *Sermo III, In Annuntiationem*, ed. Migne, Patrologia Graeca CXXXIX, cols. 112–113.

[42]*Description of the Garden of St. Anna*, ed. J. F. Boissonade, *Anecdota graeca*, vol. 3, Hildesheim 1962, 59–70; translation by M.-L. Dolezal and M. Mavroudi, "Theodore Hyrtakenos' *Description of the Garden of St. Anna* and the Ekphraseis of Gardens," in A. Littlewood, H. Maguire, and J. Wolschke-Bulmahn, eds., *Byzantine Garden Culture*, Washington, DC, 2002, 143–150.

[43]*Protoevangelion of St. James* 2:3–3:3.

[44]Boissonade, ed., *Anecdota graeca*, vol. 3, 60–61; translation by Dolezal and Mavroudi, "Theodore Hyrtakenos," 144.

[45]Boissonade, ed., *Anecdota graeca*, vol. 3, 64–65; translation by Dolezal and Mavroudi, "Theodore Hyrtakenos," 146.

an ornament. . . . For it was hewn in porphyry, while the tube was constructed from a different, gleaming stone, so that . . . purple was at the top, bright green at the bottom, and in between them both there was linen-color." The cone was pierced with holes, from which "jets of water . . . flowed, as if [they were] streams of tears [flowing] from eyes." Around the outside surface of the fountain "the bounding of lions, the leaping of leopards, and the swaying of bears, as well as the images of other wild animals that the craftsman had excellently carved, were so close to moving that the beholder wished he could withdraw somewhere far away, lest the beasts suddenly leap on him and tear him to pieces."[46]

Medieval church poetry, also, associated the Virgin with the fruits of the earth and with fountains. For example, the fourteenth-century poet Manuel Philes composed an epigram on a stone *panagiarion*, or paten, that had an image of the Virgin carved upon it. The title of the poem reads, "On a stone *panagiarion*, on which was the Theotokos of Pege." The Virgin's epithet "of Pege" refers to her sacred spring just outside the walls of Constantinople. In all likelihood the verses were inscribed upon the paten itself, which was probably carved out of green steatite, as we can deduce from the references to the earth and its crop:

> The stone bears the earth, but the earth bears the crop.
> The crop, the earth, the Virgin are the nurse of souls.
> Or rather, seeing the spring of the living stream,
> O faithful one, suck grace from the stone.[47]

Here, in a highly compressed form, we have the same idea that found expression in rhetorical texts: the green stone of the paten portrays the Virgin, who is celebrated as the earth and from whom sprang the salvation that nourishes our souls.

In summary, after iconoclasm the tradition of *Hexaemeron* writing waned, with the exception of its brief revival by Constantine Manasses and Michael Glykas around the middle of the twelfth century. The relative lack of interest in the *Hexaemeron* in medieval Byzantium contrasts with the situation in the Western Europe, where there was a revival of *Hexameron* literature in the eleventh and twelfth centuries by authors such as Thierry of Chartres and Peter Abelard. In Byzantium rhetorical treatments of nature were regarded with suspicion and often were accompanied by disclaimers or by material that would neutralize their glorification of terrestrial phenomena. On the other hand, the concept of the sanctification of nature through the incarnation allowed the celebration of

[46]Boissonade, ed., *Anecdota graeca*, vol. 3, 61–63; translation by Dolezal and Mavroudi, "Theodore Hyrtakenos" 144–145. Another fountain composed of multicolored marbles and incorporating sculptures of animals is described by Eustathios Makrembolites in his romance *Hysmine and Hysminias*, 1.5; ed. R. Hercher, *Erotici scriptores graeci*, vol. 2, Leipzig, 1859, 163–164. See Dolezal and Mavroudi, "Theodore Hyrtakenos," 130.

[47]E. Miller, ed., *Manuelis Philae carmina*, vol. 2, Paris, 1857, 157–158, no. 115.

FIGURE 2.4. Istanbul, Zeyrek Camii (Pantocrator Monastery), opus sectile floor, detail.

nature in certain contexts, such as the Annunciations to the Virgin and St. Anne. When we turn to Byzantine church art during the Middle Ages, we find that the depictions of nature correspond to the attitudes found in literature; that is, we can see an abiding ambivalence between denial and acceptance, punctuated by a brief return of interest in all of terrestrial creation during the twelfth century.

As we saw in the previous chapter, the most conspicuous change in the decoration of churches after iconoclasm is the virtual disappearance of the tessellated floors with their depictions of various animals and plants, which had been so characteristic of early Byzantine churches from the fifth to seventh centuries. In medieval churches the commonest form of pavement was opus sectile, generally arranged in geometric patterns. Although tessellated motifs, such as eagles or snakes, were occasionally inserted into these medieval floors, they no longer displayed the wealth of subjects such as Nilotic motifs and hunting scenes that had characterized the earlier pavements.[48] The well-preserved floors at Hosios Loukas are typical of medieval opus sectile pavements:

[48]On this phenomenon, see H. Maguire, "The Medieval floors of the Great Palace," in N. Necipoğlu, ed., *Byzantine Constantinople, Monuments, Topography and Everyday Life*, Leiden, 2001, 153–174.

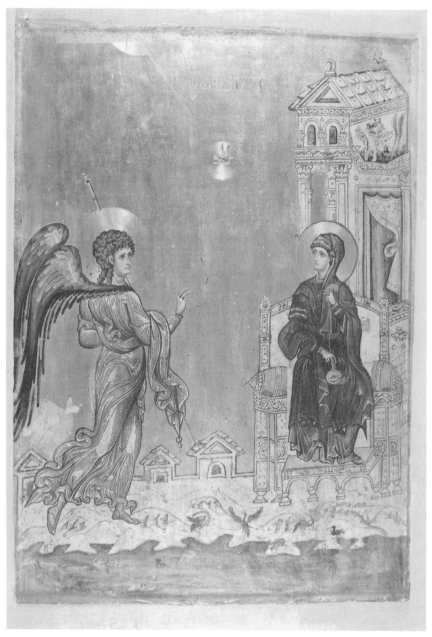

FIGURE 2.5. Mount Sinai, Monastery of St. Catherine, panel painting. The Annunciation to the Virgin.

abstract geometrical compositions based on squares, rectangles, and circles and deprived of figural imagery (plate XIV).[49] Only in the twelfth century, in the exceptional floor of the Pantocrator Monastery in Constantinople, do we find a church pavement that comes close to rivaling the early Byzantine floor mosaics in the wealth of its animal and human imagery (figure 2-4). Here we find the forms of fish and quadrupeds portrayed in opus sectile. There are even Nilotic motifs, including rowboats and a human swimmer, together with fragments of hunting scenes.[50] It is tempting to link this pavement, which dates to the 1130s, with the renewed interest in the *Hexaemeron* evidenced by the slightly later ekphraseis of Constantine Manasses and by the *Biblos chronike* of Michael Glykas.

As for the ekphraseis of the springtime, which Byzantine homilists introduced so eloquently into their sermons on the Annunciation, it too occurs in medieval Byzantine art, but very rarely. The best-known example is the famous late twelfth-century icon of the Annunciation now at Mount Sinai, which draws on the ancient repertoire of Nilotic motifs to illustrate many of the topoi associated with descriptions of the spring. Here we discover the golden sky, the river at the bottom teeming with aquatic creatures, the earth producing grass and flowers, the leafing trees that grow from the elevated garden on the right of the Virgin's house, and the nesting birds in their branches and on top of the roof (figure 2-5).[51] But this icon is exceptional among Byzantine portrayals of the Annunciation for the wealth of its imagery from nature. In other Byzantine Annunciation scenes, the springtime, if it is evoked at all, is represented by an isolated motif, such as the tree that grows out beside the Virgin in an eleventh-century lectionary manuscript in the Dionysiou Monastery on Mount Athos.[52] Occasionally the tree will harbor birds, as can be seen just to the right of the Virgin in the early twelfth-century enamel of the Pala d'Oro in Venice.[53] But in medieval art it is more common to find the Annunciation unadorned by the rhetoric of nature, as, for example, in the famous late eleventh- or early

[49]R. W. Schultz and S. H. Barnsley, *The Monastery of Saint Luke of Stiris in Phocis*, London, 1901, pl. 30.

[50]A. H. S. Megaw, "Notes on Recent Work of the Byzantine Institute in Istanbul," *Dumbarton Oaks Papers* 17 (1963), 333–371, esp. 337–338. R. Ousterhout, "Architecture, Art, and Komnenian Ideology at the Pantokrator Monastery," in Necipoğlu, ed. *Byzantine Constantinople*, 133–150. The poorly preserved floor of the Stoudion basilica was comparable to the Pantocrator floor in its technique and wealth of iconography and was probably contemporary with it; see Megaw, "Notes on Recent Work of the Byzantine Institute in Istanbul, 339.

[51]H. C. Evans and W. D. Wixom, *The Glory of Byzantium. Art and Culture of the Middle Byzantine Era, a.d. 843–1261* (exhibition catalogue, Metropolitan Museum of Art), New York, 1997, 374–375, no. 246.

[52]Dionysiou, MS. 587, fol. 150; S. M. Pelekanidis et al., *The Treasures of Mount Athos. Illuminated Manuscripts*, vol. 1, Athens, 1974, 444, fig. 264.

[53]H. R. Hahnloser and R. Polacco, *La Pala d'oro*, Venice, 1994, 26, fig. 52.

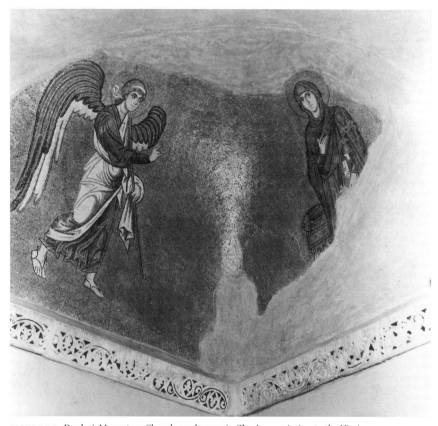

FIGURE 2.6. Daphni, Monastery Church, vault mosaic. The Annunciation to the Virgin.

twelfth-century mosaic of Daphni, where the scene is played out against an unbroken background of pure gold (figure 2-6).[54]

If medieval Byzantine artists were reluctant to accept the rhetoric of ekphraseis into their depictions of the Annunciation to the Virgin, this was not the case when it came to portrayals of the Annunciation to St. Anne. In the Annunciation to the Virgin's mother, Byzantine artists felt free to portray nearly all of the motifs associated with the ekphraseis of a garden. Accordingly, in the early fourteenth-century mosaic at the Kariye Camii (Monastery of the Chora), we see the thick growth of trees that encloses her garden, as was described in the ekphraseis by Hyrtakenos. We also find the elaborate fountain at the center of the garden, with its colored marbles and its carvings of animals—in this case the head of a lion (figure 2-7). We also see the birds that inhabited the garden. One of them is flying down to her nest, following the account in the *Protoevangelion*.[55]

[54]L. Safran, ed., *Heaven on Earth. Art and the Church in Byzantium*, University Park, 1998, 139–140, fig. 5.17.

[55]P. A. Underwood, *The Kariye Djami*, vol. 2, London, 1967, plates 93–95.

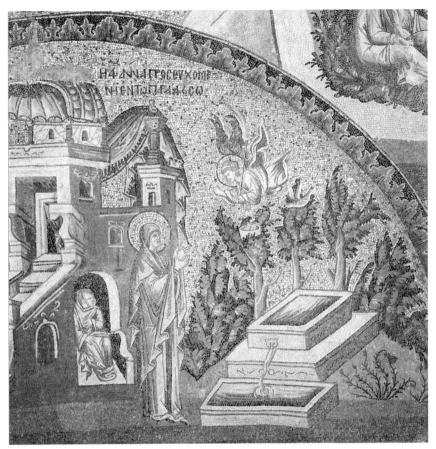

FIGURE 2.7. Istanbul, Kariye Camii (Monastery of the Chora), wall mosaic. The Annunciation to St. Anne.

But four other birds have escaped from St. Anne's paradise and can be seen wandering in the borders of the mosaics in the neighboring bays of the narthex, which depict other episodes from the early life of the Virgin. A pair of fine peacocks disport themselves beneath the scene of the Virgin being caressed as an infant by her parents, Joachim and Anne (plate V).[56] In the adjoining bay there are handsome representations of a male and a female pheasant below the mosaic of the Presentation of the Virgin in the Temple.[57]

The miniature of the Annunciation to St. Anne in the Vatican manuscript of the *Homilies of James of Kokkinobaphos* exhibits a more variegated collection of plants and trees together with birds flying among their branches (figure 2-8). Here, too, we find an elaborate fountain at the right of the image. In this case

[56]Ibid., plates 114, 116–118.
[57]Ibid., plates 120, 125.

FIGURE 2.8. Vatican Library, MS. Gr. 1162 (*Homilies of James of Kokkinobaphos*), folio 16v. The Annunciation to St. Anne.

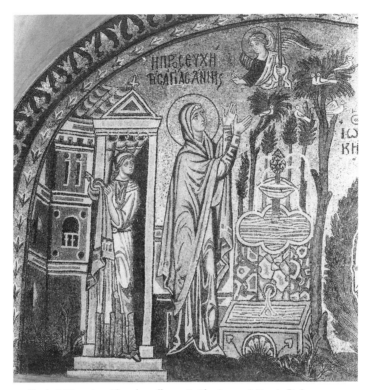

FIGURE 2.9. Daphni, Monastery Church, wall mosaic. The Annunciation to St. Anne.

a cone on a cylindrical pier surmounts the tiered fountain and produces jets of water, just like the fountain described by Hyrtakenos.[58] Another ornamented fountain is on display in the mosaic of the Annunciation to St. Anne at Daphni (figure 2-9).[59] Once again there is a pinecone on a stalk, which rises above three superimposed basins, carved of yellow, green, and pink marble. Behind the fountain are the encircling trees, with birds sitting in their branches.

In each of these depictions of the Annunciation to St. Anne, the artists have indulged freely in the rhetorical description of nature. But in each case, we can also contrast the visual wealth of the Annunciation to St. Anne with the comparative severity of the Annunciation to the Virgin. At Daphni we have seen that the angel delivers the news of Christ's birth against a background that is devoid of any kind of reference to the terrestrial world (figure 2-6). Only divine

[58]Vatican Library, MS. Gr. 1162, fol. 16v.; Hutter and Canart, *Das Marienhomiliar des Mönchs Jakobos von Kokkinobaphos.* See Dolezal and Mavroudi, "Theodore Hyrtakenos," 121, fig. 15.

[59]Safran, ed., *Heaven on Earth,* 148, fig. 5.25; Dolezal and Mavroudi, "Theodore Hyrtakenos," 121, fig. 1.

FIGURE 2.10. Istanbul, Kariye Camii (Monastery of the Chora), wall mosaic. The Annunciation to the Virgin by the well.

light surrounds the actors. Likewise, in the Vatican manuscript of the *Homilies of James of Kokkinobaphos*, the five miniatures that illustrate the Annunciation to the Virgin all show the scene unfolding against a backdrop of gold, without plants or creatures of any kind (figures 5-12 to 5-16).[60] And in the Kariye Camii, although the mosaic of the Annunciation proper is lost, we can still contrast the depiction of the Annunciation by the Well (figure 2-10). Here only a single tree in the background behind the Virgin hints at themes of fertility and renewal.[61] Thus, the sensual imagery of one scene is negated by the austerity of the other. In a sermon on the Nativity of the Virgin, Emperor Leo VI described the birth of Christ as a miracle that was "above nature."[62] Through its more austere portrayal of the Annunciation of Christ's incarnation, Byzantine art itself made a critique of the earthbound rhetoric of the Annunciation to St. Anne, reproved it, and put it in its place.

[60]Vatican Library, MS. Gr. 1162, fols. 118, 122, 124, 126, 127v.; Hutter and Canart, *Das Marienhomiliar des Mönchs Jakobos von Kokkinobaphos*.

[61]Underwood, *The Kariye Djami*, vol. 2, plates 146–147.

[62]*Oratio I, in Beatae Mariae Nativitatem*; ed. Migne, *Patrologia Graeca* CVII, cols. I–4.

Nature and Rhetoric in the Panegyric of Emperors

In the rhetoric and art of the medieval Byzantine church, therefore, we find ambivalence between the acceptance and the denial of the techniques of rhetoric insofar as they were applied to the glorification of the delights of the earthly world. The same ambivalence can be found in imperial rhetoric during the same period. We may take, for example, the common topos of imperial panygyric that compared the emperor and his works to the flourishing of nature during the spring. Thus, Psellos, in a speech addressed to Constantine IX Monomachos, said of the emperor, "Like some sun in the springtime suddenly arising you fill both the morningtide and eventide with your beacon."[63] Theodore Prodromos, in his praises of John II Comnenus, went further, claiming that the emperor had surpassed the season of flowers with the flowers of his trophies. The emperor's singular warmth, he declared, was capable of bringing springtime in February, bringing a bloom to every heart, so that when the lambs were not yet skipping in the green grass the hearts of his subjects were already skipping and throbbing, having been filled with the emperor's sun-like rays.[64]

But the Byzantine orators themselves censored this kind of imagery with another rhetoric: the rhetoric that denied rhetoric. In another of his encomia, Psellos addressed Emperor Isaac Comnenus with a series of rhetorical questions: "Where is there babbling of speech [in you]?. . . . Where is there . . . an intricate wit? For there are no unseemly qualities in you, neither easily excited emotion, nor false speech . . . nor a double-tongued heart . . . nor delight, nor any graces."[65] Here, then, we have an imperial image that is completely at odds with the tropes of springtime: a ruler without the deceitful wiles of speech and without false graces or charm. These two contrasting portraits of the emperor—the one florid, the other austere—can also be found coexisting in Byzantine art. We may cite, for example, the portrait of Constantine Monomachos together with his wife, Zoe, and her sister Theodora on an enameled crown in Budapest (plate VI).[66] The emperor and the two women stand in garden-like settings, with leafy plants containing colorful birds, while beside them women, perhaps to be identified as personifications of the graces, are dancing. Such sensual delights are completely absent from the portrait of Constantine, Zoe, and Theodora in the frontispiece of a copy of John Chrysostom's sermons on

[63]Kurtz, *Michaelis Pselli scripta minora*, vol. 1, 14.

[64]W. Hörandner, ed., *Theodoros Prodromos, historische Gedichte*, Vienna, 1974, 255, 310–311, nos. 11, 19.

[65]Kurtz, *Michaelis Pselli scripta minora*, vol. 1, 46–47.

[66]Evans and Wixom, *The Glory of Byzantium*, 210–212, no. 145. On the authenticity of the enamels, see E. Kiss, "The State of Research on the Monomachos Crown and Some Further Thoughts," in O. Z. Pevny, ed., *Perceptions of Byzantium and Its Neighbors (843–1261)*, New York, 2000, 60–83.

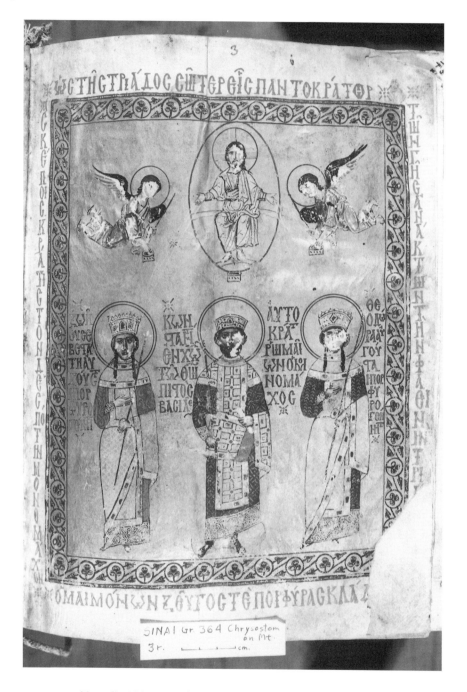

FIGURE 2.11. Mount Sinai, Monastery of St. Catherine, MS. Gr. 364, folio 3. Constantine IX Monomachos, Zoe, and Theodora.

Matthew, which is preserved in the library at Mount Sinai (figure 2-11).[67] Here the imperial figures stand silhouetted against a pure gold ground as they receive the blessing of Christ above. Thus, in the portrait that appears in the religious manuscript, the nature rhetoric of the crown has been censored.

In conclusion, the ambivalence felt by the Byzantines concerning rhetoric as both a source of elegance and of deceit was also felt about the delights of nature, which were on one hand providers of wealth and pleasure but on the other hand were corruptible and fleeting compared with the spiritual rewards of heaven. The Byzantines expressed this ambivalence both in their literature and in their art. However, in the early period, before iconoclasm, the glorification of nature in writing and art tended to outweigh its denigration, while in the later period it was the rejection of the terrestrial world that tended to gain the upper hand. Both in their literature and in their art, the Byzantines found ways to put nature securely in its subordinate place, even while they were still prepared to deploy their eloquence in acknowledgment of its charms.

[67]MS. 364, fol. 3; K. Weitzmann and G. Galavaris, *The Monastery of Saint Catherine at Mount Sinai. The Illuminated Greek Manuscripts*, vol. I, *From the Ninth to the Twelfth Century*, Princeton, NJ, 1990, 66, fig. 185.

3 }

Nature and Metaphor

Introduction

During the fifth and sixth centuries preachers and poets of the Byzantine church described the Virgin with a rich array of metaphorical images, many of which they derived from the natural world. These metaphors were repeated in sermons and hymns until the end of Byzantium. Many of the same images were associated with the Virgin in Byzantine art, but much less frequently than they appeared in literature and not at all periods. This disjunction between constantly reiterated verbal metaphors on one hand and sporadically appearing visual imagery on the other is the topic that will be explored in this chapter. We shall see how artists successively avoided, then to a limited extent accepted, and then again avoided many of the nature-derived metaphors of the Virgin provided by the literature of their church. From the Virgin we shall turn to paradise, where evocations of nature lay between metaphor and the description of reality. Here again, the literature of Byzantium provides a greater abundance of imagery than its art. The Byzantine ambivalence toward visualized metaphors from nature can be contrasted with their acceptance in the West, where attitudes toward the character and functions of religious art were different.

At the outset it is necessary to attempt a distinction between the terms *metaphor* and *symbol* in the context of Byzantine art. The definition of these words has been a matter of debate,[1] but in this chapter *metaphor* is used to describe an image of one thing that evokes another thing or things by analogy. By this definition, metaphors are inherently multivalent. A sheep, for example, could represent either Christ the sacrificial Lamb or else a member of the flock of Christ the Shepherd, such as an apostle or another of his followers. On the

[1]See L. M. Peltomaa, *The Image of the Virgin Mary in the Akathistos Hymn*, Leiden, 2001, 116–125; M. B. Cunningham, "Divine Banquet: the Theotokos as a Source of Spiritual Nourishment," in L. Brubaker and K. Linardou, eds., *Eat, Drink, and Be Merry (Luke 12:19)—Food and Wine in Byzantium*, Aldershot, 2007, 235–244, esp. 243–244.

other hand, in this chapter *symbol* denotes an image whose meaning has been fixed in some way—by its context, the addition of an attribute or attributes, or an inscription. For example, a sheep accompanied by eleven other sheep would be a symbol of an apostle, whereas a lamb distinguished by a nimbus containing a cross would be a symbol of Christ, the Lamb of God. According to this definition, a symbol is a metaphor that has been disciplined and deprived of its ambiguity. In the context of Christian art, and to a lesser extent literature, metaphor created an obvious problem: how was the viewer to interpret the image? Was the worshipper to see an unidentified sheep as Christ, or as an apostle, or, even worse, as an animal associated with pagan cults, such as the ram of Ammon? Therein lay the problem of metaphor in art, both for viewers and for those who might wish to control the reception of religious art.

The Early Byzantine Period

In the first half of the fifth century we begin to find the Virgin addressed in Byzantine literature through a wide variety of metaphorical images. In broad terms, these metaphors may be classified as cosmic, terrestrial, aquatic, nautical, architectural, horticultural, and animal. Thus, in the fifth sermon of Hesychius of Jerusalem, the Virgin becomes the mother of light and the star of life, the rain-bearing cloud, the field that produces the fruit, the mine from which was cut the stone that covers the whole earth, the enclosed source of the river, the case for the pearl, the ark wider than the one built by Noah, the vessel full of cargo, the temple greater than the sky, the closed door of paradise, the enclosed garden fertile without seed, the untouched vine well hung with grapes, and finally the turtle dove and the dove.[2] Richer still is the list of metaphors contained in the *chairetismoi*, or invocations, of the *Akathistos Hymn*. This poem, which is probably dated to the fifth century,[3] is built up of an accumulation of images representing the Virgin that follow each other like an endless cascade, as in the following series from the fifth strophe:

> Hail, vine of the unwithered shoot;
> hail, field of the immortal crop;
> hail to you who harvest the harvester, friend of man;
> hail to you who plant the planter of our life;
> hail, field that flourishes with a fertility of compassion;
> hail, table that bears a wealth of mercy;
> hail to you who make a meadow of delight to blossom. . . .[4]

[2]*Homilia V*, 1–3; ed. M. Aubineau, *Les homélies festales d'Hésychius de Jérusalem*, vol. 1, Subsidia hagiographica LIX, Brussels, 1978, 158–164.

[3]On the date, see Peltomaa, *Image of the Virgin Mary*, 114.

[4]Peltomaa, *Image of the Virgin Mary*, 6–7; translation by C. A. Trypanis, *The Penguin Book of Greek Verse*, Harmondsworth, 1971, 377.

Most of the metaphors in the *Akathistos Hymn* fall into the same broad cat-
egories as those used by Hesychius, that is, cosmic (the star and the dawn),
terrestrial (the promised land, the source of milk and honey, the unsown field,
the sweet field, the rock), aquatic (the ocean, the river of many streams, the
rock giving water), nautical (the boat, the ark, the harbor), architectural (the
wall, the mansion, the strong tower, the pillar, the heavenly ladder, the bridge,
the gate, and the key), horticultural (the spiritual paradise, the tree of bril-
liant fruit, the branch of fair-shading leaves, the vine of abundance, the flower
of incorruption), and animal (the filler of the nets of fishermen, the fold of
the flock). Such streams of metaphors, many drawn from nature, expressed the
belief that the created world had been sanctified through the incarnation and,
in the words of the sixth-century patriarch Anastasius of Antioch, "changed
into a wealth of beauty."[5]

In the sixth century, we begin to find some of the same images from nature
that had evoked the Virgin in hymns and sermons also accompanying her por-
trayals in works of art. This phenomenon occurs both in the public and the
private sphere. Among public monuments, the best examples are the mosaic
apses at Kiti, in Cyprus, and Poreč in Istria. At Kiti, we find the Virgin and
Child framed by a rich border portraying six fountains, represented by vases
rising from luxuriant cups of acanthus, three on each side of the apse (plate
VII).[6] The topmost vases are flanked by pairs of stags, the ones in the middle
by parrots, and those at the bottom by ducks. A similar nature-derived imagery
accompanies the Virgin on an object from the domestic sphere, a late sixth- or
early seventh-century bracelet now in the British Museum.[7] Here the Virgin is
portrayed with her hands raised in prayer on the bezel, while the hoop displays
a vase from which grow two plant scrolls enclosing peacocks and two pairs of
swans.

In the apse of the mid-sixth-century cathedral of Eufrasius at Poreč we find
a different set of images depicted beneath its central portrayal of the Virgin
and Child, namely, a set of nine large scallop shells executed in golden mosa-
ics, separated by fourteen discs of actual mother of pearl (plate VIII).[8] Besides
Hesychius of Jerusalem, whom I have already cited,[9] a sermon attributed to
Proclus also used the metaphor of the Virgin as the shining shell that contained
the pearl of truth. He declared:

[5]*In Annuntiationem*, ed. J.-P. Migne, Patrologiae cursus completus, Series Graeca LXXXIX, col. 1384.

[6]D. Michaelides, *Cypriot Mosaics*, Nicosia, 1987, 55–56, figs. 69, 70a–70c.

[7]D. Buckton, ed., *Byzantium, Treasures of Byzantine Art and Culture* (exhibition catalogue, British Museum), London, 1994, 95–96, no. 99.

[8]A. Terry and H. Maguire, *Dynamic Splendor: the Wall Mosaics in the Cathedral of Eufrasius at Poreč*, vol. 2, University Park, 2007, figs. 140–153.

[9]*Homilia V*, 1; ed. M. Aubineau, *Les homélies festales d'Hésychius*, 158. *Homilia V*, 3; ed. M. Aubineau, *Les homélies festales d'Hésychius*, 164.

How will I dare to search out the depth of the Virginal sea and find the great mystery hidden therein, if you do not instruct me, O Mother of God! ... Only then, shining with the light of your mercy, shall I find within you the pearl of truth.[10]

The origin of the metaphor lay in the ancient belief that pearls were created when lightning struck the oysters as they lay on the seabed, a marvel that became an image of divine conception.[11] Preaching on the birth of the Virgin, John of Damascus declared, "An oyster is born in her, the one who will conceive in her womb from the heavenly lightning-flash of divinity and will bear the pearl of great price, Christ."[12]

Of course, shells, animals, and vases also appeared in other contexts in early Byzantine art and could be given other meanings. But the literary metaphors addressed to the Virgin were well-known by the middle of the sixth century; anyone who looked at these motifs depicted in association with the Virgin in works of art must surely have been reminded of their reiteration in Marian hymns and sermons.

It is possible to view the portrayals of the Virgin that surrounded her with birds, beasts, plants, and shells as a Christianization of the old nature personifications, with their accompanying imagery of fertility and prosperity. In the floor mosaic at Khirbet el-Mukhayyat, the earth appeared as a woman framed by scrolling acanthus plants enclosing beasts, fishes, and fruits (figure 1-3). The personification of the sea in the nave pavement of the church of the Apostles at Madaba was at the center of a trellis pattern composed of long-tailed parrots framing flowering and fruiting plants (figure 1-4). But we have found that such nature personifications, with their pagan overtones, could cause discomfort to Christian viewers. Their replacement by the Virgin was a first phase in the cleansing of Christian images of the tainted subjects from nature. We shall see that eventually the accompanying animals and plants themselves became unwelcome, even in association with the Virgin. As a result, a second cleansing had to take place, which expelled from many of her icons all reference to the natural world.

[10]*In sanctissimae Deiparae Annuntiationem*, 4; ed. Migne, Patrologia Graeca LXXXV, col. 436A. For the citation and the attribution to Proclus, see N. P. Constas, "Weaving the Body of God: Proclus of Constantinople, the Theotokos and the Loom of the Flesh," *Journal of Early Christian Studies* 3, no. 2 (1995), 169–194, esp. 177, note 27.

[11]M. Cunningham, *"Wider than Heaven": Eighth-Century Homilies on the Mother of God*, Crestwood, NY, 2008, 58, note 21. On the image of mother of pearl, see N. P. Constas, *Proclus of Constantinople and the Cult of the Virgin in Late Antiquity: Homilies 1–5, Texts and Translations*, Leiden, 2003, 290–294.

[12]*In nativitatem Mariae*, ed. B. Kotter, *Die Schriften des Johannes von Damaskos*, vol. 5, Berlin, 1988, 172–173; translation by Cunningham, *"Wider than Heaven,"* 58.

The Middle Period

In the course of the eighth century, the period of the iconoclastic dispute, there was a spate of sermons in praise of the Virgin, which frequently evoked her qualities with the aid of the familiar metaphors from nature. Thus, John of Damascus, in the same sermon on the *Nativity of the Theotokos* in which he revived the metaphors of the oyster and the pearl, described the Virgin as a lily and a rose among thorns and her parents as a pair of turtle doves.[13] Another eighth-century preacher, John of Euboea, made a play with the image of a garden, by turns the Garden of St. Anne, the garden of Christ's incarnation, and the Garden of Eden:

> Behold Joachim and Anna! While he was fasting on the mountain, she was in her garden beseeching God, and they received a receptacle for the One who set up the mountains and caused the garden to grow! Behold, the good news of happiness in a garden, that the garden of old might be returned to humanity![14]

It has been suggested that iconophile homilists emphasized the Virgin's links with the terrestrial world as proof of the incarnation of Christ, which was the principal justification for the veneration of his portraits.[15] In the words of John of Damascus, who wrote in defense of icons, "The spiritual ladder, the Virgin, has been set up on earth, for she takes her origin from the earth, but her head is lifted up to heaven."[16]

After the end of iconoclasm in the ninth century until the close of the Middle Byzantine period with the Crusaders' conquest of Constantinople in 1204, the stream of metaphors continued to flow unabated in church literature. To take only one example, in a sermon on the Annunciation by Emperor Leo VI, we find the Virgin described as the one who revealed the pearl, as the rock from which gushed the fountain of life, as a fruitful paradise, and as a lily.[17] As we saw in chapter 2, some writers of this epoch, taking their inspiration from the much admired sermon on the New Sunday by Gregory of Nazianzus,[18]

[13]*In nativitatem Mariae*, ed. Kotter, *Die Schriften des Johannes von Damaskos*, vol. 5, 174–175; translation by Cunningham, *"Wider than Heaven,"* 60–61.

[14]Migne, ed., Patrologia Graeca XCVI, col. 1465; translation by Cunningham, *"Wider than Heaven,"* 176.

[15]See N. Tsironis, "The Mother of God in the Iconoclastic controversy," in M. Vassilaki, ed., *Mother of God: Representations of the Virgin in Byzantine Art* (exhibition catalogue, Benaki Museum, Athens), Milan, 2000, 27–39; M. B. Cunningham, "The Meeting of the Old and the New: The Typology of Mary the Theotokos in Byzantine Homilies and Hymns," in R. N. Swanson, ed., *The Church and Mary*, Woodbridge, 2004, 52–62, esp. 60–62.

[16]*In Nativitatem*, 3, ed. P. Voulet, *S. Jean Damascène: Homélies sur la Nativité et la Dormition*, Sources Chrétiennes LXXX, Paris, 1961, 52; cited by Cunningham, "Meeting of Old and New," 60.

[17]*Homilia I, In Annuntiationem*, ed. T. Antonopoulou, *Leonis VI Sapientis Imperatoris Byzantini homiliae*, Corpus Christianorum, Series Graeca LXIII, Turnhout, 2008, 8–9.

[18]*Oratio XLIV, In novam Dominicam*, 10–11; ed. Migne, Patrologia Graeca XXXVI, cols. 617–620; translation by B. E. Daley, *Gregory of Nazianzus*, Abingdon, 2006, 160–161.

used a formal ekphraseis of the season of spring to convey the sanctification of creation through the incarnation on the feast of the Annunciation. In the tenth century, John Geometres described the gentle streams, the land covered with flowers, the trees with leaves, and the birds, fishes, and terrestrial animals bringing forth their young, all seeming to celebrate the renewal of our nature.[19] Other writers, such as the Cypriot hermit Neophytos, repeated the traditional *charetismoi* in their sermons on the Annunciation. In this excerpt from a homily that he preached at the end of the twelfth century, we hear the saint mixing together architectural with organic images while spelling out for his listeners, the meanings of the metaphors:

> Hail, impassable gate, through which the angel passed
> Hail, heavenly ladder, by means of which He who is above the heavens came down to earth
> Hail, spiritual paradise of the flower of incorruption.
> Hail, spring rising from Eden and irrigating paradise, that is, the church of God and the congregation of the faithful
> Hail, "Tree of Life, that is in the midst of Paradise," from which we the faithful eat the fruit for the remission of our sins.
> Hail, door of Paradise, that admits the faithful and turns aside the faithless.
> Hail, unsown field, from which sprouted the head of corn that brings life.
> Hail, vine of abundance and stem rich in fruit, which the Father planted, the Holy spirit watered, and the son cultivated well
> Hail, great and spacious sea, in which sailed the helmsman of the universe
> Hail, strong tower, that guards those that flee for refuge in you unharmed in the face of the enemy
> Hail land flowing with milk and honey
> Hail, divinely abundant river
> Hail, holy spring.
> Hail, fount of flowing water
> Hail, solitude-loving turtle dove, who has released the world from solitude.
> Hail, holy swallow, through whom the spring of salvation has come to us.
> Hail, sweet-sounding nightingale, with your clear song prophesying glory.[20]

[19] *In Annuntiationem*, ed. Migne, Patrologia Graeca CVI, col. 841.

[20] M. Torniolo, ed., "Omelie e catechesi mariane inedite di Neofito il Recluso (1134–1220c.)," *Marianum* 36 (1974), 184–315, esp. 242–244, 262.

St. Neophytos, the composer of these lines, excavated a cell for himself together with an adjoining chapel in a cliff near Paphos, on the south side of the island of Cyprus. In 1183 he had the cell and the sanctuary of the chapel painted with a variety of scenes from the Life of Christ, including the Annunciation, the Crucifixion, the Anastasis (Resurrection), and the Ascension, together with portrayals of Christ, of the Virgin, of angels, and of saints. But nowhere in the decoration of these spaces did the artist depict any motifs from nature, neither in association with the Annunciation nor accompanying the icons of the Virgin.[21] Thus, while the sermons of the ascetic saint teemed with horticultural and animal metaphors, the paintings that he commissioned for himself were austere and deprived of such images. Clearly the visual arts of medieval Byzantium were governed by different conventions than the verbal. In general, it may be said that in art inanimate objects, such as mountains, towers, ladders, and gates, were completely acceptable as metaphors, a topic that will be explored further in chapter 5, with particular reference to architecture. Horticultural metaphors, on the other hand, were evoked with more reserve,[22] although we shall see that there were some striking examples of their use. Least common were portrayals of animals, which appeared rarely in association with the Virgin, especially in monumental art, where the images were on permanent view and were more likely to attract criticism.

For an example of floral imagery, we may take the splendid enamels from an icon of the Virgin, dating to the late eleventh or early twelfth century and now partly preserved in the Metropolitan Museum of Art (plate IX).[23] Here both the Virgin's halo and the background are filled with highly stylized but brilliantly colored flowers, the ones in the halo possibly evoking lilies.

The most famous of the icons that associate the Virgin with animals is the small late twelfth-century panel of the Annunciation at Mount Sinai, discussed in chapter 2, where we found birds nesting on her house and a riverscape depicted at her feet, complete with water birds of different kinds and a variety of sea creatures, including a swordfish and an octopus (figure 2-5).[24] This riverbank, with its creatures and its cliff-like edge, is a Nilotic motif derived

[21]C. Mango and E. J. W. Hawkins, "The Hermitage of St. Neophytos and Its Wall Paintings," *Dumbarton Oaks Papers* 20 (1966), 136–206.

[22]See the remark of H. Papastavrou with reference to the depiction of trees in Annunciation scenes: "Bien que la littérature et les chants liturgiques byzantins abondent de métaphores et d'allégories adressées à la Vierge, ces images littéraires trouvent des équivalences plus discrètes dans la domaine de la peinture byzantine que dans l'art occidental." H. Papastavrou, *Recherche iconographique dans l'art byzantin et occidental du XIe au XVe siècle. L'Annonciation*, Venice, 2007, 254.

[23]H. C. Evans and W. D. Wixom, *The Glory of Byzantium, Art and Culture of the Middle Byzantine Era a.d. 843–1261* (Exhibition catalogue, Metropolitan Museum of Art), New York 1997, 348–349, no. 236; B. V. Pentcheva, *The Sensual Icon: Space, Ritual, and the Senses in Byzantium*, University Park, 2010, 116–120, figs. 44, 47.

[24]Evans and Wixom, *Glory of Byzantium*, 374–375, no. 246; Papastavrou, *Recherche iconographique*, 317–323.

from late antique art. It can be compared to the stream that ran beneath Old Testament scenes depicted in the dome mosaics of Santa Costanza in Rome, which are now known only through copies in watercolor (figure 3-1).[25] It is also possible that the painter of this panel alluded to the metaphor of the shell, in the form of the yarn bowl on the Virgin's lap, which has the shape of a scallop.[26] As we have seen, however, the fame of this icon has obscured its rarity. Usually Byzantine artists confined themselves to representing the architecture of the Virgin's house, without animal life (plate XIX), or, as in the case of the mosaic at Daphni, they opted for a plain gold ground (figure 2-6).

Manuscript paintings provide the richest displays of images from the natural world in praise of the Virgin. In the illuminated copies of the *Homilies of James of Kokkinobaphos*, each of the sermons has a splendid headpiece, many of which take the form of lush carpets that combine horticultural with animal imagery. At the beginning of the manuscript, for example, before the sermon on the Conception of the Virgin, we find a dense vegetation burgeoning with red flowers and baskets of fruit, at the center of which a tall plant rises like a candelabrum (figure 3-2).[27] If we explore this vegetation further, we find that it harbors a variety of animals, including birds of prey, parrots, hares, and lions.

FIGURE 3.1. Rome, S. Costanza, mosaics in the dome (watercolor copy by F. d'Ollanda).

[25]H. Maguire, *Art and Eloquence in Byzantium*, Princeton, 1981, 50–52, figs. 42–43.

[26]M. Evangelatou, "The Purple Thread of the Flesh: The Theological Connotations of a Narrative Iconographic Element in Byzantine Images of the Annunciation," in A. Eastmond and L. James, eds., *Icon and Word: The Power of Images in Byzantium—Studies Presented to Robin Cormack*, Aldershot, 2003, 261–279, esp. 269.

[27]Vatican Library, MS. Gr. 1162, fol. 3; I. Hutter and P. Canart, *Das Marienhomiliar des Mönchs Jakobos von Kokkinobaphos, Codex Vaticanus Graecus 1162*, Codices e vaticanis selecti LXXIX, Zurich, 1991.

FIGURE 3.2. Vatican Library, MS. Gr. 1162 (*Homilies of James of Kokkinobaphos*), folio 3.
Headpiece with plants and animals.

In summary, medieval Byzantine writers continued to employ the wealth of imagery that had been used to describe the Virgin in preiconoclastic literature. In art, however, the situation was different. While artists depicted inanimate objects and, less frequently, plant forms in association with the Virgin, they were more reluctant to portray animals. The few exceptions come mostly from the twelfth century and tend to be small in scale. They can be considered the exceptions that proved the rule.

What were the reasons for this selectiveness on the part of posticonoclastic artists? Of key importance is the eighty-second canon of the Quinisext Council, which met in Constantinople in 692. Even if it was not always rigorously observed, this canon enshrined attitudes that came to predominate in Byzantine artistic practice. The council decreed as follows:

> On some venerable images is depicted a lamb at whom the Forerunner points with his finger: this has been accepted as a symbol of Grace, showing us in advance, through the Law, the true Lamb, Christ our Lord. . . . We decree that [the figure of] the Lamb, Christ our God, who removes the sins of the world, should henceforth be set up in human form on images also, in the place of the ancient lamb, inasmuch as we comprehend thereby the sublimity of the humiliation of God's Word,

and are guided to the recollection of His life in the flesh, His Passion and His salutary Death, and the redemption which has thence accrued to the world.[28]

The Quinisext Council, therefore, associated the image of the lamb with the ancient law of the Old Testament, whose last spokesman was John the Baptist, and stipulated that in the New Dispensation Christ should be portrayed in art as a human being and not symbolically as a lamb. For the most part, the canon appears to have been respected in Byzantium, for after the seventh century depictions of Christ as a lamb became extremely rare. A few examples of the old iconography did survive in the cave churches of Cappadocia, but apart from these exceptions the ruling of the council seems to have prevailed.[29] Eventually, beginning in the twelfth century, Byzantine artists developed another image to substitute for the ancient lamb. Although this new image was called *o amnos*, or the lamb, it actually portrayed Christ as a human baby, lying as a victim on an altar. The *amnos* was portrayed in the apses of churches, where it was associated with the performance of the Eucharist.[30]

It is generally accepted that the ruling of the Quinisext Council was a statement of the orthodox doctrine of the incarnation of Christ,[31] which was to become a cornerstone of the defense of Christian icons. As the council's decree explained, the requirement that Christ be shown in human form stressed his incarnation more clearly than the old symbol of the lamb. But, in addition, there was probably another motivation behind the canon, which was the association of representations of animals with idolatry.[32] In this context, the Quinisext Council's relative denigration of the lamb can be seen as a denigration of all imagery from the natural world in cultic settings.

The debates over iconoclasm of the eighth century, especially as expressed in the acts of the council of Nicaea in 787, also may have contributed to the reluctance of medieval Byzantine artists to embellish icons of the Virgin with portrayals of animals. We saw in chapter 1 that the proponents of images were eager to distinguish themselves from the idolatry of the pagans, who had

[28]G. Mansi, *Sacrorum conciliorum nova et amplissima collectio*, vol. XI, Florence, Venice, 1759–1798, col. 977–980; translation by C. Mango, *The Art of the Byzantine Empire 312–1453*, Englewood Cliffs, NJ, 1972, 139–140.

[29]C. Jolivet-Lévy, "Le canon 82 du Concile Quinisexte et l'image de l'Agneau: à propos d'une église inédite de Cappadoce," *Deltion tes Christianikes Archaiologikes Etaireias* 17 (1993–4), 45–52; M. Evangelatou, "Pursuing Salvation through a Body of Parchment: Books and Their Significance in the Illustrated Homilies of Iakobos of Kokkinobaphos," *Mediaeval Studies* 68 (2006), 239–284, esp. 279–280.

[30]L. Hadermann-Misguich, *Kurbinovo: les fresques de Saint-Georges et la peinture byzantine du XII siècle*, Brussels, 1975, 73–78, figs. 21, 29; A. P. Kazhdan, ed., *The Oxford Dictionary of Byzantium*, Oxford, 1991, vol. 1, 79, vol. 2, 1171.

[31]Jolivet-Lévy, "Le canon 82," 49–50.

[32]See A. Grabar, *L'Iconoclasme byzantin: le dossier archéologique*, Paris, 1984, 113–114.

worshiped images of creatures.[33] The defenders of icons cleverly managed to accuse the *iconoclasts* of putting representations of birds and beasts into their churches, while they, the orthodox supporters of images, had cleansed their own places of worship of such images, portraying there only the anthropomorphic icons of the saints. As John of Damascus expressed it in the eighth century, "Is it not far more worthy to adorn all the walls of the Lord's house with the forms and images of the saints rather than with beasts and trees?"[34] The fact that depictions of animals seem to have been avoided in the context of icons of the Virgin certainly suggests that they never entirely lost their negative associations with pagan idolatry. Only in the twelfth century do we find some loosening of the taboos, as exemplified by the icon of the Annunciation at Sinai.

The Late Period

In the period between the fall of Constantinople to the Latins in 1204 and the final fall of the city to the Turks in 1453, we find a continuing disjunction between Byzantine literature and art. In the hymns and sermons the same metaphors addressed to the Virgin were repeated. Thus, in a thirteenth-century poem by Theodore Laskaris, she appears as a star, a bright light, the fount of the perennial stream, the sweet-smelling meadow, the flower, and the swallow, welcome harbinger of spring.[35] In a fourteenth-century sermon on the Annunciation by Isidore of Thessalonica we find another ekphraseis of the spring, with all of the usual images, including the flocks skipping and leaping in the fields and the nestlings spreading their wings.[36] Once again, these embellishments contrast with the relative restraint displayed by artists. While horticultural imagery does appear in some contexts, especially the infancy of the Virgin, portrayals of animals continued to be rare. The experiment of the late twelfth-century icon of the Annunciation from Sinai had no successors in the period after the Latin conquest.

In the Late Byzantine period, the most striking example of the invocation of nature in praise of the Virgin occurs in the early fourteenth-century mosaics of the Kariye Camii in Constantinople. Here both plant and, unusually, animal motifs were deployed in her celebration. In the inner narthex of the church, the bays that are devoted exclusively to scenes from the infancy of the Virgin have an exceptionally rich decoration. In these bays, garlands of leaves silhouetted against a white ground cover the undersides of the wall arches that frame the

[33]Mansi, Sacrorum conciliorum nova collectio, vol. XIII, col. 285.

[34]*De imaginibus oratio I*, ed. Migne, Patrologia Graeca XCIV, col. 1252.

[35]S. Eustratiades, *Theotokarion*, vol. 1, Chennevières-sur-Marne, 1931, 39–42.

[36]*Homilia III, In Annuntiationem*, ed. Migne, Patrologia Graeca CXXXIX, cols. 112–113.

vaults and the lunettes containing the narrative episodes from the early life of Mary (plate V). In addition, medallions filled with plant motifs, also silhouetted against white, occupy the centers of two of the arches that separate these bays.[37] By contrast, the framing arches of the outer narthex contain medallions with portraits of saints set against a gold ground (plate X).[38] And here, in the outer narthex, we may observe a further distinction. The arches in the two northern bays are associated with scenes from the early life of Christ, including the Journey to Bethlehem, the Enrollment of Joseph and Mary for Taxation, the Nativity, John the Baptist bearing Witness to Christ, and the Return of the Holy Family from Egypt. In these northern bays of the outer narthex, on all but one of the wall arches, the portrait medallions are set between sprays of leaves (plate X).[39] On the south side of the outer narthex, however, the arches frame scenes from the Massacre of the Innocents, beginning with the Magi before Herod and proceeding to the slaughter itself, followed by a poignant depiction of the Mothers Mourning their Dead Children and then the Flight of Elizabeth and John from a menacing soldier (plate XI). Here the framing wall arches contain no vegetal decoration whatsoever; the medallions with the saints are set starkly against a plain gold ground.[40] The series of mosaics relating the Massacre of the Innocents concludes with the Return of the Holy Family from Egypt.[41] As we have seen, this final scene is placed on the north side of the outer narthex, where it serves as a prelude to the mosaic of John the Baptist bearing Witness, portrayed in the vault above.[42] It is noteworthy that the arch that frames the lunette containing the last of the scenes connected with the Massacre is the one wall arch on the north side that has no decoration of leaves; in this case, as on the wall arches framing the mosaics of the Massacre on the south side of the narthex, the saints' portraits appear against a simple gold ground.[43]

It is evident, then, that logic governed the deployment of vegetal motifs in the mosaics of the Kariye Camii. The richest decoration was reserved for the scene of the infancy of the Virgin, in the inner narthex, where the garlands were silhouetted against a conspicuous white ground (plate V). The use of white in this context may not have been accidental, for, as will be shown later in this chapter, a white background was associated in Byzantine art with depictions of paradise (figure 3-5). A somewhat less rich decoration of foliage accompanied

[37]P. A. Underwood, *The Kariye Djami*, vol. 2, London, 1967, plates 14–15, 108–109, 114, 119–121, 131, 138.
[38]Ibid., plates 10–11.
[39]Ibid., plates 159, 166, 216.
[40]Ibid., plates 173, 194, 197.
[41]Ibid., plate 200.
[42]Ibid., plate 216.
[43]Ibid., plates 200, 216.

the majority of the scenes from the life of Christ portrayed in the outer narthex. Here the framing arches depicted saints in medallions against a gold ground with leaves between the roundels (plate X). However, in those arches that framed the mosaics of the Massacre of the Innocents, the vegetal motifs were completely excluded, leaving only barren gold behind the icons (plate XI). In addition to this hierarchy of vegetation, from its profusion around the infancy of the Virgin to its total absence around the Massacre of the Innocents, prominent depictions of birds accompany the scenes from the Virgin's childhood, a rarity in monumental art. A large pair of peacocks flanks the Caressing of the Virgin by her parents (plate V), and a couple of pheasants frame her Presentation in the temple.[44] It is tempting to connect the exceptional appearance of these adornments with the sophisticated literary tastes of the patron of the mosaics, Theodore Metochites, who wrote a poem describing the beauties of his own garden in Constantinople while he was in exile.[45]

The creation of a hierarchy of spaces by means of ornament can also be seen in the contemporary mosaics of another building in Constantinople, the Fetiye Camii, originally the church of the monastery of St. Mary Pammakaristos. In this building there is a clear distinction between the mosaics of the central dome and the sanctuary, which have unbroken gold grounds, and those in the prothesis, diakonikon, and corner bays of the nave, which display a rich ornament of plants. The dome is occupied by a bust of Christ, at the center, surrounded by his prophets in the gores.[46] Christ appears again in the apse of the sanctuary, where he is enthroned and flanked by the Virgin and St. John the Baptist on the side walls, with the four archangels depicted on the cross vault above (plate XII).[47] The background behind all of these figures is an unbroken expanse of gold. The vaults over the prothesis and the diakonikon, on either side of the sanctuary, display crosses framed by various foliate designs, either executed in gold or green against a white ground or in white against a gold ground (plate XIII).[48] In the vaults of the three corner bays of the nave that still preserve their mosaics, we find plants springing from the corners to frame central medallions containing portraits of two holy bishops (St. Ignatios Theophoros and St. Gregory of Armenia) and an abbot (St. Anthony).[49] In each of these nave bays the plants are silhouetted against white tesserae (plate XIII). As

[44]Ibid., plates 114, 117–118, 120, 125.

[45]C. N. Constantinides, "Byzantine Gardens and Horticulture in the Late Byzantine Period, 1204–1453: the Secular Sources," in A. Littlewood, H. Maguire, and J. Wolschke-Bulmahn, eds., *Byzantine Garden Culture*, Washington, DC, 2002, 87–103, esp. 97–99.

[46]H. Belting, C. Mango, and D. Mouriki, *The Mosaics and Frescoes of St. Mary Pammakaristos (Fethiye Camii) at Istanbul*, Washington, DC, 1978, fig. 27.

[47]Ibid., fig. 4.

[48]Ibid., figs. 10, 60–61.

[49]Ibid., figs. 10–11, 54, 56, 58.

in the Kariye Camii, then, the artists of the Fetiye Camii used plant ornament to distinguish between levels of content, but in a different way. In the Kariye Camii an absence of vegetation signified scenes that portrayed violence and evil, while its presence celebrated the Virgin. At the Fetiye Camii, on the other hand, the most sacred figures, in the dome and sanctuary, were deprived of terrestrial vegetation, while the more earthbound saints were framed by flourishing growths. As so often in Byzantine art, the symbolism of plants and animals is not absolute, but relative, and varies according to context.

The most striking examples of artistic poverty in face of the luxuriant nature-derived metaphors of the texts come in the cycles of the *Akathistos*, which was frequently illustrated in the fourteenth and fifteenth centuries, in both churches and manuscripts.[50] In paintings of the *Akathistos* the rich animal and even horticultural imagery of the poem is generally ignored. In the first, or "historical," section of the hymn, the artists usually illustrated the underlying

FIGURE 3.3. Marko, Church of St. Demetrius, fresco. Akathistos, stanza 4.

[50]I. Spatharakis, *The Pictorial Cycles of the Akathistos Hymn for the Virgin*, Leiden, 2005. See p. 5 on the supposed relationship between the twelfth-century icon of the Annunciation at Mount Sinai and the *Akathistos*.

Gospel episode for each stanza, following the traditional iconography for each scene. In the second, or "theological," section, they showed groups of people, or angels, venerating the Virgin or Christ. For the most part, these illustrations are rigorously anthropomorphic, with very little attention paid to the nature imagery of the poem. For example, the fourth strophe declares, "Then the power of the All-highest overshadowed her, planning the conception of one without experience of marriage; and she showed forth her fruitful womb as a sweet field for all who would harvest salvation. . . ."[51] Several of the cycles, such as the paintings in the Church of St. Demetrius at Marko, depict these words by showing the Virgin seated on a throne with two maidens behind her holding a large veil (figure 3-3).[52] Thus, the metaphor in the text, which evokes the fecundity of nature, is replaced by the inorganic image of the veil.[53] Only one of the metaphors in the stanzas of the *Akathistos* consistently receives a direct illustration in the visual cycles, and this also is inorganic. Strophe twenty-one begins, "We see the holy Virgin as a lamp full of light, shining to those in darkness."[54] Accordingly, in the fresco at Marko, and elsewhere she is portrayed with a column of flame rising from her head.[55] In sum, the twelfth-century flirtation with illustrating the literary celebration of nature in icons of the Virgin was decisively rejected in the late medieval paintings of the *Akathistos Hymn*.

Paradise

The distinction between verbal and visual metaphor in Byzantium is strikingly apparent in the contrast between portrayals of paradise in writing and in art. In posticonoclastic Byzantine literature, paradise was a place occupying an ambiguous space between metaphor and reality.[56] Some medieval writers, such as

[51]Peltomaa, *Image of the Virgin Mary*, 6–7; translation by Trypanis, *Penguin Book of Greek Verse*, 376–377.

[52]Spatharakis, *Pictorial Cycles of the Akathistos*, 131, fig. 115.

[53]On the image of the veil, see Papastavrou, "Le voile, symbole de l'Incarnation, contribution à une étude sémantique," *Cahiers archéologiques* 41 (1993), 141–168; Papastavrou, *Recherche iconographique*, 323–326.

[54]Peltomaa, *Image of the Virgin Mary*, 16–17; translation by Trypanis, *Penguin Book of Greek Verse*, 387.

[55]Spatharakis, *Pictorial Cycles of the Akathistos*, 150–151, fig. 131. See also the frescoes at Roustika and at St. Phanourios at Valsamonero, Crete, and at Cozia, Valachia, and the miniatures of Moscow, Historical Museum, MS. Synodal Gr. 429, fol. 29v., Escorial, MS. R.I. 19, fol. 24v., Moscow Historical Museum MS. Muz. 2752 (Tomič Psalter), fol. 294; ibid., figs. 21, 57, 145, 169, 190, 212.

[56]For general treatments of the topic, see A. Wenger, "Ciel ou Paradis," *Byzantinische Zeitschrift* 44 (1951), 560–569; E. Patlagean, "Byzance et son autre monde: Observations sur quelques récits," in *Faire croire*, Collection de l'École Française de Rome LI, Rome, 1981, 201–221; A. Kazhdan, ed., *Oxford Dictionary of Byzantium*, vol. 3, Oxford, 1991, 1582–1583; Maguire, "Paradise Withdrawn," in Littlewood et al., *Byzantine Garden Culture*, 23–35, esp. 26–28; J. Baun, *Tales from Another Byzantium: Celestial Journey and Local Community in the Medieval Greek Apocrypha*, New York, 2007.

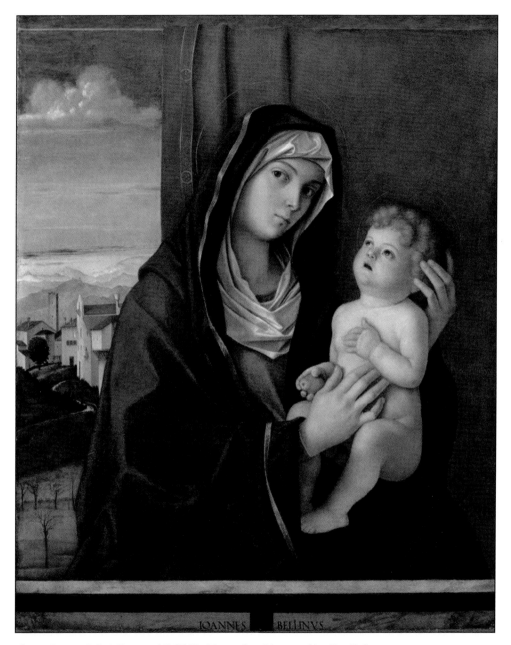

Plate I. Govanni Bellini, Virgin and Child. The Metropolitan Museum of Art, New York.

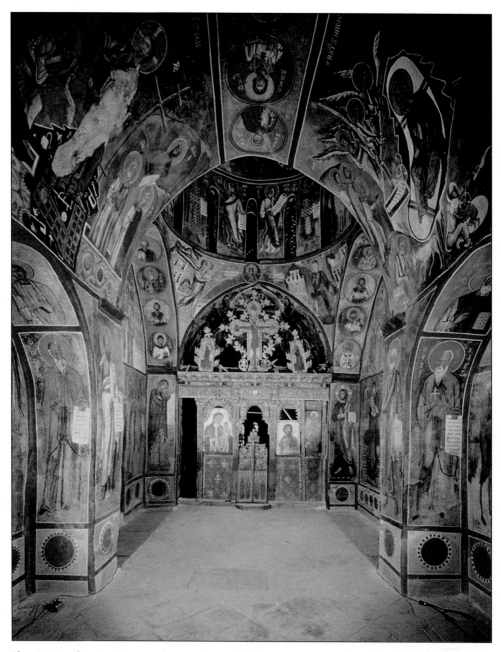
Plate II. Lagoudera, Panagia tou Arakos, view looking east, frescoes.

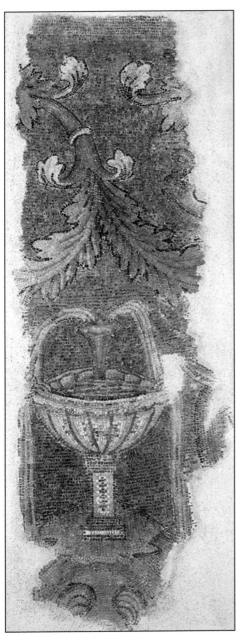

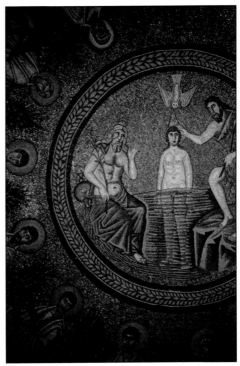

Plate IV. Ravenna, Arian Baptistery, dome mosaic.
Baptism with the river Jordan.

Plate III. Thessaloniki, Church of the Acheiropoietos,
wall mosaic. Fountain and plants.

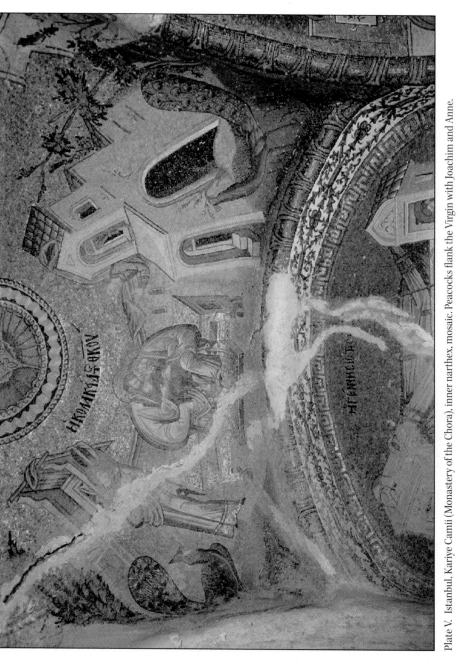

Plate V. Istanbul. Kariye Camii (Monastery of the Chora), inner narthex, mosaic. Peacocks flank the Virgin with Joachim and Anne.

Plate VI. Budapest, Hungarian National Museum, gold and enamel crown. Constantine IX Monomachos, Zoe, and Theodora.

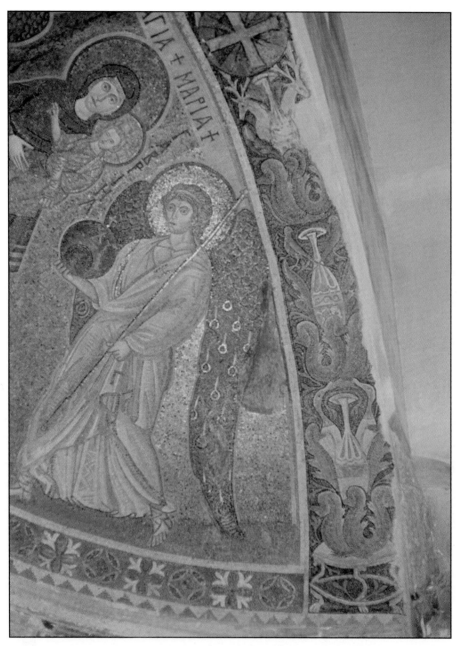

Plate VII. Kiti, Panagia Angeloktistos, apse mosaic. Border with fountains and animals.

Plate VIII. Poreč Cathedral of Eufrasius, wall mosaics in the main apse. Real and fictive shells.

Plate IX. New York, The Metropolitan Museum of Art, enameled revetments from an icon of the Virgin.

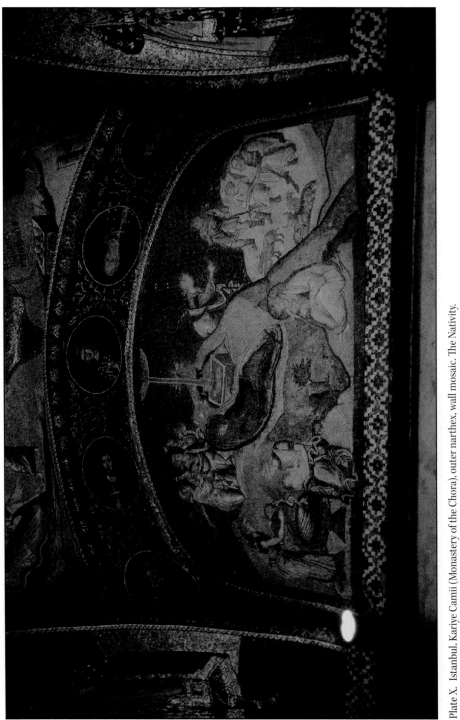

Plate X. Istanbul, Kariye Camii (Monastery of the Chora), outer narthex, wall mosaic. The Nativity.

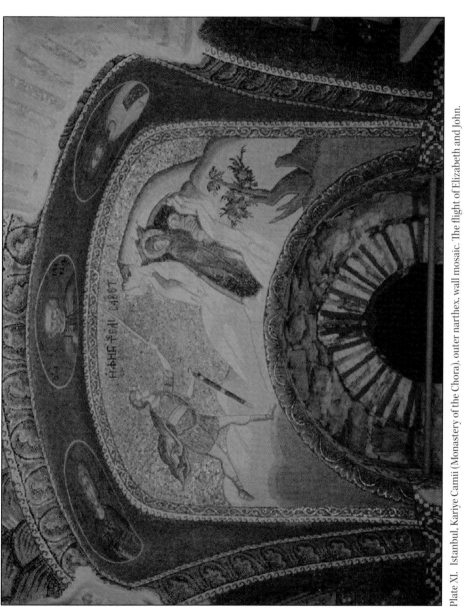

Plate XI. Istanbul. Kariye Camii (Monastery of the Chora), outer narthex. wall mosaic. The flight of Elizabeth and John.

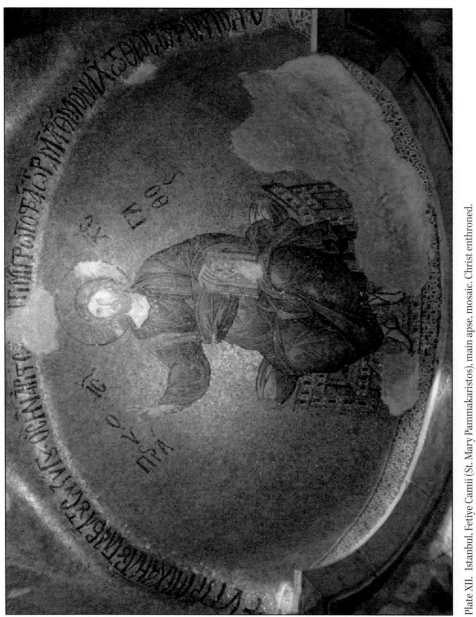

Plate XII. Istanbul, Fetiye Camii (St. Mary Pammakaristos), main apse, mosaic. Christ enthroned.

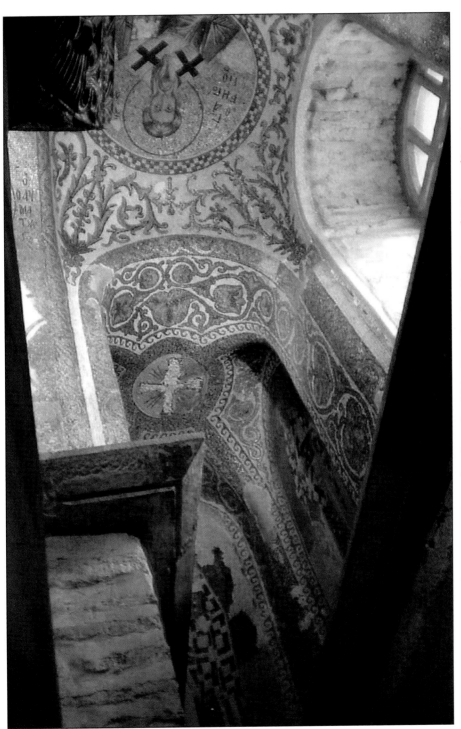

Plate XIII. Istanbul, Fetiye Camii (St. Mary Pammakaristos), vault mosaics of diakonikon and south-east bay. Cross and St. Gregory of Armenia.

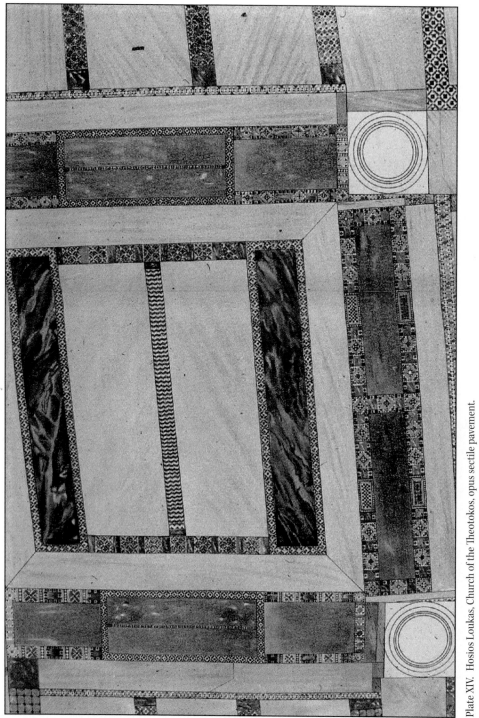

Plate XIV. Hosios Loukas, Church of the Theotokos, opus sectile pavement.

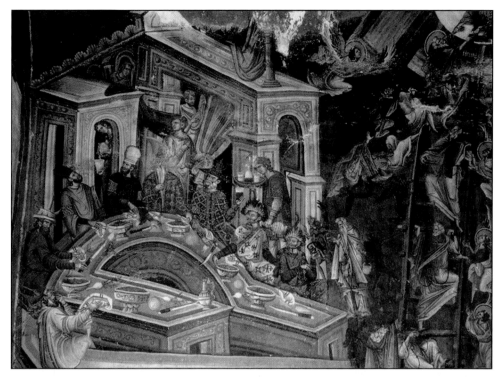

Plate XV. Mount Athos, Vatopedi Monastery, Katholikon, fresco in outer narthex. Gluttony.

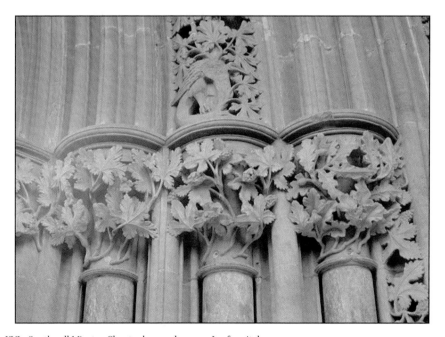

Plate XVI. Southwell Minster, Chapter house, doorway. Leaf capitals.

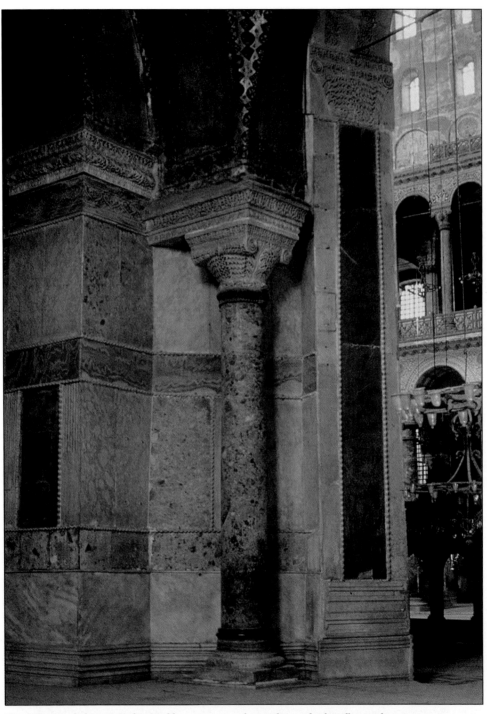

Plate XVII. Istanbul, Hagia Sophia. Marble revetments with partial view of aisle, gallery, and tympanum.

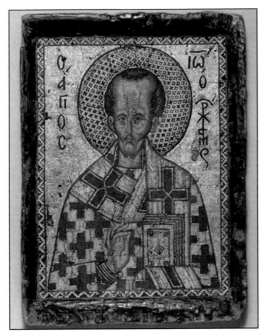

Plate XVIII. Washington, D.C.,
Dumbarton Oaks, miniature mosaic icon.
St. John Chrysostom.

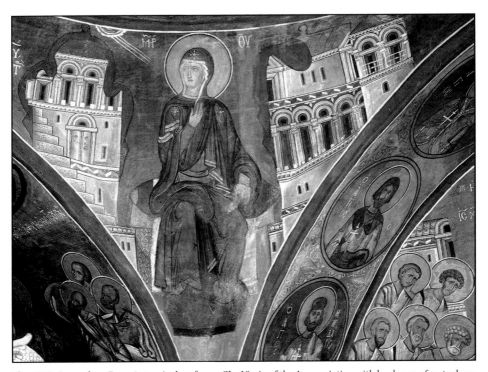

Plate XIX. Lagoudera, Panagia tou Arakos, fresco. The Virgin of the Annunciation with her house of metaphors.

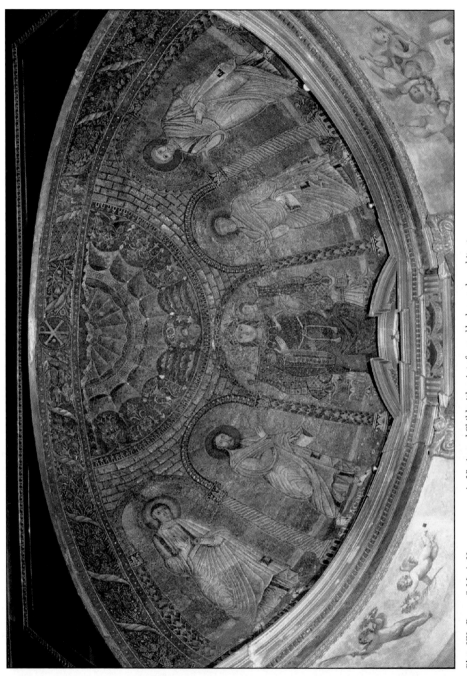

Plate XX. Rome, S. Maria Nova, apse mosaic. Virgin and Child with saints framed by heavenly architecture.

the eleventh-century theologian Niketas Stethatos, opined that paradise was to be understood only in spiritual terms and allegorized its plants and fruits.[57] Another group of authors, however, saw paradise as a real place, with a physical topography. Among this group, a few, such as Constantine Manasses and St. Neophytos in the twelfth century, followed the old tradition of the *Hexaemeron* commentaries, describing the source of the four rivers in the garden and their continuations in the inhabited world.[58] Others saw paradise as a real but more distant place, without the connecting rivers and cut off from the inhabitants of our world by terrible lakes or rivers of fire.[59] In each case, however, medieval Byzantine writers represented paradise in rich and colorful terms, as a place abounding with marvelous trees and fruits and often animal life as well.[60] Thus, in the Life of Philaretos the Merciful, composed at the beginning of the ninth century, we read how Nicetas, the grandson of Philaretos, saw a vision of paradise. The boy described the place as a marvelous garden, planted with huge pomegranate trees bearing fruits the size of giant punch bowls, vines hung with grapes the size of men, and trees with nuts the size of barrels.[61] A similar conception of paradise can be found in the Apocalypse of Anastasia, a visionary account of a nun's visit to the world beyond, which may have been composed at the end of the tenth or beginning of the eleventh century.[62] Here the righteous, including the Good Thief, enjoy a garden containing olives, vines with ripe grapes, and fruiting trees.

The Life of Andrew the Fool, composed in the tenth century, contains an especially detailed account of paradise. According to this text, the saint went to sleep and found himself in a wonderful garden. At first, he was puzzled: "I used to live in Constantinople," he mused. "What I am doing here I do not

[57]J. Darrouzès, ed. and trans., *Opuscules et lettres par Nicétas Stéthatos*, Paris, 1961, 154–291. On the question of the extent to which medieval descriptions of the Other World were intended to be allegorical, see Baun, *Tales from Another Byzantium*, 142–144.

[58]Constantine Manasses, *Breviarium chronicum*, lines 181–230; ed. O Lampsidis, *Constantini Manassis Breviarium chronicum*, Corpus Fontium Historiae Byzantinae XXXVI, Athens, 1996, 14–16; translation in I. Nilsson, "Narrating Images in Byzantine Literature: The Ekphraseis of Konstantinos Manasses," *Jahrbuch der Österreichischen Byzantinistik* 55 (2005), 144–145. Neophytos, *Homilia VII*; ed. I. Ch. Chatziioannou, *Historia kai erga Neophytou presbyterou monachou kai enkleistou*, Alexandria, 1914, 180.

[59]See, for example, *Life of Makarios*, ed. A. Vassiliev, *Anecdota graeco-byzantina*, Moscow, 1893, 135–165; the *Life of Philaretos the Merciful*, ed. M. H. Fourmy and M. Leroy, "La vie de S. Philarète," *Byzantion* 9 (1934), 85–170, esp. 161–165; the *Apocalypse of Anastasia*, ed. R. Homburg, *Apocalypsis Anastasiae*, Leipzig, 1903, 11–23.

[60]H. G. Saradi, "Space in Byzantine Thought," in S. Ćurčić and E. Hadjitryphonos, eds., *Architecture as Icon: Perception and Representation of Architecture in Byzantine Art* (exhibition catalogue, Princeton University Art Museum), Princeton, 2010, 73–111, esp. 92–95.

[61]Fourmy and Leroy, ed., "La vie de S. Philarète," 161–165.

[62]Homburg, ed., *Apocalypsis Anastasiae*, 22; translation in Baun, *Tales from Another Byzantium*, 409. On the date, see Patlagean, "Byzance et son autre monde," 202; Baun, *Tales from Another Byzantium*, 17–18.

know." Then he pulled himself together and noticed that he was in a disembodied state, wearing a golden wreath woven of all kinds of flowers and a dazzling snow-white garment set with precious stones. The garden was glowing with an indescribable light, shimmering with the color of roses. Looking around him, Andrew also saw:

> Evergreen trees . . . dripping with honey, with lofty and pleasant foliage, with branches bowing down and rising in waves against each other, bringing pleasure and offering a sight like the crystal of heaven, trees for the blessed to enjoy. . . . To some had been given everlasting and never-fading flowers, to others only leaves; some had been ordained by God to be adorned with fruit. . . . A great wonder of the trees was that there were birds in them, sparrows, cicadas and other beautiful kinds, species after species, with wings like gold or snow Their beauty was as strange and lofty, as it were, as that of roses or lilies or any other kind of flower. . . [63]

In the eleventh century, the courtier Michael Psellos described a similar vision of paradise, which was received by his daughter, Styliane, as she was dying. In the funerary speech that he composed for his child, Psellos says that she saw "a garden shaded by trees, hanging with fruit, abundantly planted with all the other varieties of flora and exceedingly delightful. Nor was any species of rose, or lily, or any other fragrant flower missing."[64] When the sister of Psellos died, her brother asked, "What meadows, what graces, what kind of paradise enchant you . . . what kind of flower pulls you away, what beds of roses, what bubbling stream, what nightingales, what cicadas emitting a sweet sound?"[65] In the twelfth century, the account of the earthly paradise by Constantine Manasses evoked the fragrance of its plants, the abundance of its fruits, the brilliant colors of its flowers, the iridescence of its grass, and the wafting of its breezes.[66]

These verbal descriptions of paradise, with their vividly colorful birds and plants, had few counterparts in Byzantine monumental art. It is only in smaller objects, such as ivories and manuscript illuminations, that we encounter visual equivalents to the variety, inventiveness, and splendor of the textual evocations. For example, on the reverse of the Harbaville Triptych, a tenth-century ivory carving now in the Louvre, the cross flowers as the Tree of Life in paradise,

[63]L. Rydén, ed. and trans., *The Life of St. Andrew the Fool*, vol. 2, Uppsala, 1995, 46–49.

[64]K. Sathas, ed., *Mesaionike bibliotheke*, vol. 5, Paris, 1876, 83; cited by A.-M. Talbot, "The Death and Commemoration of Byzantine Children," in A. Papaconstantinou and A.-M. Talbot, eds., *Becoming Byzantine: Children and Childhood in Byzantium*, Washington, DC, 2009, 283–308, esp. 308.

[65]Sathas, ed., *Mesaionike bibliotheke*, 30, cited by Talbot, "The Death and Commemoration of Byzantine Children," 307.

[66]Constantine Manasses, *Breviarium chronicum*, lines 181–215; ed. Lampsidis, *Constantini Manassis Breviarium chronicum*, 14–15; translation in Nilsson, "Narrating Images in Byzantine Literature: The Ekphraseis of Konstantinos Manasses," 144.

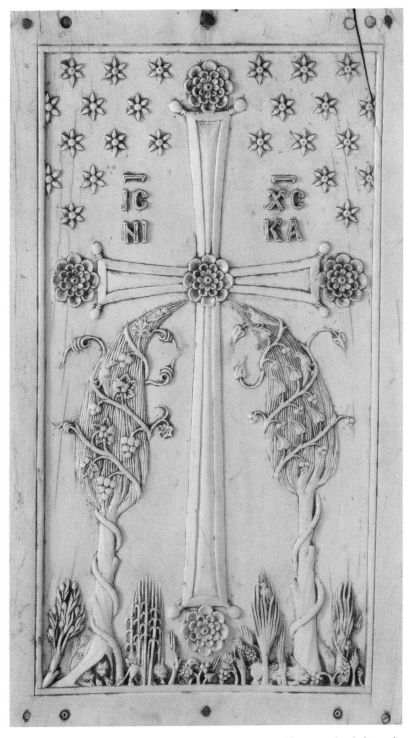

FIGURE 3.4. Paris, Musée du Louvre, ivory triptych (Harbaville Triptych), reverse, detail of central panel. Cross as Tree of Life in paradise.

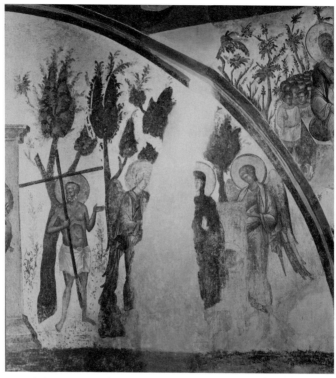

FIGURE 3.5. Istanbul, Kariye Camii (Monastery of the Chora), parekklesion, fresco. Paradise from the Last Judgment.

which is represented as a garden containing both plants and animals (figure 3-4).[67] The dominant features are two large cypress trees, which are entwined by two different species of fruiting vine. In the shade of the cypresses smaller trees grow, one bearing fruit, another a bird. On the ground we can distinguish various beasts at peace with one another, including a rabbit or hare and a pair of diminutive lions. But this richly furnished paradise is a rarity in Byzantine art. More often the emphasis is on the sacred inhabitants of that blessed place rather than on its extraordinary flora and fauna, as can be seen in the many depictions of paradise included in Last Judgment scenes. In most Byzantine portrayals of the Last Judgment, paradise appears as a small enclosure in the lower left-hand corner of the composition; usually it is given considerably less space than the torments of hell. Inside paradise we find the Virgin, the Good Thief carrying his cross on his shoulders, Abraham with the soul of Lazarus

[67]*Byzance* (exhibition catalogue, Musée du Louvre), Paris, 1992, 233–236, no. 149; Evans and Wixom, *Glory of Byzantium*, 133–134, no. 80.

in his bosom, and the souls of the saved crowding around him. Plant life is restricted to glimpses of a few schematically rendered trees behind the figures and to a few plants with stylized flowers growing at their feet. In some cases a white background indicates the unchanging climate of paradise, which does not suffer the changes of the seasons. Even at the Kariye Camii the vegetation appears sparse. In the frescoes of the parekklesion, the funerary chapel attached to the main church, there is a large painting of the Last Judgment on the vault and walls in front of the apse. At the lower left corner of this composition, we see a depiction of paradise, which, according to the usual iconography, contains the Virgin enthroned, the good Thief with his cross, and, at the upper right, Abraham surrounded by a throng of child-like souls (figure 3-5).[68] In this representation of paradise the people have more prominence than the plants. There are a few spindly shrubs growing in the foreground and some disheveled trees in the background, but there are no colorful fruits, no blossoms, and no colorful birds.

In some medieval Byzantine works of art, paradise was indicated in a more abstract way. In a twelfth-century panel painting of the Last Judgment in the monastery at Mount Sinai, for example, the garden is simply suggested by the slender scrolling stem of a plant, which is traced over the white background behind the figures of the Virgin, the thief, and Abraham.[69] In other works of art paradise was portrayed in a still more schematic fashion, as a lattice of diamond shapes enclosing leaves. As we saw in chapter 1, this pattern suggests either a fence, through which a garden is seen, or else a trellis supporting a

FIGURE 3.6. Mount Sinai, Monastery of St. Catherine, church. Capital with paradisal lattice.

[68]Underwood, *Kariye Djami*, vol. 3, plates 394, 396, 404–407.
[69]G. Soteriou and M. Soteriou, *Eikones tes Mones Sina*, Athens, 1956, fig. 151.

climbing plant. The design already appears as an abstract representation of paradise on the sixth-century granite capitals in the church of the monastery at Mount Sinai (figure 3-6).[70] Here the lattice encloses trefoil-shaped leaves with pointed tips and fruits such as pomegranates and bunches of grapes, together with crosses. A more stripped-down version of the design appears in the apse mosaics of Hagia Eirene in Constantinople, which date shortly after 753 (figure 1-22). In this church two bands of golden diamonds run around the inner arch of the apse. In the interstices created by the diamond pattern there are white pointed trefoils arranged in cross-shaped configurations against a predominantly deep-blue ground.[71] This golden leaf-filled lattice can be read as a highly abstract portrayal of the garden of paradise, suitable for inclusion in a church decorated by iconoclasts. A related design of diamonds appears in the late tenth- or early eleventh-century paintings of a cave church in Cappadocia, the Bahattin samanlığı kilisesi at Belisırma, where it fills a band running along the apex of the barrel vault over the nave. In this instance, garlands of laurel leaves create the diamonds, which frame stars and crosses against a white ground. As has been argued by Catherine Jolivet-Lévy, the pattern of leaves and diamonds, at the top of the vault, evokes the baldachin, or canopy, of heaven.[72]

In conclusion, whether paradise was seen as an allegory or as a real place, Byzantine artists after iconoclasm still showed a reluctance to fully illustrate its animals and plants. While writers exercised their imaginations in recounting the varied wonders of its garden, painters for the most part restricted themselves to depictions that were relatively spare and formulaic. The hesitations about the portrayal of nature in churches applied as much to the paradisal fauna and flora as to the terrestrial.

Byzantium and the West

Ever since the iconoclastic period, Western artists had been incorporating nature-derived imagery into their churches to a much greater extent than the Byzantines. Often the motifs from nature were prominently displayed at focal points, such as the principal apses of churches, and frequently in direct imitation

[70]G. H. Forsyth and K. Weitzmann, *The Monastery of Saint Catherine at Mount Sinai: The Church and Fortress of Justinian*, Ann Arbor, MI, 1965, plates 63C, 64B; E. Maguire, "The Capitals and Other Granite Carvings at Justinian's Church on Mount Sinai," Ph.D. dissertation, Harvard University, Cambridge, MA, 1986, 79–131.

[71]W. S. George, *The Church of Saint Eirene at Constantinople*, Oxford, 1912, plates 17–18. Another lattice framing trefoil leaves decorates the arches and columns of the tenth-century ceramic iconostasis from the palace at Preslav; A. Djourova and G. Guerov, *Les trésors des icônes bulgares* (exhibition catalogue, Château de Vincennes), Paris, 2009, 20–21, no. 10.

[72]C. Jolivet-Lévy, "The Bahattin samanlığı kilisesi at Belisırma (Cappadocia) Revisited," in C. Hourihane, ed., *Byzantine Art: Recent Studies*, Princeton, NJ, 2009, 81–110, esp. 86–89.

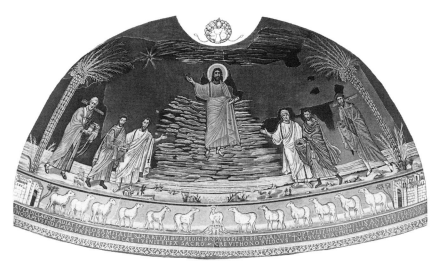

FIGURE 3.7. Rome, SS. Cosma e Damiano, apse mosaic.

of early Christian models. The wall and vault mosaics in the churches of Rome provide an interesting case study of Western attitudes toward the depiction of nature. During the fifth and sixth centuries, Roman apses were filled with rich displays of nature-derived motifs. We may take as an example the mosaic in the church of Santi Cosma e Damiano, which Pope Felix IV commissioned between 526 and 530 (figure 3-7).[73] Here the central group of Christ, saints, and the papal donor is flanked by two palm trees, the one on the left bearing a phoenix. The figures stand on a bright-green ground, behind which runs a wide, blue river, identified by an inscription as the Jordan, flowing with rippling currents across the bottom of the scene. The grassy bank is sprinkled with plants growing from rocky outcrops. Lower down is a wide band containing twelve sheep converging on the central lamb, which stands on a hill from which flow the four streams of paradise.

After the eighth century, the decoration of Roman churches diverged from Byzantine practice. We have seen that in the East the lamb was rarely portrayed, in accordance with the decree of the Quinisext Council. But in Rome sheep and other nature-derived motifs continued to feature prominently in apses, such as the mosaic commissioned by Pope Gregory IV between 827 and 844 in the Church of San Marco, which portrays Christ flanked by five saints and the donor (figure 3-8).[74] Now the band at the bottom containing the twelve

[73]G. Matthiae, *Mosaici medioevali delle chiese di Roma*, Rome, 1967, 135–142, figs. 78, 80–85; B. Brenk, *The Apse, the Image and the Icon*, Wiesbaden, 2010, 92–93, figs. 98–99.
[74]Matthiae, *Mosaici medioevali*, 243–244, 261–264, figs. 215, 217–224, 266–267.

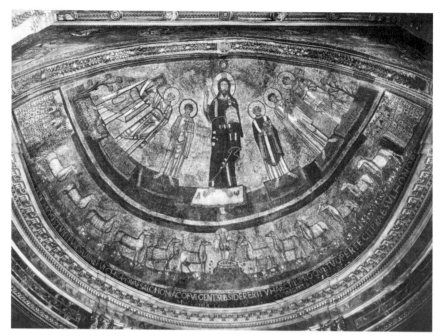

FIGURE 3.8. Rome, San Marco, apse mosaic.

sheep flanking the lamb was given even greater prominence than before. At San Marco the flock takes up fully a third of the total height of the composition. The plant decoration around this apse is also particularly rich. The sheep stand in a meadow blooming with lilies and roses, while a wreath containing fruits and flowers adorns the arch that frames the apse on its west side. Finally, between Christ and the lamb, a dove can be seen perching on a brimming fountain.[75]

Nature plays a still more prominent role in the apses of twelfth-century Roman churches. At San Clemente, a central image of the Crucifixion is surrounded by a luxuriant scrolling plant inhabited by a variety of flowers, birds, including peacocks and pheasants, beasts, such as stags, reptiles, and even insects, together with winged putti riding on dolphins (figure 3-9).[76] An inscription beneath the mosaic refers to the plant as a vine and likens it to the Church of Christ.[77] This careful explanation of the meaning of the symbol may betray a certain apprehension on the part of the designers that the images might be misinterpreted in view of their potentially profane content. Finally, there is the

[75]Ibid., fig. 223.

[76]Matthiae, *Mosaici medioevali*, 279–304, figs. 228, 230–259; M. Andaloro and S. Romano, "L'immagine nell'abside," in M. Andaloro and S. Romano, eds., *Arte e iconografia a Roma da Costantino a Cola di Rienzo*, Milan, 2000, 93–132, esp. 108–110, fig. 60.

[77]Matthiae, *Mosaici medioevali*, 283–284, 303, note 15.

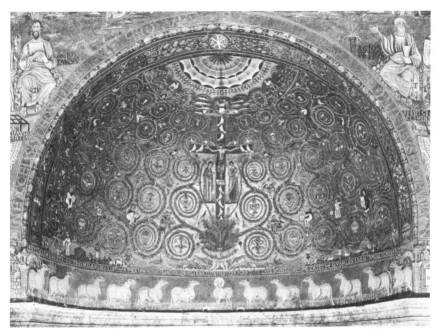

FIGURE 3.9. Rome, San Clemente, apse mosaic.

thirteenth-century apse of Santa Maria Maggiore with its mosaic executed by
Giacomo Torriti. Here we see the Coronation of the Virgin flanked by a plant
scroll containing different birds and taking place above a river represented
both as a personification, in the antique manner, and as a stream teeming with
Nilotic motifs (figure 3-10).[78] The latter are reminiscent of the river beneath
the Annunciation icon at Mount Sinai (figure 2-5). In both the icon and the
Roman mosaic we find the jagged bank and a variety of creatures including
fish and waterfowl. One can see how such Western apses could have inspired
the complaints found in the twelfth- and thirteenth-century lists of the errors of
the Latins. Their Greek authors accused the Latins of not depicting the images
of saints but only the Crucifixion.[79] In the eyes of an orthodox Byzantine, such
as Stephen the Deacon, the swirling plant scrolls enclosing birds would have

[78]Ibid., 355–366; figs. 293–301. The extent to which the mosaic reproduced an original fifth-century
mosaic in the apse has been disputed. See Andaloro and Romano, "L'immagine nell'abside," 120–124,
figs. 70, 72; S. Sande, "Egyptian and Other Elements in the Fifth-Century Mosaics of S. Maria Mag-
giore," *Acta ad archaeologiam et artium historiam pertinentia* 21 (2008), 65–94, esp. 65–76; Brenk, *Apse,
Image and Icon*, 22–23, 75, fig. 10.

[79]J. Darrouzès, "Le mémoire de Constantin Stilbès contre les Latins," *Revue des études byzantines* 21
(1963), 72. *Opusculum contra Francos* 8; ed. J. Hergenroether, *Monumenta graeca ad Photium eiusque
historiam pertinentia*, Rattisbon, 1869, 65. On these texts see T. M. Kolbaba, *The Byzantine Lists: Errors
of the Latins*, Urbana, 2000.

FIGURE 3.10. Rome, Santa Maria Maggiore, apse mosaic.

left the apses "altogether unadorned."[80] From the Byzantine perspective, these Roman apses, with their celebration of the created world in the most prominent part of the church, would have been sorely deficient as icons.

It was not only in Rome that the early Christian repertoire of plants and animals continued to be an important element in the decoration of Western churches. In the Cathedral of Torcello, for example, the artists who decorated the southeastern side- chapel during the late eleventh or early twelfth century made a reduced copy of the mosaic in the sanctuary vault at San Vitale in Ravenna (figures Intro-2 and 3-11).[81] Because the vault at Torcello is rectangular, rather than square as at San Vitale, the medieval mosaicists had to truncate the original composition on its east and west sides, thus cutting off the feet of two of the angels supporting the lamb. In other respects, however, the medieval mosaic was faithful to the sixth-century original, including the peacocks with spread tails standing on globes at the four corners of the vault and the acanthus scrolls containing a variety of beasts and birds in the four segments. The mosaic at Torcello demonstrates that not only did the imagery of animals and plants continue to flourish in Western churches, but also in some places the old preiconoclastic compositions carried such prestige that they were faithfully repeated.

[80]M.-F. Auzépy, ed., *La Vie d'Étienne le Jeune par Étienne le Diacre*, Aldershot, 1997, 126–127, 221–222; translation in Mango, *The Art of the Byzantine Empire*, 153.

[81]C. Rizzardi, "La basilica di Santa Maria Assunta di Torcello fra Ravenna e Bisanzio: note sui mosaici dell'abside destra," in G. Trovabene, ed., *Florilegium artium: Scritti in memoria di Renato Polacco*, Padua, 2006, 153–160, esp. 157, with earlier bibliography.

FIGURE 3.11. Torcello Cathedral, south-east chapel, vault mosaic.

During the eighth century, therefore, there was a parting of ways between the Christian art of the West and the East with respect to the depiction of nature. The root cause of this division lay in contrasting attitudes toward the sacred image. The differences between the Latin and the Greek churches were apparent already during the period of iconoclasm and can be seen in the *Libri Carolini*, the official Carolingian response to the acts of the Second Council of Nicaea, which discusses the portrayal of nature in art. The basic Byzantine position on sacred icons was that they provided access to Christ and his saints. This key concept had been formulated by the Greek Church Father St. Basil in the fourth century, when he said, "The honor paid to an image passes to its prototype."[82] This idea was constantly reiterated by the Byzantine defenders of icons, from John of Damascus in the eighth century[83] to the author of the Life of Theodora at the end of the ninth.[84] The *Libri Carolini*, on the other hand, took the view that all images, whether Christian or profane, are false, since they

[82]*De Spiritu sancto*, 18; ed. Migne, Patrologia Graeca XXXII, col. 149; translation in Mango, *Art of the Byzantine Empire*, 47.

[83]*De fide Orthodoxa*, 4.16; ed. Migne, Patrologia Graeca XCIV, col. 1158; translation in Mango, *Art of the Byzantine Empire*, 169.

[84]S. A. Paschalides, ed., *O Bios tes osiomyroblytidos Theodoras tes en Thessalonike*, Thessaloniki, 1991, 92; translation in A.-M. Talbot, ed., *Holy Women of Byzantium: Ten Saints' Lives in English Translation*, Washington, DC, 174.

are artists' fictions and not the truth. As examples of images that are untrue and manifestly ridiculous, the *Libri Carolini* described nature personifications, such as the earth depicted in human form as a woman overflowing with fruits or rivers portrayed as men pouring water out of urns or the seasons shown as four different figures with their attributes of flowers for the spring, grain for the summer, grapes for the autumn, and captured birds for the winter. Furthermore, the *Libri Carolini* argued that painters cannot truthfully represent sacred subjects either. The best that they are capable of is "a certain ability to remind one of things that have happened."[85]

The Byzantine position, that sacred icons enable a privileged access to Christ and the saints, left open the possibility that profane images could work in the same way. If the honor paid to the image passed to the prototype, then this could apply as well to profane images as to Christian ones. Indeed, St. Basil originally formulated his famous statement with reference to the respect paid to portraits of the emperor. Thus, the Byzantine position on sacred icons allowed for the possibility of the veneration of images of profane subjects. But the position taken by the *Libri Carolini*, that *all* images are false, did not encourage the veneration of either Christian or profane images, so that, paradoxically, the profane images became less of a threat.

The *Libri Carolini* severed the connection between art and the "truth," that is, the prototype, and made every kind of representation into a metaphor or a symbol, whether it was a portrayal of a personification, a saint, or an animal. Even though the *Libri Carolini* made an uncompromising statement that was not shared by all Western writers, its view of the functioning of art helps to explain why Western artists, unlike their Eastern counterparts, never developed a system of sacred portraiture. As we shall see in the following chapter, in Byzantium from the tenth century onward every major saint had an agreed-upon portrait type, which represented his true image through which he could be venerated by the faithful. In the West, with only a few exceptions such as Saints Peter and Paul, the portrait types of each saint varied, so that their portrayals functioned essentially as symbols or as reminders rather than as authentic likenesses that were thought to be true. In the West, therefore, religious art had a lower status than in the East, in that it did not provide a direct access to the prototype but at the same time had more freedom. There was less danger that the personifications, animals, and plants portrayed in the apses of Roman churches could be interpreted as anything other than symbols or metaphors, and their presence caused less offense, even if the inscription beneath the apse mosaic in San Clemente may testify to some lingering qualms (figure 3-9).

[85]*Opus Caroli regis contra synodum*, 3.23; ed. A. Freeman, *Monumenta Germaniae historica, Concilia*, vol. 2, Supplement 1, Hannover, 1998, 441–447; translation by C. Davis-Weyer, *Early Medieval Art 300–1150: Sources and Documents*, Toronto, 1986, 100–103. On the Libri Carolini and Western responses to it, see H. L. Kessler, *Spiritual Seeing*, Philadelphia, 2000, 119–125, 149–153.

In the West, to a much greater extent than in Byzantium, animals and plants lost much of their potential for idolatrous veneration but became, instead, a language for understanding the divine. In addition to this concept, of image as mere metaphor, symbol, or reminder, another theory of religious art became important in the West, namely, the idea that the natural world was a reflection of the divinity but one that was distant and not direct. The philosopher and theologian Eriugena, who wrote at the court of the Carolingian emperor Charles the Bald in the middle of the ninth century, said that trees and beasts should not be worshipped,[86] but at the same time God makes himself visible in even the lowliest of creatures[87] because God creates himself in the creature.[88] Thus, Eriugena took from the sixth-century writings of the eastern theologian Pseudo-Dionysios the Neoplatonic idea that created things are both a descent from God and a means of ascent to him but at the same time insisted that they were not to be venerated. The terrestrial world provided a reflection of the divine, but not direct access in the manner of Byzantine icons. The continuing importance of Pseudo-Dionysios in the West provided an ideological basis for the unrestricted acceptance of the wealth of nature into religious buildings, most notably in the precious stones of Suger's abbey at St. Denis.[89] Although the next chapter also will show that Pseudo-Dionysios was known and cited in posticonoclastic Byzantium, he was less popular there than in the West.[90] In the East, after iconoclasm, the fear of nature worship continued to haunt the visualization of metaphor, creating a constant tension between acceptance and denial.

In Byzantium, the imagery of nature tended to flourish most abundantly in relatively inconspicuous locations, such as the privately commissioned manuscripts of the *Homilies of James of Kokkinobaphos* (figures 2-3 and 3-2). In more public settings, such as the walls of churches, there was more circumspection (figures 2-6 and 3-3). Even when there was a rich literary store of imagery for artists to draw on, they were often, as in the case of the *Akathistos* cycles or the descriptions of paradise, reluctant to illustrate the nature-derived imagery. The deployments of visual metaphors and of verbal metaphors were bound by different rules in Byzantium.

[86]*Periphyseon*, 3; ed. Migne, Patrologia Latina CXXII, col. 736; translation in J. O'Meara, *Eriugena, Periphyseon*, Montreal, 1987, 373.

[87]Migne, ed., Patrologia Latina CXXII, col. 684; O'Meara, *Eriugena, Periphyseon*, 311.

[88]Migne, ed., Patrologia Latina CXXII, col. 678; O'Meara, *Eriugena, Periphyseon*, 305.

[89]E. Panofsky, *Abbot Suger on the Abbey Church of St.-Denis and Its Art Treasures*, Princeton, 1979, 18–25; Kessler, *Spiritual Seeing*, 190–205.

[90]Kazhdan, *Oxford Dictionary*, vol. 1, 629–630.

4 }

Nature and Abstraction

Earlier chapters of this book have discussed the ambivalence displayed toward the depiction of nature in Byzantine art, which in some contexts was avoided and in others celebrated. But medieval Byzantine artists, even when they did depict the terrestrial world, did not show it in the same way that they portrayed Christ and the saints. In posticonoclastic church art, motifs from nature were represented in an undefined manner that clearly demonstrated their inferior status. In this chapter we will show how this principle applied to the depiction of plant life, the portrayal of which was rarely neutral or merely ornamental.

Plant Imagery in Churches before and after Iconoclasm

Up until the outbreak of iconoclasm, in the eighth century, the decoration of Byzantine churches celebrated nature in a discriminating way, portraying the diversity of different species. Various kinds of animals and plants were carefully distinguished and a delight was taken in their recognition. For example, in the early sixth-century narthex of the Large Basilica at Heraklea Lynkestis there is a richly figured floor mosaic, which depicts, in a map-like arrangement, the earth surrounded by the ocean.[1] The ocean is portrayed by a variety of sea creatures and water fowl displayed in octagons in the border. These surround a rectangle representing the earth. Here we see a grapevine growing from a vase at the center (figure 4-1), flanked by a line of ten trees beneath which there are beasts. Each of the trees belongs to a different species, clearly identifiable by its own fruit and leaves. Reading from left to right we can distinguish a pine

[1]R. E. Kolarik, "The Floor Mosaics of Eastern Illyricum," *Hellenika* 26 (1980) (Proceedings of the Tenth International Congress of Christian Archaeology, Thessaloniki, 1980), 173–203, esp. 193; H. Maguire, *Earth and Ocean: the Terrestrial World in Early Byzantine Art*, University Park, 1987, 36–40, figs. 42–49.

tree with a goat beneath its branches; a lion and a bull charging at each other through the trunks of an apple tree; two cypress trees flanking the central vase with the vine, which itself is flanked by two peacocks and two deer (figure 4-1); two trees that are only partly preserved, of which one has bare branches with no leaves (figure 4-2), a fig tree to which a dog is tied (figure 4-3), and finally, at the far right, a pomegranate tree beneath which a cheetah tears apart its prey, a dead hind (figure 4-4). Each of the trees can be recognized not only by its fruit but also by the distinctive shape of its leaves, lobed in the case of the fig (figure 4-3), and lance shaped in the case of the pomegranate (figure 4-4). Under the trees grow smaller plants, among which can be recognized roses, lily, and ivy (figure 4-1).

As Ruth Kolarik shows, the mosaic portrays not only the plant and animal life of land and water but also the seasons, for the artist chose the trees, plants, and creatures of the central rectangle to illustrate the changing phases of the year.[2] Thus, the tree without its foliage represents winter, a meaning that is reinforced by the ducks flying above its branches, for these birds were associated with the winter season (figure 4-2). The central motif of this floor, the vine flanked by a pair of peacocks and a pair of deer, has symbolic significance as the vine of Christ (figure 4-1). However, the evocation of the seasons, and especially the animal combats, indicates that the rest of the floor is a celebration

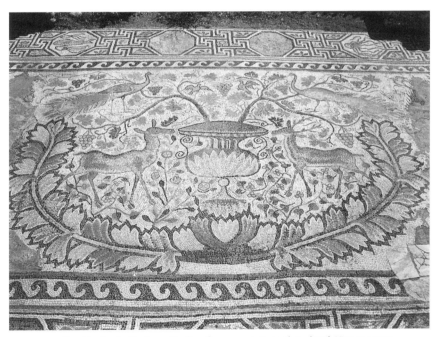

FIGURE 4.1. Heraklea Lynkestis, Large Basilica, floor mosaic in narthex, detail. Vine at center.

[2]Kolarik, "The Floor Mosaics of Eastern Illyricum," 193.

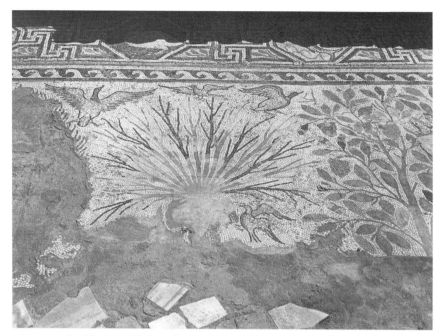

FIGURE 4.2. Heraklea Lynkestis, Large Basilica, floor mosaic in narthex, detail. Tree in winter.

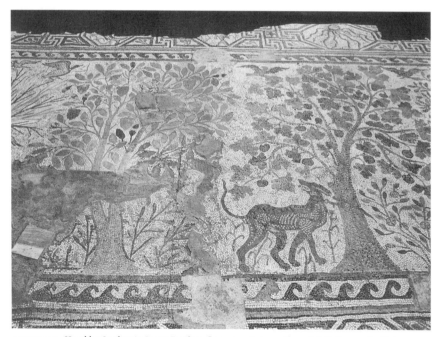

FIGURE 4.3. Heraklea Lynkestis, Large Basilica, floor mosaic in narthex, detail. Dog under fig tree.

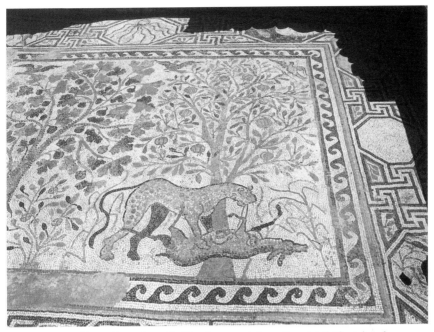

FIGURE 4.4. Heraklea Lynkestis, Large Basilica, floor mosaic in narthex, detail. Cheetah and prey under pomegranate tree.

of the variety of terrestrial nature rather than a vision of paradise (figure 4-4).[3] Not only are the different times of the year evoked, but also each animal and plant can be recognized clearly as an individual species.

We have already seen a similar pavement at Tegea, in Greece, which presents the terrestrial world and the specific harvests of its seasons (figure 1-2). In this case the central rectangle contained personifications of the twelve months, each holding the appropriate attributes, such as July with his sickle and his sheaf of wheat and August with his melon and his eggplant.[4] The pavements of early Byzantine churches in Syria and Palestine frequently portrayed different varieties of fruits, including pears, pomegranates, bunches of grapes, citrons, and, in some cases, a freshly cut fruit such as a melon with the knife still lying beside it.[5] Sometimes we encounter images of people picking fruit, as can be seen in

[3]Maguire, *Earth and Ocean*, 37–40.

[4]A. K. Orlandos, "Palaiochristianika kai byzantina mnemeia Tegeas-Nykliou," *Archeion ton Byzantinon Mnemeion tes Hellados*, 12 (1973), 12–81.

[5]See, for example, the nave pavement of the Theotokos Chapel at Mount Nebo. M. Piccirillo, *Madaba, le chiese e i mosaici*, Milan, 1989, 163–165; Piccirillo, *The Mosaics of Jordan*, Amman, 1993, 151. On the fruit and knife motif, see P. Donceel-Voûte, *Les pavements des églises byzantines de Syrie et du Liban: décor, archéologie et liturgie*, vol. 1, Louvain -la-Neuve, 1988, 196, note 4, 483, note 41; G. Bisheh, "An Iconographic Detail from Khirbet al-Mafjar: The Fruit and Knife Motif," in L. E. Stager, J. A. Greene, and M. D. Coogan, eds., *The Archaeology of Jordan and Beyond: Essays in Honor of James A. Sauer*, Cambridge, MA, 2000, 59–66. On fruit-bearing trees in the decoration of baptisteries, see R. M. Jensen, *Living Water: Images, Symbols, and Settings of Early Christian Baptism*, Leiden, 2011, 270–271.

the sixth-century nave mosaic of the Church of the Deacon Thomas in the 'Uyun Musa valley of Jordan, where a boy places pomegranates in his basket.[6] Other mosaics portrayed fruits in contexts that pointed to their Christian symbolism. In the nave pavement of the East Church at Qasr-el-Lebia, for example, a pomegranate tree is shown growing out of a vase shaped like a chalice,[7] a reference to its deep-red juice, which evoked the blood of Christ (figure 1-5, second panel from the right, four rows from the bottom).[8]

Such images of identifiable produce appeared not only on the floors of early Byzantine churches but also on the walls and vaults. In the rotunda of St. George in Thessaloniki the magnificent mosaics decorating the lower vaults of this church portray apples, pears, and pomegranates with their stalks and leaves still attached.[9]

In the decoration of posticonoclastic churches, plant life played a much smaller role, even if it was not entirely absent. Compared with the early Byzantine period, motifs derived from nature, including plants and their fruits, became less abundant in every part of the church, except in those instances where the depiction of plants was explicitly called for by the content of the text that was being illustrated. It is, of course, possible to find exceptions to this rule, such as the rich herbaceous ornament that accompanies the mosaics of the infancy of the Virgin in the mosaics of the Kariye Camii (plate V). But, in general, the abundant imagery of nature that had characterized preiconoclastic churches receded after the ninth century, to be replaced by an art that was more anthropocentric and more concerned with the depiction of the sanctified human body (plate II).

In particular, the fully tessellated mosaics, with their naturalistic portrayals of the variety of nature's bounty, disappeared from church floors, to be replaced by abstract compositions in opus sectile.[10] These posticonoclastic pavements were primarily composed of large plaques or bands of marble, as

[6]Piccirillo, *Madaba, le chiese e i mosaici*, 216–223; Piccirillo, *Mosaics of Jordan*, 187, figs. 256, 263.

[7]E. Alföldi-Rosenbaum and J. Ward-Perkins, *Justinianic Mosaic Pavements in Cyrenaican Churches*, Monografie di Archeologia Libica XIV, Rome, 1980, 122, fig. 10.

[8]On the symbolism of the pomegranate, see F. Muthmann, *Der Granatapfel: Symbol des Lebens in der alten Welt*, Fribourg, 1982.

[9]J.-M. Spieser, *Thessalonique et ses monuments du IVe au VIe siècle: contribution à l'étude d'une ville paléochrétienne*, Paris, 1984, 133–134, plates 19–21. For a survey of the dating problems, see S. Čurčić, *Some Observations and Questions Regarding Early Christian Architecture in Thessaloniki*, Thessaloniki, 2000.

[10]On the medieval Byzantine opus sectile floors, see U. Peschlow, "Zum byzantinischen opus sectile-Boden," in R. M. Boehmer and H. Hauptmann, eds., *Beiträge zur Altertumskunde Kleinasiens. Festschrift für Kurt Bittel*, Mainz, 1983, 435–447; A. Guiglia Guidobaldi, "L'opus sectile pavimentale in area bizantina," in *Atti del I Colloquio dell' Associazione Italiana per lo Studio e la Conservazione del Mosaico*, Ravenna, 1993, 643–663. On the floors in Turkey, see Y. Demiriz, *Interlaced Byzantine Mosaic Pavements*, Istanbul, 2002. On the marble floors of palaces, see H. Maguire, "The Medieval Floors of the Great Palace," in N. Necipoğlu, ed., *Byzantine Constantinople, Monuments, Topography and Everyday Life*, Leiden, 2001, 153–174.

may be seen in the fine tenth-century example still preserved in the Church of the Theotokos at Hosios Loukas (plate XIV).[11] Occasionally, especially in later churches, these abstract compositions contained inserted motifs executed in tesserae, as we find, for example, in the nave pavement of the church of the Blachernai Monastery at Arta. Here a quincunx pattern composed of bands of white marble frames small areas of mosaic, four of which portray plants. The four plants, however, are extremely stylized, so that it is not easy to determine the species to which they belong.[12]

One explanation for the switch from opus sectile to tessellated floors could be a change of taste generated by an increasing scarcity of materials.[13] The quarrying of marble ceased, or all but ceased, in the Byzantine empire after the seventh century;[14] thus, large pieces of colored stone became an increasingly rare commodity and could be obtained only by spoliating earlier buildings. Consequently, the display of panels of marble, as opposed to smaller pieces of stone in the form of tesserae, signified luxury and expense in new construction. The opus sectile floors of medieval buildings, especially those appearing in palaces and imperial foundations, implied the control of scarce resources; the marble floor could be seen as a conspicuous display of wealth and power.

A medieval text that testifies to this attitude is the *Narratio de S. Sophia*, a semilegendary account of the construction of Hagia Sophia in Constantinople that was written in the ninth century. According to the *Narratio*, the original floor of Justinian's church "made visitors marvel, for it appeared like the sea or the flowing waters of a river, thanks to the great variety of its marble." Then, however, late in Justinian's reign, the dome collapsed, destroying the floor. After this disaster, reports the text, the emperor had to economize in the reconstruction; he was unable to make "the ambo and the solea . . . as lavish and precious" as before, and "he did not wish to make a cupola for the ambo because of the great expense." Furthermore, quoting again from the text, "For the floor he [Justinian] was unable to find slabs of such great size and variety, and so he sent Manasses, patrician and Praepositus, to Proconnessus to cut slabs that would denote the earth, while the green ones signify the rivers that flow into the sea."[15] In other words, the ninth-century author implies that the quarrying of a

[11]R. W. Schultz and S. H. Barnsley, *The Monastery of Saint Luke of Stiris in Phocis*, London, 1901, 33; Peschlow, "Zum byzantinischen opus sectile-Boden," 444, plate 93.2.

[12]A. K. Orlandos, "E para ten Artan mone ton Blachernon," *Archeion ton Byzantinon Mnemeion tes Hellados* 2 (1936), 1–56, esp. 30, fig. 25; B. N. Papadopoulou, *H Byzantine Arta kai ta mnemeia tes*, Athens, 2002, 78–79, fig. 89.

[13]On the aesthetic considerations, see H. Maguire, "Medieval Floors," 8–11.

[14]R. Ousterhout, *Master Builders of Byzantium*, Princeton, 1999, 136–139; J.-P. Sodini, "Marble and Stoneworking in Byzantium, Seventh–Fifteenth Centuries," in A. E. Laiou, ed., *The Economic History of Byzantium*, vol. 1, Washington, DC, 2002, 129–146, esp. 137–145.

[15]*Narratio de S. Sophia*, 26, 28; ed. Th. Preger, *Scriptores originum Constantinopolitanarum*, vol. 1, Leipzig, 1901, 102, 107–108; translation by C. Mango, *The Art of the Byzantine Empire, 312–1453*, Englewood Cliffs, NJ, 1972, 101–102.

few kinds of stone was an inferior option to the acquisition of a greater variety of marbles, presumably through spoliation. In his eyes, the spoliated marbles declared lavishness of spending and control of a finite commodity.[16]

This explanation for the general adoption of opus sectile pavements in post-iconoclastic churches, however, does not account for the changes in the mosaics and frescoes decorating the walls above, where the depiction of motifs from nature also became less frequent. Two other factors discouraged portrayals of plants in posticonoclastic churches. One was the growing influence of monastic asceticism on Byzantine thought and art and the association of natural bounty with indulgence in eating. Ascetic writers linked the vice of gluttony with lust and with the original sin that had caused the fall—for the eating of fruit had been at the root of man's problems. The treatise on the monastic life known as the *Heavenly Ladder*, composed by the seventh-century ascetic John Klimax, devotes its fourteenth chapter to gluttony, describing this vice as the chief of all the vices, the gateway of the passions, the cause of Adam's fall.[17] An eleventh-century illustrated copy of the *Heavenly Ladder*, now in the Vatican Library, associates the image of gluttony with the fall of man. In this manuscript the fourteenth chapter is illustrated by a painting of gluttony represented as a richly dressed woman who stands in profile view eating an apple. To her left, John Klimax is instructing three monks concerning her evils.[18] The following miniature shows the relationship between gluttony and original sin, for there we see Adam and Eve eating from the tree before being driven out of paradise by an angel.[19]

At one point in his fourteenth chapter, John Klimax describes how gluttony can never be satiated: "Know that oftentimes this demon sits in a man's stomach, and does not allow him to get satisfaction, even if he were to eat all of Egypt and drink the whole of the river Nile."[20] This reference to the Nile as a metaphor for an abundance of food and drink was a commonplace of early Byzantine art and literature, and it has already been seen that early Byzantine churches used the imagery of the River Nile to convey the idea of God-given plenty.[21] For the ascetic John Klimax, however, the Egyptian river was a metaphor for unstoppable sin.

[16]On spoliation in the *Narratio* and the ideology of Christian triumph, see M. Maskarinec, "Hagia Sophia's Marble Meadows and the Marble Imperial Presence in Constantinople," *Thirty-Sixth Annual Byzantine Studies Conference, Abstracts of Papers*, Philadelphia, 2010, 11–12.

[17]*Scala Paradisi*, 14.23; ed. J.-P. Migne, Patrologiae cursus completus. Series Graeca LXXXVIII, col. 869.

[18]J. R. Martin, *The Illustration of the Heavenly Ladder of John Climacus*, Princeton, NJ, 1954, 68, fig. 105.

[19]Ibid., 68, fig. 106.

[20]Migne, ed., Patrologia Graeca LXXXVIII, col. 868.

[21]On the Nile as a sign of abundance, see A. Hermann, "Der Nil und die Christen," *Jahrbuch für Antike und Christentum* 2 (1959), 30–69; H. Maguire, "The Good Life," in G. W. Bowersock, P. Brown, and O. Grabar, eds., *Late Antiquity: A Guide to the Postclassical World*, Cambridge, MA, 1999, 238–257, esp. 245–246, 249–250.

Partly as a result of the change in mentality exemplified by the writing of John Klimax, fruits and vegetables were expelled from the decoration of Byzantine churches, except for depictions of meals described in the Bible, such as the Marriage at Cana or the Last Supper.[22] In later Byzantine church art, the most sumptuously described feasts are those that are given negative connotations. One of the richest feasts in medieval Byzantine painting can be found in the outer narthex of the Katholikon of the Vatopedi monastery on Mount Athos (plate XV).[23] In this early fourteenth-century fresco, a banquet is served to an array of exotically clad guests. They eat to a musical accompaniment provided by a man with a stringed instrument who is partly concealed by a curtain in the background. The luxury of the feast is indicated by the dinnerware. The food on the table is contained in silver vessels or perhaps even in imported blue and white ceramic bowls. The wine is served in glass goblets by waiters bearing glass decanters. The victuals include meat, fish, and bread, together with many radishes scattered upon the table; radishes were considered to be an antidote to drunkenness and could thus be associated with excessive indulgence in the pleasures of wine.[24] The abundance of food on the table is further suggested by the number of knives needed to cut it. In the foreground a man stuffs his mouth with food.

Appropriately for its setting on the Holy Mountain, this banquet is intended to serve as a warning to its monastic viewers, for it is an illustration of the fourteenth chapter of the *Heavenly Ladder*. The ladder is depicted on the right. One of the monks has already abandoned his climb toward heaven to join the barbarous feast; he is being escorted there by a pair of devils. In this fresco the full ambivalence of the presentation of food in medieval Byzantine churches can be seen. There is certainly a pleasure in the description of the details, but this is accompanied by an underlying moral condemnation. The spiritual banquet must always have priority over the physical.

A second factor that affected the Christian view of plant-derived imagery in places of worship was competition with Islam. As far as the depiction of plants was concerned, there was the need to distinguish the church from the mosque. Plant forms predominated in the decoration of many mosques, as can be seen in the early eighth-century wall mosaics in the court of the Great Mosque of Damascus that surround the space with unbroken lines of trees and other vegetation (figure 4-5).[25] Christians were well aware that Muslims had banned

[22]I. Anagnostakis and T. Papamastorakis, "'. . . And Radishes for Appetizers.' On Banquets, Radishes, and Wine," in D. Papanikola-Bakirtzi, ed., *Food and Cooking in Byzantium*, Athens, 2005, 147–172, esp. 158–166; H. Maguire, "A Fruit Store and an Aviary": Images of Food in House, Palace, and Church," in Papanikola-Bakirtzi, *Food and Cooking*, 133–145, esp. 140, fig. 12.

[23]E. N. Tsigaridas, *Ta psephidota kai oi byzantines toichographies, in Iera Megiste Mone Vatopaidiou: Paradose-Istoria-Techne*, Mount Athos, 1996, 254–277; Anagnostakis and Papamastorakis, ". . . Radishes for Appetizers," 165–166, fig. 21; Maguire, "Fruit Store," 142–143, fig. 13.

[24]Anagnostakis and Papamastorakis, "'. . . Radishes for Appetizers,'" 162–166.

[25]K. A. C. Creswell and J. W. Allan, *A Short Account of Early Muslim Architecture*, Aldershot, 1989, 58, figs. 36–9.

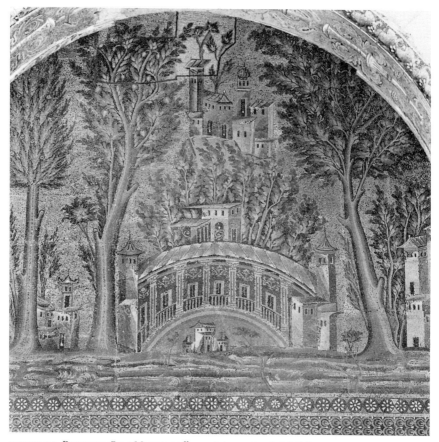

FIGURE 4.5. Damascus, Great Mosque, wall mosaic in courtyard, detail. Trees.

representations of all living beings from their places of worship, with the exception of plants. Theodore Abu Qurrah, who was bishop of Harran in Syria in the early ninth century, attacked the Muslims for allowing vegetal decoration in their mosques, even as they mocked the Christians for prostrating themselves before icons of Christ and the saints.[26]

Defined and Undefined Images

After iconoclasm, it is more common to encounter plant ornament as well as other images from nature in the less public media of Byzantine art, such as

[26]S. H. Griffith, *A Treatise on the Veneration of the Holy Icons Written in Arabic by Theodore Abu Qurrah, Bishop of Harran (C.755–C.830 a.d.)*, Louvain, 1997, 55–56. See also S. H. Griffith, "Crosses, Icons and the Image of Christ in Edessa: The Place of Iconophobia in the Christian-Muslim Controversies of Early Islamic Times," in P. Rousseau and M. Papoutsakis, eds., *Transformations of Late Antiquity: Essays for Peter Brown*, Aldershot, 2009, 63–83, esp. 78–79.

ivory carving and manuscript painting, than in the more openly visible arena of church decoration. But both in the monumental art of churches and in smaller religious objects we can observe an interesting paradox: as portrayals of plants tended to become more generic and *less* differentiated, at the same time portrayals of the saints became *more* differentiated and more specific. This means that we cannot ascribe the lack of naturalism in the portrayal of nature to a general tendency toward abstraction in medieval art. Some images, namely, the plant forms, were represented in an unspecific way, whereas other images, the sacred portraits, were carefully distinguished.

We can illustrate this paradox in the illuminations of the *Homilies of James of Kokkinobaphos*, by taking a closer look at the miniature that depicts the Virgin resting on her way to the Visitation with her cousin Elizabeth (figure 2-3).[27] The text accompanying this painting describes how creation venerated the Virgin as she took her repose. In the miniature, Mary is shown sitting beside a stream while her servant climbs a tree to collect figs. To the left of her, the earth, personified as a naked woman, raises her hands in veneration. The Virgin is surrounded by a dense forest of vegetation, but in it the artist has reduced the variety of created plants to three basic types of tree. The first type is represented by the fig, which does not have naturalistic leaves, such as we saw in the mosaic at Heraklea (figure 4-3). Instead, it seems to resemble an umbrella pine or perhaps a mushroom. Most of the other trees and plants in the landscape conform to this basic type. The second type of tree resembles a cypress; there are three of these in the background. Finally, there is the tree immediately above the Virgin's head, which may be a palm. We find similarly generic and unspecific plants in other miniatures in this manuscript, for example, in the portrayal of the Garden of St. Anne, where the angel announced to her the conception of her daughter (figure 2-8).[28]

The undifferentiated plants of these miniatures make a striking contrast with the highly differentiated portraits of the saints and prophets that appear in another miniature of the same manuscript, where we see a view of heaven in which the Virgin sits surrounded not by plants but by the servants of God (figure 4-6).[29] The holy personages are divided into five groups as bishops, monks, rulers, soldiers, and women. Although the portraits are on a very small scale, for this is a miniature in a manuscript, they are highly differentiated. Each of the individuals standing in the front rows of the groups can be recognized according to the standard conventions of Byzantine sacred portraiture, which were established by the eleventh century. Thus, among the bishops at the upper left, moving from left to right, we can make out St. Gregory of

[27]I. Hutter and P. Canart, *Das Marienhomiliar des Mönchs Jakobos von Kokkinobaphos, Codex Vaticanus Graecus 1162*, Codices e vaticanis selecti LXXIX, Zurich, 1991, fol. 147.

[28]Ibid., fol. 16v.

[29]Ibid., fol. 5.

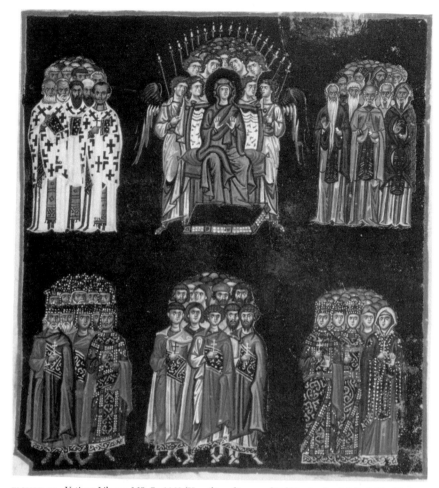

FIGURE 4.6. Vatican Library, MS. Gr. 1162 (Homilies of James of Kokkinobaphos), folio 5. The Virgin with the servants of God.

Nazianzos, who is shown as a balding white-haired man, with a white spade-shaped beard.[30] Immediately beside St. Gregory stands St. Nicholas, who also has white, receding hair, but his beard is short and rounded.[31] As in other portraits of St. Nicholas in Byzantine art, he has a distinctive cowlick of hair

[30]For other, similar portraits of this saint in wall paintings, see, for example, H. Maguire, *The Icons of Their Bodies: Saints and Their Images in Byzantium*, Princeton, NJ, 1996, 34–36, fig. 33 (church of St. Nicholas tis Stegis at Kakopetria); fig. 20; I. Sinkević, *The Church of St. Panteleimon at Nerezi: Architecture, Programme, Patronage*, Wiesbaden, 2000, fig. 20; D. Winfield and J. Winfield, *The Church of the Panaghia tou Arakos at Lagoudhera, Cyprus: the Paintings and Their Painterly Significance*, Washington, DC, 2003, fig. 38.

[31]For comparable portraits, see H. Maguire, *Icons of Their Bodies*, 25, figs. 22 (Menologium of Basil II: Vatican Library, MS. Gr. 1613), 44 (fresco in the church of St. Nicholas tou Kasnitzi at Kastoria), 77 (Leo Bible: Vatican Library, MS. Reg. gr. IB).

at the center of his forehead.[32] Next in the row of bishops we can recognize St. Basil the Great, portrayed as younger than his companions, because he died at the age of fifty. He has an elongated face, with dark black hair and a long, pointed beard.[33] Beside St. Basil stands St. John Chrysostom, characterized by the balding dome of his head, sunken cheeks, and a relatively narrow chin with a short beard. A similar portrait of him appears in the fourteenth-century mosaic icon illustrated in plate XVIII, which is now at Dumbarton Oaks in Washington, D.C.[34]

Moving to the monks, on the right of the Virgin, we find at the left of the group a monk with short white hair and a very long, pointed beard. This ascetic can be identified as St. Euthymios. A similar portrait of the saint, but with a somewhat shorter beard, appears in a tenth-century Gospel book preserved in the Stauronikita Monastery on Mount Athos.[35] The monk immediately to his right is St. Arsenios. Like Euthymios, he has a long white beard, but in his case the hair is distinctly curly.[36] The monk in the middle is St. Sabas, who is characterized by a completely bald pate and by a strange cleft beard, which terminates in a triangular point at each side of his chin.[37] Next, to the right of St. Sabas stands St. Theodore of Stoudios, with short white hair and a beard that divides into two narrow vertical strands.[38] Finally, at the far right, we have St. Anthony, who has a similar style of beard to Theodore of Stoudios but is differentiated by his cowl.[39]

If we look at the groups at the bottom of the miniature, we discover that all of the males depicted in the front rows can be identified by means of their facial features. For example, two Old Testament kings, David and Solomon, appear in the front rank of the rulers, David at the far left and Solomon in the center.

[32]Compare, for example, Winfield, *Church of the Panaghia tou Arakos at Lagoudhera*, fig. 113; K. A. Manafis, ed., *Sinai: Treasures of the Monastery of Saint Catherine*, Athens, 1990, 177, fig. 51 (panel painting); A. Papageorgiou, *Eikones tes Kyprou*, Nicosia, 1991, 52–53, plates 32a–32b (panel painting from the church of St. Nicholas tis Stegis at Kakopetria).

[33]H. Maguire, *Icons of Their Bodies*, 25, fig. 20 (Menologium of Basil II: Vatican Library, MS. Gr. 1613); Sinkević, *Church of St. Panteleimon at Nerezi*, fig. 22; Winfield, *Church of the Panaghia tou Arakos at Lagoudhera*, fig. 36.

[34]H. C. Evans, ed., *Byzantium: Faith and Power 1261–1557* (exhibition catalogue, Metropolitan Museum of Art), New York, 2004, 227–228, no. 135. Compare also H. Maguire, *Icons of Their Bodies*, 25, figs. 19 (Menologium of Basil II: Vatican Library, MS. Gr. 1613), 54 (Mount Sinai, Monastery of St. Catherine, MS. 364); Sinkević, *Church of St. Panteleimon at Nerezi*, fig. 21; Winfield, *Church of the Panaghia tou Arakos at Lagoudhera*, fig. 35.

[35]MS 43, fol. 13v.; Ch. Mavropoulou-Tsioumi and G. Galavaris, *Holy Stavroniketa Monastery: Illustrated Manuscripts*, Mount Athos, 2007, 36, fig. 26; H. Maguire, *Icons of Their Bodies*, 24, fig. 17. Compare also Sinkević, *Church of St. Panteleimon at Nerezi*, fig. 52.

[36]So also at Nerezi; Sinkević, *Church of St. Panteleimon at Nerezi*, fig. 55.

[37]Compare Sinkević, *Church of St. Panteleimon at Nerezi*, fig. 53; Winfield, *Church of the Panaghia tou Arakos at Lagoudhera*, figs. 110, 112.

[38]See also H. Maguire, *Icons of Their Bodies*, 22–24, fig. 16 (mosaic in the Katholikon of Hosios Loukas); Sinkević, *Church of St. Panteleimon at Nerezi*, fig. 67.

[39]Compare Sinkević, *Church of St. Panteleimon at Nerezi*, fig. 50; Winfield, *Church of the Panaghia tou Arakos at Lagoudhera*, figs. 199–200.

Both are shown according to their established portrait types: David as an older man with a short white beard[40] and Solomon as a younger man with a more rounded, beardless chin.[41]

The twelfth-century miniatures of the *Homilies of James of Kokkinobaphos*, therefore, accurately defined the portrait images of prophets and saints who no longer existed or in some cases never existed so that they can still be recognized. On the other hand, terrestrial nature, the world that existed all around the Byzantines of the twelfth century, was rendered in an undefined and schematic fashion; the plants were reduced to only a few categories, so that most of them cannot be identified.

It should be emphasized that what is at issue here is not illusionism, since neither the depictions of the saints nor of the plants can properly be termed illusionistic in a photographic sense. The contrast is in the degree of definition. The portraits of the saints were organized into many different schemata, which allowed for the identification of a large number of individuals. For the plants, on the other hand, there were far fewer schemata, and their employment was inconsistent, so that recognition of individual species is difficult. Another example is the beautiful foliage executed in the enamels from the halo and background of an icon of the Virgin, now partly preserved in the Metropolitan Museum of Art in New York (plate IX). Although the colorful red and white flowers in the halo might possibly evoke lilies, it is difficult to recognize any of the plants in the enamels with certainty.[42] Likewise, in the fourteenth-century mosaics of the Kariye Camii in Constantinople, the plant forms in the borders, though rich, are abstract and unidentifiable (plate V).

There were certainly exceptions to the general preference for undefined plant forms in posticonoclastic Byzantine art. Occasionally in medieval church decoration it is possible to recognize individual species, as in the early fourteenth-century frescoes of St. Nicholas Orphanos in Thessaloniki, where date palms and olive trees can be distinguished among the generally unspecific plants.[43] Some of the most striking exceptions date to the tenth century and are in luxury

[40]For comparable portraits of David, see, for example, A. D. Kartsonis, *Anastasis: The Making of an Image*, Princeton, 1986, figs. 77 (Paris Psalter: Paris, Bibilothèque Nationale, MS. Gr. 139), 78 (Leo Bible: Vatican Library, MS. Reg. gr. IB), 80 (Mount Athos, Lavra Monastery, Skevophylakion Lectionary), 81 (mosaic of the Anastasis, Chios, Nea Moni), 83 (mosaic of the Anastasis, Hosios Loukas), 85 (mosaic of the Anastasis, Daphni). See also Winfield, *Church of the Panaghia tou Arakos at Lagoudhera*, fig. 69.

[41]Compare Kartsonis, *Anastasis*, 80 (Mount Athos, Lavra Monastery, Skevophylakion Lectionary), 83 (mosaic of the Anastasis, Hosios Loukas), 85 (mosaic of the Anastasis, Daphni). See also Winfield, *Church of the Panaghia tou Arakos at Lagoudhera*, fig. 61.

[42]There are other pieces from the same composition in the Louvre and in the State Museum of Fine Arts in Tbilisi; H. C. Evans and W. D. Wixom, *The Glory of Byzantium, Art and Culture of the Middle Byzantine Era* a.d. *843–1261* (Exhibition catalogue, Metropolitan Museum of Art), New York 1997, 348–349, no. 236; B. V. Pentcheva, *The Sensual Icon: Space, Ritual, and the Senses in Byzantium*, University Park, 2010, 116–120, figs. 42–44, 47.

[43]O.-M. Bakirtzi, "Plants and Vegetation," in Ch. Bakirtzis, ed., *Ayios Nikolaos Orphanos: The Wall Paintings*, Nea Smirni, 2003, 130–133.

arts such as ivory carving, especially in secular contexts. Often there is a specific reason for the accurate depiction of a particular species. For example, the back of a tenth-century ivory casket now in the Cathedral of Troyes portrays an oak tree, distinguished by its carefully carved acorns, behind a monstrous boar that is being speared by a hunter (figure 4-7).[44] In this case the carefully delineated oak refers to autumn, the season of the hunt, when the wild boar come out to eat the acorns shed by the trees, while the hunt itself refers to the military triumph of the two emperors depicted on the lid of the box.[45] Such examples of botanical naturalism, however, were relatively rare, even in nonreligious art. In the realm of scientific illustration, the medieval copies of the herbal by Dioscurides, such as the tenth-century manuscript now in the Morgan Library of New York, contain paintings of plants that are notably more schematic than those in the sixth-century version now in Vienna.[46]

Why, then, in medieval Byzantine art do we find such discrimination in the sacred portraits and such a lack of discrimination in portrayals of plant life? To explain this contradiction, we need once again to take into account the rejection of symbolic imagery by the Quinisext Council of 692, which discouraged the representation of Christ as a lamb while prescribing instead images

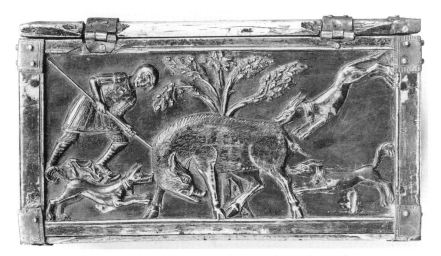

FIGURE 4.7. Troyes Cathedral Treasury, ivory casket, back. Boar hunt under an oak tree.

[44]Evans and Wixom, *Glory of Byzantium*, 204–206, no. 141.

[45]H. Maguire, "Imperial Gardens and the Rhetoric of Renewal," in P. Magdalino, ed., *New Constantines: The Rhythm of Imperial Renewal in Byzantium, 4th–13th Centuries*, Aldershot, 1994, 181–197, esp. 193–197.

[46]New York, Pierpont Morgan library, MS. M652. See L. Brubaker, "The Vienna Dioskorides and Anicia Juliana," in A. Littlewood, H. Maguire, and J. Wolschke-Bulmahn, eds., *Byzantine Garden Culture*, Washington, DC, 2002, 189–214, esp. 204–206, with earlier bibliography.

of Christ as a man to better stress his incarnation.[47] Since the decision of the Quinisext Council tended to discourage all images derived from nature that had the potential for Christian symbolism, it also discouraged their differentiation. It was no longer necessary for an artist to depict a plant such as a pomegranate in a way that made it identifiable by the viewer, when that plant was no longer functioning as a symbol of a Christian concept. On the other hand, the portraits of the saints certainly needed to be distinguished if they were to be recognizable by the worshipper and hence to work as icons. Moreover, the requirement that each sacred icon should be an authentic and accurate portrait if it was to give access to the prototype carried with it the corollary that an unidentifiable image could not function in the same way as an icon. Artistic representations that were poorly defined, including images from the natural world, had less potential for veneration. In posticonoclastic Byzantine art, therefore, differentiation was associated with the approved adoration of Christ and the saints through their portraits, whereas an absence of differentiation implied a distancing of the image from the prototype and the consequent reduction of its potential to receive idolatrous worship. Thus, Byzantine attitudes toward sacred images also affected their attitudes toward earthly ones. If the portrait icons needed to be well defined, representations of nature, including plants, did not.

As a result of their attitudes toward sacred images, the Byzantines never developed an equivalent of *Gothic naturalism* in their art. From the early thirteenth century onward, Western artists began to observe nature precisely, producing accurate reproductions of a variety of plants. Famous examples are the carved stone capitals of Reims Cathedral in France, Naumburg Cathedral in Germany, and the chapter house at Southwell Minster in England.[48] At Southwell, at the end of the thirteenth century, we find recognizable carvings of the leaves, flowers, and fruits of many different native plants, including oak, hawthorn, vine, hop, maple, buttercup, rose, and ivy (plate XVI).[49] After iconoclasm, such an interest in the particularities of the created world would not be allowed to appear in Byzantine churches.

Variegation and Purity

If naturalistic images of plants and produce became less conspicuous in posticonoclastic churches, it can still be argued that nature was present in the medieval churches in another way, through the use of colored stones in the floors,

[47]G. Mansi, *Sacrorum conciliorum nova et amplissima collectio*, vol. 11, Florence, Venice, 1759–1798, col. 977–80; translation by C. Mango, *The Art of the Byzantine Empire 312–1453*, Englewood Cliffs, NJ, 1972, 139–140.

[48]J. A. Givens, *Observation and Image-Making in Gothic Art*, Cambridge, 2005.

[49]N. Pevsner, *The Leaves of Southwell*, London, 1945.

walls, and columns of the buildings. These polychromatic stones depicted nature in a completely unspecific and abstract way that was splendid but at the same time innocuous. To explore this theme of the variety of earthly creation frozen in marble, we will examine a common convention, or topos, of the rhetorical description of buildings, namely, the comparison of their painted, mosaic, or opus sectile decoration to landscapes.[50]

For the Byzantines, the archetype of this topos was the description of a hall by the ancient author Lucian, a passage that was frequently quoted by later Byzantine ekphraseis. Describing the building's decoration, Lucian declares:

> The frescoes on the walls, the beauty of their colors, and the vividness, exactitude, and truth of each detail might well be compared with the face of spring and with a flowery field, except that those things fade and wither and change and cast their beauty, while this is spring eternal, field unfading, bloom undying.[51]

Here Lucian likens the vivid and colorful paintings, whatever their subjects, with the burgeoning of springtime. Referring to Plato's description of the ideal, intelligible earth, Lucian declares that the flowers of the building's meadow are not subject to fading or corruption.[52] An encomium of St. Theodore, attributed to the fourth-century church father Gregory of Nyssa, makes a similar comparison between the Christian paintings in the saint's martyrion and a flowering field:

> The painter, too, has applied the flowers of his art, having depicted on an image the martyr's prowess . . . the athlete's most blessed consummation and the portrayal in human form of Christ who presides over the contest . . . he clearly related the struggles of the martyr in detail and made the church glorious like a radiant meadow.[53]

In both of these descriptions, of the pagan hall and of the Christian church, the topos of the flowering field served as a metaphor for varied and polychromatic paintings in a general sense. But from the beginning of the sixth century

[50]On this topos, see H. Maguire, "Originality in Byzantine Art Criticism," in A. R. Littlewood, ed., *Originality in Byzantine Literature, Art, and Music*, Oxford, 1995, 101–114, esp., 102–104; W. Tronzo, "Shield, Cross, and Meadow in the Opus Sectile Pavements of Byzantium, Southern Italy, Rome and Sicily," in N. Oikonomides, ed., *L'ellenismo italiota dal VII al XII secolo*, Athens, 2001, 241–260, esp. 246–249.

[51]*De domo* 9; translation by A. M. Harmon, *Lucian*, vol. 1, London, 1991, 187.

[52]*Phaedo*, 110b–e; see H. G. Saradi, "Space in Byzantine Thought," in S. Ćurčić and E. Hadjitryphonos, eds., *Architecture as Icon: Perception and Representation of Architecture in Byzantine Art*, Princeton, NJ, 2010, 73–111, esp. 100.

[53]Migne, ed., Patrologia Graeca, XLVI, col. 737; translation in Mango, *Art of the Byzantine Empire*, 36–37.

writers began to use the topos in a more specific way, to describe marble revetments and opus sectile patterns on walls. An anonymous poem that was composed, probably between 524 and 527, to be inscribed in the now lost church of Hagios Polyeuktos in Constantinople described the veined marbles on the side walls as follows:

> The opposite walls in innumerable paths are girt around with marvelous meadows of mosaics, which Nature made to flower in the depth of the rock, and hid their glory, keeping them for the House of God.[54]

More famous is the slightly later passage in the *Buildings* of Procopius, which praises the marble columns and revetments of the sixth-century church of Hagia Sophia in Constantinople, which still survive (plate XVII):

> Who could recount the beauty of the columns and the stones with which the church is adorned? One might imagine that he had come upon a meadow with its flowers in full bloom. For he would surely marvel at the purple of some, the green tint of others, and at those on which the crimson glows and those from which the white flashes, and again at those which Nature, like some painter, varies with the most contrasting colors.[55]

The courtier Paul the Silentiary, in a poem that he recited to celebrate the reconstruction of Hagia Sophia after 563, elaborated upon the metaphor, seeing in the veins of the book-matched marbles on the walls not only meadows but also landscape features such as rushing flower-banked streams and green hills in addition to fields of ripe corn, the shade of thick forests, flocks of skipping sheep, and vines with flourishing tendrils. He also, in a well-known passage, described the Proconnesian marble pavement of the church as a sea and the pulpit with its colored marbles as "an island amidst the waves . . . adorned with cornfields, and vineyards, and blossoming meadows, and wooded heights. . . ."[56]

After iconoclasm, the composers of ekphraseis continued to make use of the topos of the field flowering in the spring, especially to describe the pavements of church buildings. However, as we have seen, these medieval church floors, with a few exceptions, no longer resembled the tessellated mosaic floors that had featured in many pre-iconoclastic churches, but instead they were abstract compositions in opus sectile. At the end of the ninth century Emperor Leo VI described an aniconic pavement of this kind, in his ekphraseis of the church founded in Constantinople by his father-in-law, Stylianos Zaoutzes. According

[54]*Anthologia Palatina*, 1.10, lines 60–64; R. M. Harrison, *Excavations at Sarachane in Istanbul*, vol. 1, Princeton, NJ, 1986, 6.

[55]*De aedificiis*, 1.1.59; translation by H. B. Dewing and G. Downey, *Procopius*, vol. 7, London, 1961, 27.

[56]*Descriptio S. Sophiae*, lines 286–295, 618; *Descriptio ambonis*, lines 224–239; ed. P. Friedländer, *Johannes von Gaza und Paulus Silentiarius*, Leipzig-Berlin, 1912, 235–245.

to Leo, the marbles of the lower part of the church represented the earth in springtime, with its rivers and plants:

> The pavement is covered all over with the mingled and various colors of flowers. In places the surface is suffused by white, in others the white is framed by a composition of other colors, consisting of multicolored stones cut into tesserae, and this, in turn, is surrounded by purple slabs, as if by rivers; the latter, too, are enclosed by a composition imitating the variegated flowers of the earth . . .

Taking his cue from an ekphraseis of a painting of Narcissus by the ancient author Philostratus the Elder,[57] Leo goes on to describe some gullible bees:

> If bees were to happen to come there [i.e., to the church], they would seem to me to take delight in the flowers and to hasten to make honey from the flowers of the pavement. Thus not only is the likeness to springtime flowers not lacking, but there is added beauty besides.[58]

Although the church described by Leo is no longer preserved, Cyril Mango has suggested that its floor must have resembled the still surviving floor in the tenth-century church of the Theotokos at the monastery of Hosios Loukas (plate XIV).[59] Here we find large slabs of off-white marble framed by borders of opus sectile, which Leo described as "multicolored stones cut into tesserae." Around the perimeter of the composition are broad bands of colored marble, which Leo compared to "rivers." These colored bands are themselves enclosed by further strips of opus sectile, which, in Leo's ekphraseis, resembled the "variegated flowers of the earth." It is probable that the resemblance to flowers, noted by Leo and by his bees, was restricted to the varied effect of the different colors of the small pieces of stone and not to any illusionism or attempts at botanical naturalism.

In the twelfth century we find a South Italian Greek preacher, Philagathos, likening the cut marbles of an opus sectile pavement to flowers in a field in the course of his description of the Cappella Palatina, the palace chapel of the Norman King Roger II in Palermo. He said that the floor was "absolutely comparable to a meadow in springtime, blooming with many-colored marble pebbles, as though with flowers." Philagathos went on to add a direct quotation from Lucian's ekphraseis of the hall: "the only difference is that flowers decay, and are changed, but this meadow is undecaying, and everlasting, preserving

[57]*Imagines*, 1.23.2. I owe this reference to Ruth Webb.

[58]*Homilia XXXVII*; ed. T. Antonopoulou, *Leonis VI Sapientis Imperatoris homiliae* (Corpus Christianorum. Series Graeca LXIII), Turnhout, 2008, 476–477; A. Frolow, "Deux églises byzantines," *Etudes Byzantines* 3 (1945), 53–54; partial translation in Mango, *Art of the Byzantine Empire*, 205.

[59]Mango, *Art of the Byzantine Empire*, 205, note 120.

in itself the flower unfading."[60] In this case the pavement that was the subject of the ekphraseis still survives (figure 4-8). The floor of the Cappella Palatina is abstract. Its purely geometrical design is derived from Islamic sources, with bands of opus sectile creating circles and interlaces framing plain marble slabs.[61] There are no recognizable representations of flowers. It is evident that when Philagathos was employing the simile of the flowering field, he was referring to the colorful and variegated impression of the stones rather than to illusionistic portrayals of individual plants.

Our comparisons of the ekphraseis with the objects that they described, the veined marble slabs and the opus sectile, have shown that patterns that appear to viewers today as abstract and without representation were identified by the Byzantines with a range of landscape features, from rivers to flowers. An influential article published by John Onians in 1980 considered this phenomenon.[62] He suggests that when Late Antique viewers saw natural images in the marbles this was more than rhetorical inflation but reflected real contemporary experience on the part of the observers. Onians also argues that Late Antique spectators had their imaginative sensibilities heightened by rhetoric, so that they became able to read more and more vivid detail into images, a process that had the effect of encouraging artists to make their images less illusionistic. He proposed that works of art became more abstract even as their viewers became more capable of supplying the detail in the images for themselves. In his words, the Late Antique spectator was able "to make more and more out of the same or less information." At the same time, the artists ceded their former territory, that is, the ability to create illusion, to the viewer so that the progressive abstraction of Late Antique and medieval art was driven by people's imaginations.[63] According to this line of reasoning, the abstract character of the medieval opus sectile floors, which were described by contemporaries as representing the elements of nature such as flowers and rivers, could be explained by a change in the manner of viewing or, in other words, by a different aesthetic. This theory gives to rhetoric an extraordinarily influential role, as rhetoric is seen as a cause of one of the greatest changes in the history of art, namely, the shift from naturalism to abstraction in Late Antique and Byzantine art.

The remainder of this chapter builds upon these ideas while interpreting the transition from tessellated to marble pavements in a different way. We will start from the perception that the description of the marbles as elements of nature was more than rhetorical verbiage but reflected the way people actually

[60]*Homilia XXVII*, 2; ed. G. Rossi Taibbi, *Filagato da Cerami, Omelie per i vangeli domenicali e le feste di tutto l'anno*, Palermo, 1969, 175.

[61]W. Tronzo, *The Cultures of his Kingdom*, Princeton, NJ, 1997, 9, 29–37, 99–100, 129, figs. 18–22.

[62]J. Onians, "Abstraction and Imagination in Late Antiquity," *Art History* 3, no. 1 (1980), 1–23, esp. 9–12.

[63]Ibid., 11–12.

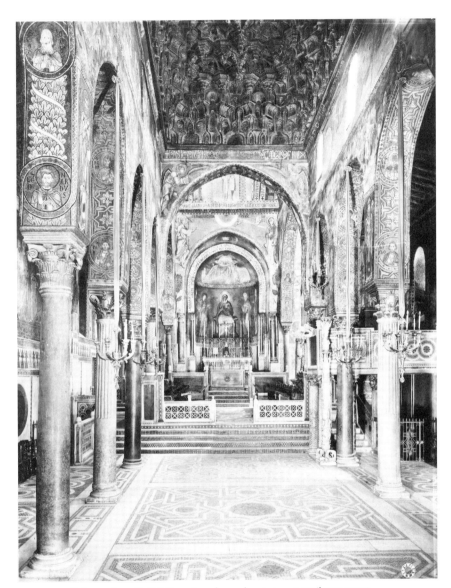

FIGURE 4.8. Palermo, Cappella Palatina, view of nave showing opus sectile pavement.

interpreted these materials.[64] For both artists and spectators, the marbles on the walls and floors of churches really did represent the earth; they were intended by the designers of the buildings to be viewed as the terrestrial world. As such,

[64]The point is also made by Tronzo, *Shield, Cross, and Meadow*, 247–248. See also L. Brubaker, "Aniconic Decoration in the Christian World (6th–11th Century): East and West," in *Cristianità d'occidente e cristianità d'oriente (secoli VI-XI)*, Settimane di Studio della Fondazione Centro Italiano di Studi sull'Alto Medioevo LI, Spoleto, 2004, 573–590, esp. 578.

they fitted into an overall concept of church decoration, which placed the earth at the bottom of the cosmic hierarchy. We shall also see that the adoption of veined marbles and polychromatic stones as nonfigural representations of terrestrial nature was not a purely aesthetic choice, prompted by the increasing capacity of the viewers' imaginations, but rather it was a response to the anxieties that already have been described concerning the status of nature-derived imagery in ecclesiastical buildings.

In the tenth century the poet and rhetorician John Geometres composed a verse ekphraseis of the basilica of the Stoudios Monastery in Constantinople, which is now a ruin.[65] John's ekphraseis demonstrates that in his time the marbles of the lower part of a Byzantine church were considered to represent terrestrial nature, in distinction to heaven, which was evoked in the vaults above. John Geometres described the marble columns that carried the nave arcades, a no-longer-surviving marble pavement, and the lost figural mosaics of the apse vault.[66] The apse vault depicted Christ accompanied by the cherubim and seraphim, the Virgin, and St. John the Baptist, the patron saint of the monastery. Thus, the apse portrayed a combination of the Deesis with the *Majestas Domini*.[67] The poet starts his ekphraseis by identifying the church as a miniature kosmos:

> If you long to see all beauties of the earth together with those of the heavens and every costly material, cease from running over the great widths of the earth and abandon searching the far away heights of the sky, but look at everything assembled here, at this small hall, the imitation of all.[68]

Then John Geometres, using the same metaphor as Paul the Silentiary, compares the marble floor to a sea, adding that the columns of the nave arcade were like snow melting into its waters:

[65]The text has been edited by J. A. Cramer, *Anecdota graeca e codd. manuscriptis bibliothecae regiae parisiensis*, vol. 4, Oxford, 1841, 306–307. For an art historical analysis of the text, especially of the images in the apse, see W. T. Woodfin, "A Majestas Domini in Middle-Byzantine Constantinople," *Cahiers archéologiques* 51 (2003–4), 45–53.

[66]The present, very damaged, opus sectile floor appears to date to the twelfth century, on account of its close similarity to the floor of the Pantocrator Monastery in Constantinople; see A. H. S. Megaw, "Notes on Recent Work of the Byzantine Institute in Istanbul," *Dumbarton Oaks Papers* 17 (1963), 333–371, esp. 339. Thus, the floor described by John Geometres must have been an earlier floor, which, however, appears to have incorporated slabs of marble, since the poet compares its glistening stones to "another sea," a simile also used to describe the slabs of Proconnesian marble that made up the floor of Hagia Sophia by Paul the Silentiary, *Descriptio ambonis*, lines 224–239 (ed. Friedländer, *Johannes von Gaza*, 263), by the *Narratio de Sancta Sophia*, 26 (ed. Preger, *Scriptores originum Constantinopolitana-rum*, 102–103), and by Michael the Deacon, lines 175–185 (C. Mango and J. Parker, "A Twelfth-Century Description of St. Sophia," *Dumbarton Oaks Papers* 14 (1960), 233–245, esp. 239). On this simile, see F. Barry, "Walking on Water: Cosmic Floors in Antiquity and the Middle Ages," *Art Bulletin* 89 (2007), 627–656.

[67]Woodfin, "Majestas Domini," 45–53.

[68]Cramer, ed., *Anecdota graeca*, 306, lines 20–25.

The brightness and whiteness of these columns and the charm of their many flashes of color, empty below like a bright stream of melting snow, flowing somehow without sound onto the glistening stones of the pavement, as if into another sea.[69]

Then the poet changes his metaphor, using the familiar topos to identify the variegated hues of the stones in the pavement as the earth:

But observe, if you will, the earth itself and the things of the earth, the variety of their colors and the beauty of the depictions. Here is painted another meadow, wrought from art, decked with flowers that wither not with time.[70]

From the description of the marbles that represent the terrestrial world, John Geometres turns to the golden mosaics in the semidome of the apse, which he describes in the following words:

The golden section of a sphere above flashing forth with a great light, where every color of mosaic cube comes together, as if to bring about one framed body, among the stars, or hanging, full of light, as if the whole breadth of the sky was illuminated by one single star of all colors. Take pleasure in seeing the kosmos in this way in all its beauty. But if you are kindled with the love above, see also the intelligible kosmos in the form.[71]

The poem goes on to describe the images of Christ, the Virgin, St. John the Baptist, and the celestial beings. Finally, John Geometres concludes by declaring that the building combines the two worlds, earthly and spiritual:

But if indeed there was some mixture of opposites, of all the kosmos below and of the things above, it is here, and let it now be called only the place of the beauties as is fitting for mortals.[72]

In his ekphraseis, then, the poet contrasts the colorful variety of the marbles below, which represent the earth, with the unified color of the golden apse above, which represents the immaterial light of the heavens. The language of the poem is derived from the Neo-Platonic mysticism of the sixth-century theologian Pseudo-Dionysios, who described a hierarchy of lights connecting the variety of the created world at the bottom to the single Light of God at the top. In the system of Pseudo-Dionysios even the lowliest of created matter shares in the divine light, so that contemplation of terrestrial things can lead, by a process of enlightenment, to an ascent toward the "One," that is, God. Speaking of the

[69]Ibid., 306, line 30–307, line 2.
[70]Ibid., 307, lines 3–7.
[71]Ibid., 307, lines 10–19.
[72]Ibid., 307, lines 27–30.

soul striving for union with the divine, Pseudo-Dionysios wrote, "Its movement is in a straight line when . . . it is uplifted from external things, as from certain variegated and pluralized symbols, to the simple and united contemplations."[73] A similar language was used by John Geometres to describe the Church of the Stoudios. His ekphraseis proceeds from the polychromy of the pavement and columns, with their glistening brightness and flashes of color, to the one great light of the semidome. Thus, even while Earth and heaven are separated by variegation of color below and by unity above, they are linked by the hierarchy of lights that they share.

The decoration of the Stoudios church described by John Geometres no longer survives, but we can gain an impression of what he was describing from the still preserved interior of Hagia Sophia in the same city. At Hagia Sophia the composition of the north and the south walls can be divided into two zones (plate XVII). The lower zone encompasses the arches opening onto the aisles and the galleries, where the worshippers would congregate. The upper zone encompasses the great arched tympana beneath the vaults. The spandrels of the aisle and gallery arches contain a sixth-century decoration derived from nature; leaves are carved in the openwork sculpture that frames the lower arches, while songbirds, water fowl, and vines are naturalistically portrayed in the intarsia work around the upper arches.[74] The great piers that flank the arches of the aisle and gallery are revetted with a variety of colored marbles, which, as we have seen, were described as the earth with its varied landscapes and vegetation by Procopius and Paul the Silentiary.[75] Above these depictions of earthly creation, both naturalistic and abstract, the upper zone received late ninth-century mosaics depicting saints, prophets, and angels, who were portrayed in the tympanum against a gold ground.[76] Thus, at Hagia Sophia, as in the Stoudios basilica, the marbles of the lower parts of the church contrasted with the golden gallery of sacred portraits above.

The posticonoclastic decoration of these two churches can be described as half-iconic, in that the spiritual was embodied in anthropomorphic images whereas the terrestrial in large part was represented abstractly, through polychromatic stones. Many preiconoclastic buildings, such as San Vitale in Ravenna, displayed portraits of Christ, the prophets, and the saints, together with naturalistic images of animals and plants (figures Intro-1 and Intro-2). In the iconoclastic mosaics of the church of Hagia Eirene in Constantinople,

[73]*De divinis nominibus*, 4.9; ed. B. R. Suchla, *Corpus Dionysiacum*, vol. 1, *Pseudo-Dionysius Areopagita: De divinis nominibus*, Berlin, 1990, 154; translation by C. Luibhéid, *Pseudo-Dionysius: The Complete Works*, New York, 1987, 78.

[74]H. Kähler, *Hagia Sophia*, New York, 1967, plates 36–37, 70, 74.

[75]Ibid., plates 40, 82.

[76]Ibid., 88; C. Mango, *Materials for the Study of the Mosaics of St. Sophia at Istanbul*, Washington, DC, 1962; C. Mango and E. J. W. Hawkins, "The Mosaics of St. Sophia at Istanbul: The Church Fathers in the North Tympanum," *Dumbarton Oaks Papers* 26 (1972), 1–41.

both earthly creation and the divinity were evoked in an essentially nonfigural fashion. In this church, two prominent scriptural quotations frame the arch of the apse (figure 1-22). The inner inscription, which is taken from Psalm 64:4–5, proclaims, "We shall be filled with the good things of thy house; thy temple is holy. Wonderful in righteousness, hear us, O God our Savior, the hope of all the ends of the earth and of those far off in the sea."[77] Thus, the inscription appeals to God's power over the earth and the waters. However, the apse of the icon-oclastic church contained virtually no figural decoration to represent the ter-restrial realms evoked in these passages. There is only a single cross set starkly against a gold ground in the conch, framed by a simple wreath of leaves and the highly abstract evocation of paradise, which consists, as shown in chapter 3, of stylized trefoil-shaped leaves in a pattern of repeated diamonds.[78]

In the decoration of posticonoclastic churches, such as St. Sophia in the late ninth century and the Stoudios basilica in the tenth, heaven was depicted by means of portrait icons whereas the earth was evoked partly by portrayals of birds and plants but mainly by the aniconic revetments of marbles (plate XVII). Thus, the decoration of Byzantine places of worship can be described as moving through a fully iconic phase before iconoclasm, represented by churches such as San Vitale, to a phase that was in some cases almost fully aniconic, as at Hagia Eirene, to a final resolution that was partly iconic and partly aniconic, insofar as Christ and the saints were portrayed in human form whereas the earthly world was portrayed in an abstract way through colored stones.

If colored marbles and opus sectile represented terrestrial nature, on account of their variety and polychromy, by the same token materials that had only a single color or that lacked intense color and were therefore seen as pale could be evocative of the spiritual world. These materials, which included pure gold, steatite, and unblemished white marble, were described by Byzantine writers as being especially appropriate for sacred portraits. In some medieval Byzantine texts we find a kind of ideological opposition between the polychromy of ter-restrial nature and the monochromatic pallor of the holy figures. Leo VI makes such a juxtaposition in another ekphraseis devoted to a church in Constantino-ple, that of the Monastery of Kauleas. Leo begins his description with the floor, saying that it is composed of slabs of white marble surrounded by a border of colored marble, which varied the appearance of the pavement in a pleasing way, although he says that the design is not as colorful as those found in other pavements. He then passes to the portrayal of Christ in the dome, which is surrounded by images of the Virgin and Child and of God's own servants. These representations, says Leo, are made of "mosaic polished with gold. The

[77]W. S. George, *The Church of Saint Eirene at Constantinople*, Oxford, 1912, 50–51; L. Brubaker and J. Haldon, *Byzantium in the Iconoclast Era (ca. 680–850): The Sources—An Annotated Survey*, Alder-shot, 2001, 20. I owe the reference to this inscription to Bissera Pentcheva.

[78]George, *Church of Saint Eirene*, plates 17–18.

craftsman," he explains, "perceiving the utility of gold, has used it bounteously: for . . . he realized that the pallor of gold was an appropriate color to depict the virtue of [their] members."[79] Thus, Leo creates a contrast between the variation in the colors of the marble floors and the "pallor of gold" in the holy images above, which expresses their spiritual value.

This opposition between earthly polychromy, or *poikilia*, and heavenly pallor was only one of the rhetorical frameworks that the Byzantines used to describe their art. Paradoxically, they also employed the same concept of *poikilia* to characterize the shimmering surface qualities of gold and bejeweled icons, as Bissera Pentcheva has shown.[80] Consequently, in one context a golden image could be called pale and colorless in contrast to the colorfulness and variety of terrestrial creation, but in another context it could be appreciated for its effects of variegated light. As we have had occasion to observe before, the meanings of such symbols in Byzantine art were not fixed but were relative to context.[81]

Another statement that gold was suitable for expressing the immaterial on account of its pallor can be found in a twelfth-century poem composed by Eugenios of Palermo, a Greek administrator and man of letters who served in the Sicilian court. The epigram, which describes a gilded icon of St. John Chrysostom, reads:

> All blessed one, both your color and your voice are golden.
> For the one [your voice], pouring out to us golden words,
> took its name from your deeds,
> while pallor delineates the holiness of your color.
> For consuming your flesh by the fire of fasting,
> you have tinged it with the pallor of gold.[82]

The early fourteenth-century miniature mosaic icon of St. John Chrysostom at Dumbarton Oaks embodies the essence of this poem, with the saint's pale white body emerging from a pallid background of pure gold (plate XVIII).

In addition to gold, steatite was another monochromatic material that was considered especially suitable for expressing the spiritual qualities of sacred portraits, because this stone is not mottled and frequently is white to pale green

[79]*Homilia XXXI*, ed. Antonopoulou, 425–426; Frolow, "Deux églises byzantines," 46–47; translation in Mango, *Art of the Byzantine Empire*, 202–203.

[80]Pentcheva, *Sensual Icon*, 139–143.

[81]In other contexts, a multicolored appearance or a lack of color could have different significations. For example, in the *History* of Niketas Choniates, *poikilia* represented instability of character; A. Kazhdan, *Studies on Byzantine Literature of the Eleventh and Twelfth Centuries*, Cambridge, 1984, 258–260. For the sometimes negative connotations of *ochros* (pale) when used by Byzantine writers describing New Testament scenes, see L. James, *Light and Colour in Byzantine Art*, Oxford, 1996, 83–84. On the tendency of gold to obscure surrounding hues, see R. Franses, "When All that Is Gold Does Not Glitter," in A. Eastmond and L. James, eds., *Icon and Word: The Power of Images in Byzantium. Studies Presented to Robin Cormack*, Aldershot, 2003, 13–23, esp. 19.

[82]M. Gigante, ed., *Versus iambici*, Palermo, 1964, no. 11.

in color. Ioli Kalavrezou discusses a group of epigrams attributed to the fourteenth-century poet Manuel Philes, which describe icons carved in steatite.[83] All of the poems played upon the word *amiantos*, meaning "unstained," "without spots," or "unvariegated." One of these verses has the title "Verses on a Steatite (*'lithon amianton'*) which has the Birth of Christ carved on it and above the bust of Christ. . . ." The poem begins as follows:

> I honor you, O stone; even though you are small to look at.
> Nevertheless you contain within you the uncontainable.
> But you are truly spotless,
> for you represent the spotless mother.[84]

Another poem, describing the same steatite carving, refers to the typology that compared Christ to the "stone cut from the mountain by no human hand," described in Daniel 2:45. The epigram reads in its entirety:

> Blessings upon you, sculptor's hand!
> For you delineate on the spotless stone
> the stone that came from the mountain, cut without human hands,
> which came forth from the spotless Virgin.[85]

A third poem has the title, "To a spotless icon of the Mother of God." It begins:

> Being the unburnt burning bush,
> perfect, you have been carved into the immaculate stone.[86]

In all of these poems steatite is viewed as an appropriate material for sacred figures precisely because it lacked the variegation found in colored marbles, which, as we have seen, were associated with the earth.

The symbolism of steatite also was multivalent, especially as the stone occurs in a range of colors. In a fourth poem attributed to Philes on the same carved steatite icon of the Nativity, we read, "The stone is a meadow which has Christ as the plant [or offspring]."[87] In this case, the poet does not comment on the stone's lack of variegation but rather on its green hue, which he associates with the idea of a meadow. In other words, this is one more example of the old idea that colored stone evokes a field, which is used here as a metaphor for the Virgin. A similar sentiment is found in another fourteenth-century epigram, by

[83]I. Kalavrezou-Maxeiner, *Byzantine Icons in Steatite*, Vienna, 1985, 78.

[84]E. Miller, ed., *Manuelis Philae carmina*, vol. 1, Paris, 1855, 430, no. 218; translation after Kalavrezou-Maxeiner, *Byzantine Icons in Steatite*, 81–82.

[85]Miller, ed., *Manuelis Philae carmina*, vol. 1, 431, no. 221; Kalavrezou-Maxeiner, *Byzantine Icons in Steatite*, 82.

[86]Miller, ed., *Manuelis Philae carmina*, vol. 2, 1857, 146, no. 95; Kalavrezou-Maxeiner, *Byzantine Icons in Steatite*, 80–81.

[87]Miller, ed., *Manuelis Philae carmina*, vol. 1, 431, no. 220; Kalavrezou-Maxeiner, *Byzantine Icons in Steatite*, 83.

an unknown author, which was inscribed on a paten carved out of green steatite. This dish, formerly in the Panteleimon Monastery on Mount Athos, portrays the Virgin and Child in a medallion at the center, surrounded by a ring of prophets and by the poetic inscription in the outer border.[88] The inscription opens:

> The meadow and the plants and the light with three rays—
> the stone is the meadow and the prophets in array are the plants. . . .[89]

Some epigrams describe icons carved from pure white marble. Here, also, the immaculate and colorless character of the stone is seen as expressive of spiritual merit. For example, a twelfth-century epigram by Nicholas Kallikles on a relief icon of St. George bears the title, "On St. George represented in white stone." It declares:

> . . .If he had any ruddiness of flesh,
> this became like snow, and was found to be white,
> having been washed out by a martyr's sweats.[90]

A later poem by Philes, which has the heading, "On the marble stele of the great martyr George," conveys a similar idea:

> The stone that has been toiled at to produce a carving
> of the crowned one,
> displays his unbending strength in the face of toils.
> For it was not reasonable to cut (in stone) with colors
> the one who carries deep cuts in his flesh.[91]

Many epigrams praise icons of sacred figures for the pallor displayed by the portraits. The word used to denote pallor is often *ochrotes*, which describes a complexion that is pale, wan, and without intense color. For example, an eleventh-century poem by John Mauropous on an icon of St. Basil begins, "A certain august pallor from self-control befits the wise teacher."[92] In the fourteenth

[88]Kalavrezou-Maxeiner, *Byzantine Icons in Steatite*, 83–85, 206–208, no. 132, plate 65; Y. Piatnitsky, "The *Panagiarion* of Alexios Komnenos Angelos and Middle Byzantine Painting," in O. Z. Pevny, ed., *Perceptions of Byzantium and Its Neighbors (843–1261)*, New York, 2000, 40–55; A. Rhoby, *Byzantinische Epigramme in inschriftlicher Überlieferung*, vol. 2, *Byzantinische Epigramme auf Ikonen und Objekten der Kleinkunst*, Vienna, 2010, 362–365.

[89]Kalavrezou-Maxeiner, *Byzantine Icons in Steatite*, 83, 206; Piatnitsky, "The *Panagiarion* of Alexios Komnenos Angelos," 40; Rhoby, *Byzantinische Epigramme*, vol. 2, 363.

[90]R. Romano, ed., *Nicola Callicle, carmi*, Naples, 1980, 80, no. 3. The poem's title is given as, "On St. George represented in white stone." A fragment of a white marble relief of a military saint, perhaps George or Demetrios, has survived from the Cathedral Church of Traianoupolis in Thrace; Ch. Bakirtzis, "Byzantine Thrace (AD 330–1453)," in *Thrace*, Athens, 1994, 151–209, esp. 186.

[91]Miller, ed., *Manuelis Philae carmina*, vol. 1, 34, no. 75. The poem's title is given as, "On the marble stele of the great Martyr George."

[92]J. Bollig and P. de Lagarde, eds., *Iohannis Euchaitorum Metropolitae quae in codice vaticano graeco 676 supersunt*, Göttingen, 1882, 9, no. 16.

century Philes characterizes a portrait of St. John Chrysostom as "accurately shown thin and pale,"[93] just as he appears in the contemporary mosaic icon of John Chrysostom at Dumbarton Oaks (plate XVIII). The same author wrote an epigram on an icon of St. Michael, in which he claims that the whole of the angel's countenance "would have been red as fire even in the image, had not a certain reverence for the mystic liturgy painted it pale instead, out of artistic skill."[94]

This Byzantine distinction between variegated marbles as representing earthly matter and monochrome materials as expressing the divine was ultimately derived from classical art. For example, a second-century Roman nymphaeum in Byzantium displayed a statue group of gods defeating the giants. The gods, who included Apollo and Artemis, were carved in a pure white marble, while their rock-throwing opponents, the snake-legged giants who were the progeny of the earth, were made of a dark gray, mottled limestone.[95] A similar symbolism of materials could be seen in another Roman statue from Byzantium, which portrays a triton. In this case the creature was sculpted from a single block of partly white and partly black Aphrodisias marble. The human upper part of the creature was executed in the white portion of the block, whereas its nether portion, its fishy tail, was carved in the part of the stone that is black and spotted.[96]

Conclusion

In medieval Byzantine churches, the pavement of opus sectile represented the earth, with its flowers, trees, and rivers. Not only were the stones themselves derived from different parts of the earth, but also their variegated colors, dappled effect, and abstraction set them in opposition to the immaculate icons on the walls and vaults above, whose spiritual value was expressed by the spotless pallor of gold and whose portraits were carefully differentiated. The conversion of naturalistic portrayals of plants into patterns of colored stone relates to the sparseness of nature-derived imagery on the walls of posticonoclastic Byzantine churches and to the generic character of the few vegetal motifs that did remain. The opus sectile floors can be seen as aniconic substitutions for the tessellated floors that in preiconoclastic buildings had depicted the world of nature in a naturalistic way. Therefore, one can interpret the replacement of the naturalistic mosaic floors by the abstract marble pavements not only as the

[93]Miller, ed., *Manuelis Philae carmina*, vol. 1, 34, no. 73.

[94]Miller, ed., *Manuelis Philae carmina*, vol. 2, 202, no. 187.

[95]*From Byzantion to Istanbul: 8000 Years of a Capital* (exhibition catalogue, Sakıp Sabancı Museum), Istanbul, 2010, 60–68, nos. 019–029.

[96]Ibid., 74, 447, no. 050.

result of the heightening of viewers' imaginations through rhetoric but also as a response to the whole complex of Byzantine anxieties concerning the appropriateness of images from nature in the decoration of churches.

Even when there was no money for an expensive opus sectile floor, marble revetments, or golden mosaics, the ideas expressed by these media could be represented in less costly materials. Thus, in the well-preserved late twelfth-century frescoes in the church of the Virgin Arakiotissa at Lagoudera, on Cyprus, we see colored marbles reproduced in painted form on the dado of the walls, where there is a series of alternating roundels of fictive porphyry and green marble (plate II).[97] Above this decoration there is an almost purely anthropomorphic gallery of holy figures, with only the most minimal use of schematic floral ornament in the borders. Even St. Neophytos, the hermit and self-proclaimed ascetic, had a large panel enclosing an imitation porphyry medallion painted over the bench in his cell.[98]

Asterios, bishop of Amaseia, in the introduction to his ekphraseis of a painting of the martyrdom of Euphemia, which he composed around 400, boasted that "we men of letters can use colors no worse than painters do."[99] But in the case of the representation of nature in posticonoclastic churches, we can see that the orators had an advantage over the artists, for they were permitted to say more than the artists were encouraged to portray. In the rhetoric of medieval ekphraseis, the flowers depicted on the pavement were so true to life that they attracted live bees. But in the actual pavements, they were evoked only through the abstract patterns of colored stones.

Three conclusions of a more general nature may be drawn from the material presented in this chapter. First, as we have seen in earlier chapters, literature and the visual arts followed different imperatives. What was acceptable or desirable in speech was not necessarily so in visual representation. Second, changes in viewing accompanied changes in ideology; they did not occur in a vacuum. Finally, in the art of medieval Byzantine churches, relatively speaking, closeness of definition was reserved for the spiritual, while the avoidance of definition was associated with the mundane. This last conclusion reverses the conventional view of Byzantine art, which tends to associate abstraction with the depiction of the transcendental.[100]

[97]Winfield and Winfield, *Church of the Panaghia tou Arakos*, plates 2–4.

[98]Mango and Hawkins, "The Hermitage of St. Neophytos and Its Wall Paintings," *Dumbarton Oaks Papers* 20 (1966), 136–206, esp. 179–190, fig. 82.

[99]F. Halkin, ed., *Euphémie de Chalcédoine*, Brussels, 1965, 5; translation in Mango, *Art of the Byzantine Empire*, 38.

[100]See, for example, M. Stokstad, *Art History*, 3d ed., Upper Saddle River, NJ, 2008, 263: "The Roman interest in capturing the visual appearance of the material world gave way in Christian art to a new style that sought to express essential religious meaning rather than exact external appearance. Geometric simplification of forms, an expressionistic abstraction of figures . . . characterized the new style."

5 }

Nature and Architecture

Early Byzantine artists exploited imagery from the natural world both as metonymy and as metaphor. Portrayals of individual animals and plants evoked the whole of earthly creation, the parts standing for the whole, while they could act also as metaphors of the spiritual world. We have seen that these motifs from the terrestrial world, which had featured so prominently in early churches, became less frequent after iconoclasm, leaving a more strictly anthropomorphic gallery of sacred figures. But medieval Byzantine artists, even as they became more reluctant to depict images from nature, still placed their sacred portraits and scenes into architectural settings, which were sometimes extremely elaborate. The question, then, arises of the extent to which depictions of architecture substituted for the old portrayals of animals and plants as conveyors of Christian meaning.[1] Were the architectural backgrounds merely inert supplements to sacred iconography, or did they carry a new metaphorical significance?

We have already had occasion to observe that Byzantine artists after iconoclasm were more often willing to illustrate metaphors that were inorganic in character than ones that were organic. A case in point is the cycle of the *Akathistos Hymn*, where painters portrayed images such as the veil, or the lamp full of light (figure 3-3), while they tended to avoid visualizing the metaphors derived from animals or plants. Just as a veil or a lamp could be considered innocuous, depictions of buildings also brought no danger of idolatry, and this made them especially suitable to act as conveyors of spiritual meaning in medieval Byzantine art. In this chapter we will look at four different types of architectural symbolism in posticonoclastic Byzantine art: first, the metaphorical use of specific architectural elements, such as stairs, gates, ciboria, and columns; second, the contrast of physical and immaterial space; third, the opposition of stability and mutability; and fourth, the absence of architecture

[1]For a recent treatment of architectural space, especially the problem of "reverse perspective" in medieval and post-Byzantine art, see C. Antonova, *Space, Time, and Presence in the Icon: Seeing the World with the Eyes of God*, Farnham, 2010.

in scenes of the divine and imperial courts. In a few cases the architectural symbolism accompanies nature-derived imagery, but in other cases the organic motifs are absent, so that the buildings can be seen as substitute providers of meaning.

Architectural Metaphor

In their praises of the Virgin, Byzantine authors of all periods often compared her to various architectural shapes and forms. We have seen that the fifth-century preacher Hesychius of Jerusalem likened Mary to a temple greater than the sky, to the closed door of paradise, and to the enclosed garden fertile without seed.[2] In the *Akathistos Hymn*, we found the Virgin described as the wall, the pillar, the mansion, the strong tower, the heavenly ladder, the bridge, the gate, and finally the key.[3] These metaphors continued into the Middle Ages. Thus, at the end of the twelfth century, the Cypriot Saint Neophytos, preaching a sermon on the Feast of the Annunciation to his monks, described the Virgin as the tower, the ladder, the gate, and the door.[4] In another sermon, preached on the Feast of the Presentation, Neophytos described the Virgin bringing the Christ Child to the temple through a series of metaphors:

> She has come as the ladder, holding fast in herself the Lord in order to save and make fast mankind from destruction She has come as the pyramid, holding in her womb the grain of life in order to furnish grain to those who have need of it She has come as the palace and throne of the King and as a beautified queen, holding the king of glory as befits a mother, in order to call those who love her to the kingdom of God.[5]

As is evident from these tropes, many of the architectural metaphors were linked with Old Testament types, which foreshadowed the incarnation. Thus, the ladder was associated with Jacob's dream,[6] the pyramids with Egypt and with Joseph storing the grain,[7] and the locked gate with Ezekiel.[8]

We can find sporadic illustrations of this kind of metaphorical imagery in posticonoclastic art. For example, on a twelfth-century icon of the Virgin

[2]Homilia V, 1–3; ed. M. Aubineau, *Les homélies festales d'Hésychius de Jérusalem*, vol. 1, Subsidia hagiographica LIX, Brussels, 1978, 158–164.

[3]L. M. Peltomaa, ed. and trans., *The Image of the Virgin Mary in the Akathistos Hymn*, Leiden, 2001, 2–19.

[4]M. Torniolo, ed., "Omelie e catechesi mariane inedite di Neofito il Recluso (1134–1220c.)," *Marianum* 36 (1974), 242–245.

[5]Ibid., 304–307.

[6]Genesis 28:12.

[7]Genesis 41:47–49.

[8]Ezekiel 44:1–3.

and Child at Mount Sinai we find Ezekiel portrayed in the border standing beside his locked gate, together with Jacob flanked by the ladder.[9] For the metaphorical deployment of architecture, the best example is probably the late twelfth-century fresco of the Annunciation at Lagoudera on Cyprus, a painting approximately contemporary with the preaching of St. Neophytos on the same island (plate XIX).[10] As in many Byzantine churches, the Annunciation is positioned on either side of the arch opening into the sanctuary, on the eastern pendentives beneath the dome. Behind the Virgin is a splendid edifice, a kind of palace of metaphors. Here we find on the left a tower-like structure, with a line of steps running up its façade. The building has a prominent gate, with a clearly delineated hole for the key. Because at least one of these features, the stairs, occurs in other Annunciation scenes, it is likely that the architectural elements were intended to serve as metaphors of the Virgin and not merely as embellishments drawn from the painter's imagination.[11] In the Annunciation scene painted on a late twelfth-century polyptych now preserved at Mount Sinai, for example, a prominent staircase with a balustrade leads to the upper levels of the Virgin's house.[12] In this case architectural symbolism is combined with the imagery of nature, for the terrace to which the steps lead supports a roof garden flourishing with trees. This terraced garden resembles the one depicted in the contemporary icon of the Annunciation at Mount Sinai illustrated in figure 2-5,[13] except that in the polyptych there are no nesting birds and the background behind the plants is white. This last feature narrows the meaning of the stairway, for it is seen to lead directly to the unchanging climate of paradise.

Even if it is likely that the tower, the steps, the gate, and the keyhole in the Annunciation at Lagoudera were designed to be metaphors, in other cases it is hard to determine whether a given motif was intended by the artist to be read as a metaphor or only as a part of an actual building, or as both at the same time. We may take as an example the depiction of the Virgin's house in the aforementioned icon of the Annunciation at Mount Sinai (figure 2-5).

[9]H. Belting, *Likeness and Presence: a History of the Image before the Era of Art*, Chicago, 1994, 291–294, figs. 174, 178; E. C. Evans and W. D. Wixom, *The Glory of Byzantium: Art and Culture of the Middle Byzantine Era, a.d. 843–1261* (exhibition catalogue, Metropolitan Museum of Art), New York, 1997, 372, no. 244.

[10]A. Nicolaïdès, "L'église de la Panagia Arakiotissa à Lagoudéra, Chypre: Étude iconographique des fresques de 1192," *Dumbarton Oaks Papers* 50 (1996), 1–137, esp. 69–71, figs. 60–61; D. Winfield and J. Winfield, *The Church of the Panaghia tou Arakos at Lagoudhera, Cyprus: The Paintings and their Painterly Significance*, Washington, DC, 2003, pl. 19, figs. 81a–b. On the rich painted architectures in this church, see A. H. S. Megaw, "Background Architecture in the Lagoudera Frescoes," *Jahrbuch der Österreichischen Byzantinistik* 21 (1972), 195–201.

[11]Nicolaïdès, "L'église de la Panagia Arakiotissa," 69–70.

[12]K. A., Manafis, ed., *Sinai: Treasures of the Monastery of Saint Catherine*, Athens, 1990, 108, 158, fig. 28.

[13]Evans and Wixom, *Glory of Byzantium*, 374–375, no. 246.

Should we read the prominent opening immediately to the right of Mary as the metaphor of the door? And, if so, what should we make of the columns that rise above her head? Are they to be interpreted as illustrations of the metaphorical pillar that appears in the *Akathistos Hymn*,[14] or are they merely necessary parts of the building needed to keep the superstructure from falling down?

It is apparent that Byzantine artists themselves were troubled by questions of this kind, for sometimes they took pains to indicate that a motif that might be considered as merely a normal component of a scene was also to be read as a metaphor. A case in point is the censer held by one or more mourners in scenes of the Dormition of the Virgin. The censer was part of the traditional iconography of the death of the Virgin, since incense was a usual component of the funerary liturgy. But, in addition, the incense burner frequently appears in Byzantine literature as a metaphor of the Virgin, who held within her the fire of divinity. Among others, Andrew of Crete, John of Damascus, and St. Neophytos all used the image of the censer to evoke the incarnation through Mary.[15] Andrew of Crete, in a sermon on the Birth of the Virgin, refers to her as "the gold thurible of truly spiritual fragrances, in which Christ, the spiritual incense [was] formed from the union of the divine and the human"[16] As Maria Evangelatou shows, in at least two paintings of the Dormition, a fresco at Lagoudera and an icon at Mount Sinai, one of the bishops officiating at the Virgin's funeral not only holds the censer but also points at it with his index finger to bring attention to its spiritual meaning.[17] In the fresco of the Dormition at Lagoudera, the censer to which the bishop points occupies the exact center of the composition, so that it becomes the focal point of the entire scene (figure 5-1). This placement of the incense burner further emphasizes the spiritual significance of the vessel.

In some cases we can demonstrate that an architectural feature depicted in a work of art has a double significance, both as part of a structure that actually existed and as a symbol. A good example is an ivory panel in the Victoria and Albert Museum, which probably dates to the late twelfth or early thirteenth century (figure 5-2).[18] Although it is carved in a strongly

[14]On the symbolism of the column, see H. Papastavrou, "Le symbolisme de la colonne dans la scène de l'Annonciation," *Deltion tes Christianikes Archaiologikes Etaireias* 15 (1989–90), 145–160; Papastavrou, *Recherche iconographique dans l'art byzantin et occidental du XIe au XVe siècle. L'Annonciation*, Venice, 2007, 261–286.

[15]M. Evangelatou, "The Symbolism of the Censer in Byzantine Representations of the Dormition of the Virgin," in M. Vassilaki, ed., *Images of the Mother of God: Perceptions of the Theotokos in Byzantium*, Aldershot, 2004, 117–131, esp. 121–122.

[16]*In Nativitatem Beatae Mariae*; ed. J.-P. Migne, Patrologiae cursus completus, Series Graeca XCVII, col. 877; translation by Evangelatou, "Symbolism of the Censer," 121.

[17]Evangelatou, "Symbolism of the Censer," 119–121, figs. 10.2, 10.6.

[18]A. Goldschmidt and K. Weitzmann, *Die byzantinischen Elfenbeinskulpturen des X.-XIII. Jahrhunderts*, vol. 2, Berlin, 1934, 73–74, no. 198, pl. 66; P. Williamson, *Medieval Ivory Carvings: Early Christian*

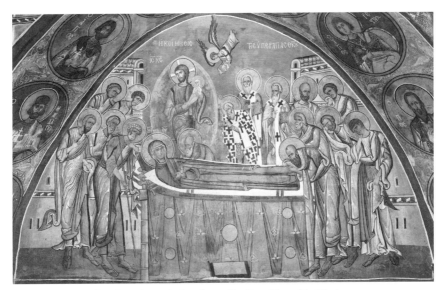

FIGURE 5.1. Lagoudera, Panagia tou Arakos, fresco. The Dormition of the Virgin.

Byzantine style, it may be classified as pilgrimage art, since it references the holy sites of Palestine. The ivory portrays six scenes from the life of Christ, beginning with the Annunciation. The Annunciation displays an unusual structure in the background; on the left of the Virgin, behind the angel, there is a wall, behind which rise two columns crowned with capitals. The columns are free-standing and do not appear to be supporting anything. They can probably be identified with the two columns that were inserted into the grotto of the Annunciation at Nazareth by the crusaders when they built the new church over the cave, at the beginning of the twelfth century. The columns were necessary to support one of the piers of the Romanesque structure. Later, however, the two columns became objects of pilgrimage in their own right. They were known as the column of the Virgin and the column of the angel, and some people tried to remove pieces of them with chisels to carry away as relics. Reportedly, the Virgin clung onto one of the columns in fright when the angel addressed her—a reaction that was illustrated in some fourteenth-century Italian paintings.[19] Thus, the Annunciation scene on the ivory illustrates the actual columns that pilgrims could see and venerate at the holy site at Nazareth. But these columns could also be read as symbols, in that they were associated with the Virgin and Gabriel, respectively.

to Romanesque, London, 2010, 134–137, no. 31. On the date, see H. Maguire, "Ivories as Pilgrimage Art: a New Frame for the 'Frame Group,'" *Dumbarton Oaks Papers* 63 (2009), 117–146, esp. 145.

[19]Maguire, "Ivories as Pilgrimage Art," 119–121.

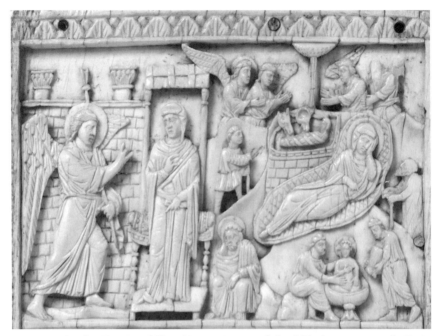

FIGURE 5.2. London, Victoria and Albert Museum, ivory panel, detail. The Annunciation to the Virgin and the Nativity of Christ.

Of all the architectural metaphors associated with the Virgin, the gate appeared most frequently in Byzantine art. In a general sense, it was implied by every Annunciation scene that was represented on an arch above the opening to the sanctuary, as was the case at Lagoudera (plates II and XIX). The Annunciation was also frequently painted on the doors of the sanctuary screen, with the angel on one leaf and the Virgin on the other. In these cases, in addition to the evocation of the Virgin as the door to paradise, there was a complex symbolism of the incarnation and its liturgical reenactment in the sanctuary through the Eucharistic rite.[20]

A subtle use of the image of the door appears in a mosaic on one of the piers flanking the sanctuary of the church of St. Demetrios in Thessaloniki (figure 5-3). The date of the mosaic is uncertain, but it was probably created after iconoclasm had ended, in the ninth century. On the right we see St. Theodore, with his hands raised in prayer. The saint stands in a frontal pose, facing the viewer. On the left is the Virgin, shown in a turning position, as the intermediary between the praying saint on the right and her son who appears in heaven above. The scroll held by the virgin contains the words of

[20]See W. Woodfin, "Wall, Veil, and Body: Textiles and Architecture in the Late Byzantine Church," in H. A. Klein, R. G. Ousterhout, and B. Pitarakis, eds., *The Kariye Camii Reconsidered*, Istanbul, 2011, 371–385, esp. 380.

her petition: "Supplication. Lord God hear the voice of my prayer, for I pray for the world."[21]

Behind the Virgin and St. Theodore is a high wall. The rays of light that come down from the half-circle of heaven appear to descend on the other side of the wall, that is, behind it. Thus, we may imagine the space beyond the wall as filled with heavenly light. The only way through the wall is by means of a tall and very narrow door, which contains a scrolling plant, suggestive of paradise. The composition clearly portrays the Virgin as the door to paradise.

It is interesting to contrast this portrayal of paradise with an earlier, sixth-century mosaic of St. Demetrios in the same church (figure 5-4). In this composition we see the saint on the left standing in prayer in front of his shrine, while on the right a woman presents her child to him. Behind the mother and child is a green landscape with hills and trees.[22] This landscape also is evocative of paradise, but in this preiconoclastic mosaic paradise is more open and accessible than is the barely visible garden glimpsed in the other panel. In the later mosaic, the wall, with its single narrow gate, encloses paradise; the desired place is attainable only through a strict protocol of petitions submitted through rising levels of saintly authority—first Theodore, who is shown facing the viewer, then the Virgin, who turns in intercession, and finally Christ in heaven. This mosaic corresponds to descriptions of paradise in posticonoclastic Byzantine texts, which tended to view it as increasingly remote, cut off, and difficult of access. In the ninth-century life of Philaretos the Merciful, for example, paradise was described as a marvelous garden, but its access was blocked by a river of fire, across which there was only a single bridge, the width of a human hair.[23] Barely more reachable was the paradise described in the late tenth- or early eleventh-century Apocalypse of Anastasia, whose fruiting trees were also guarded by a river of fire with another difficult bridge, this one twelve fingers wide.[24] The ninth-century mosaic shows in a dramatic way how, in the period after iconoclasm, an architectural metaphor, the wall with a narrow door, was substituted for the natural landscape that filled the earlier panel.

Another architectural metaphor that occasionally accompanies the Virgin in medieval Byzantine art is the ciborium, or canopy on columns. We see such a structure, for example, crowning the building behind the Virgin in the last of the

[21]G. A. Soteriou and M. G. Soteriou, *H Basilike tou Agiou Demetriou Thessalonikes*, Athens, 1952, 195–196, plate 66. On the date, see Ch. Bakirtzis, *The Basilica of St. Demetrius*, Thessaloniki, 1988, 58.

[22]Soteriou and Soteriou, *H Basilike*, 192–193, plate 62; R. Cormack, *Writing in Gold: Byzantine Society and Its Icons*, London, 1985, 80–82, fig. 23.

[23]M. H. Fourmy and M. Leroy, eds., "La vie de S. Philarète," *Byzantion* 9 (1934), 85–170, esp. 161–165.

[24]R. Homburg, ed., *Apocalypsis Anastasiae*, Leipzig, 1903, 18; J. Baun, *Tales from Another Byzantium: Celestial Journey and Local Community in the Mediaeval Greek Apocrypha*, New York, 2007, 407. Also hard to access was the grassy paradise described in the tenth-century *Vision of the Monk Cosmas*, which was reached by a very narrow path overhanging an abyss; *Synaxarium ecclesiae Constantinopolitanae*, ed. H. Delehaye, *Propylaeum ad Acta Sanctorum Novembris*, Brussels, 1902, 110–112.

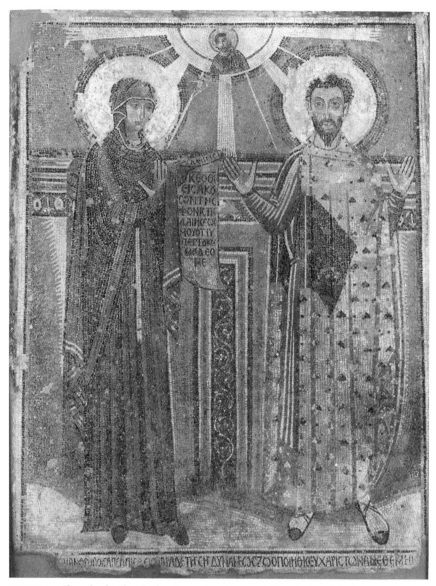

FIGURE 5.3. Thessaloniki, Church of St. Demetrios, pier mosaic. The Virgin and the door.

five miniatures that depict the Annunciation in the illustrated *Homilies of James of Kokkinobaphos* (figure 5-16).[25] Here the ciborium takes the form of a cupola supported on arches carried on slender columns. The passage that is illustrated by this miniature describes how the Virgin, after overcoming her doubts, finally

[25]I. Hutter and P. Canart, *Das Marienhomiliar des Mönchs Jakobos von Kokkinobaphos, Codex Vaticanus Graecus 1162*, Codices e vaticanis selecti LXXIX, Zurich, 1991, fol. 127v.

FIGURE 5.4. Thessaloniki, Church of St. Demetrios, wall mosaic. St. Demetrios with supplicants in a landscape.

accepted her role in the incarnation, whereupon the angels danced for joy in heaven. The ciborium does not crown the Virgin's house in any of the previous four Annunciation scenes,[26] which portray the angel's initial greeting and the Virgin's anxieties, but it appears only in the last scene of her final acquiescence to the angel's message (figures 5-12 to 5-16). There is, then, a strong likelihood that the ciborium was intended to convey a special meaning. The most likely supposition is that it portrays the temple, since Byzantine writers described the Virgin as the living temple of the incarnate Lord. St. Neophytos, for example, in a sermon on the Presentation of the Virgin, calls the Virgin an "all hallowed temple" occupied by God and "a living temple, the maiden who contains God and is chosen by God."[27] In medieval Byzantine portrayals of the Presentation, the temple of Solomon was frequently portrayed as a simple ciborium, similar to the one that is depicted on top of the Virgin's house in the miniature. It is shown in this form, for example, in a miniature of the sumptuously illustrated set of *Homilies of Gregory of Nazianzus*, now in Paris, which was originally presented to Emperor Basil I between 879 and 882 (figure 5-5).[28]

[26]Ibid., fols. 118, 122, 124, 126.

[27]Torniolo, ed., "Omelie," 213.

[28]Paris, Bibliothèque Nationale, MS. Gr. 510, fol. 137; L. Brubaker, *Vision and Meaning in Ninth-Century Byzantium: Image as Exegesis in the Homilies of Gregory of Nazianzus*, Cambridge, 1999, 68–69, fig. 18. The view of Jerusalem in the fourteenth-century mosaic of the Entry into Jerusalem in the Church of the Holy Apostles in Thessaloniki includes a portrayal of the temple as a circular building with a ciborium attached to it; A. Xyngopoulos, *E Psephidote diakosmesis tou naou ton Agion Apostolon Thessalonikes*, Thessaloniki, 1953, 23, 26, plates 22, 25, 2.

Physical and Immaterial Space

Notwithstanding the cases that have been discussed here, it is relatively seldom that we can say with certainty that a medieval Byzantine artist has used an architectural form such as a column as a metaphor or symbol in the same way as writers used such images. In most instances there is nothing in the painting to guide the viewer to a metaphorical interpretation. However, we can speak with much more assurance about another form of architectural symbolism, namely, the use of opposition to convey spiritual significance. For an illustration of this type of symbolism, which was based on the contrast of physical with immaterial space, we can turn again to the late ninth-century miniatures of the *Homilies of Gregory of Nazianzus* in Paris. Here we can compare the miniature of the Presentation of Christ in the Temple with the painting of the Consecration of St. Gregory as bishop of Constantinople in 381, which occurs later in the manuscript (figures 5-5 and 5-6).[29] The consecration of the earthly prelate with the Gospel book takes place within an interior space indicated by a low marble screen that encloses the sanctuary of a church, whose apse rises in the background. The oblique perspective employed in the rendering creates a strong illusion of the space that encloses the figures. On the other hand, in the painting of the Presentation of Christ, the sanctuary of the temple is indicated only by the altar and its ciborium. These elements of architecture stand apart, to the right of and separate from the actors in the scene. In the bishop's consecration, therefore, the candidate is enclosed by the architecture. In the case of Christ's presentation, the figures are disengaged from their architectural setting; they have become less tied to physical surroundings and thus less earthbound.

Evidently, we have here a symbolism concerned with the spiritual status of the two episodes: the consecration of the earthly bishop in the church at Constantinople on one hand and the scene from the life of Christ depicting his arrival at the temple in Jerusalem on the other. The construction of a convincing interior space required a considerable amount of architectural framework beside and behind the figures, and this had the effect of detracting from their sacrality. For this reason, the withholding of architectural detail could be a way of increasing the spiritual significance of a scene. Of course, this kind of symbolism could operate only through comparison with other scenes in the same context, meaning, in this case, paintings in the same manuscript, which shared a similar repertoire of style and motifs. The symbolism was not absolute but relative.

We can also see this symbolism of a more physical opposed to a more immaterial setting working in paired portrayals of the Annunciation by the Well and of the second, and spiritually more significant, Annunciation in the Virgin's house. When the two Annunciations were portrayed together in the same location,

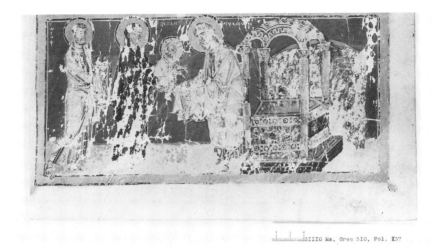

FIGURE 5.5. Paris, Bibliothèque nationale de France, MS. Gr. 510 (*Homilies of Gregory of Nazianzus*), folio 137, detail. Presentation of Christ in the Temple.

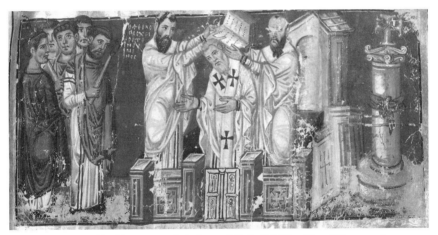

FIGURE 5.6. Paris, Bibliothèque nationale de France, MS. Gr. 510 (*Homilies of Gregory of Nazianzus*), folio 452, detail. Consecration of Gregory of Nazianzus.

medieval artists often gave more realistic architectural detail to the first, lower-status scene than they did to the second. For example, in the twelfth-century paintings of the church of the Hagioi Anargyroi at Kastoria, in northern Greece, the Annunciation by the Well, depicted in the nave, includes the realistic detail of an ancient foliate Corinthian capital turned upside down and used as a well head (figure 5-7).[30] Above the well we see the wooden mechanism for raising the water, which is shown in perspective. Such picturesque details of medieval daily life are

[30]S. Pelekanidis, *Kastoria*, vol. 1, *Byzantinai toichographiai*, Thessaloniki, 1953, plate 15a; S. Pelekanidis and M. Chatzidakis, *Kastoria*, Athens, 1985, 22–49, fig. 14 on page 34.

generally absent from scenes of the Annunciation proper, as can be seen in the fresco on the arch opening in to the sanctuary of the same church (figure 5-8).[31] In this case, the architecture of the Virgin's house is rendered as a flat screen with small window-like openings. We find none of the realia that characterized the Annunciation by the Well.

The respective roles of nature and architecture in Byzantine art can be seen especially well in the case of portraits of the Evangelists. In the preiconoclastic period, the mosaics of San Vitale preserve a set of portraits of the four Evangelists, who are portrayed flanking the openings of the galleries at the four corners of the sanctuary (figure Intro-1).[32] Through their position, they are associated with the rich panoply of plants, birds, and beasts that appears on the walls and the vault above them. The Evangelists sit in rocky landscapes, with streams of water beneath their feet, beside which marsh and river birds, such as ducks and herons, are wading. It is probable that the streams represent the four rivers of paradise, which early Christian writers associated with the Evangelists, whose teachings, like the rivers, irrigated the whole world.[33] For example, in a letter composed in the mid-third century, St. Cyprian wrote of the church: "*Ecclesia*, portraying the likeness of paradise, included within her walls fruit-bearing trees . . . [which] she waters with four rivers, that is, with the four Gospels"[34] Many other church writers, including St. Jerome and St. Augustine, associated the authors of the Gospels with the rivers of paradise.[35] In some works of art, the four rivers were explicitly linked with the Evangelists by means of an inscription. For example, Paulinus of Nola composed the following poem to be written on the apse mosaic of a basilica that he constructed at the beginning of the fifth century in Nola:

> He [Christ] himself, the rock of the church, is standing on a rock
> From which four seething springs issue,
> The Evangelists, the living streams of Christ.[36]

[31]Pelekanidis, *Kastoria*, plate 14a.

[32]F. W. Deichmann, *Frühchristliche Bauten und Mosaiken von Ravenna*, Baden-Baden, 1958, plates 332–335; Deichmann, *Ravenna, Hauptstadt des spätantiken Abendlandes*, vol. 2, *Kommentar*, part 2, Wiesbaden, 1976, 174–177.

[33]On the identification of the river scenes with the rivers of paradise, see P. Toesca, *San Vitale of Ravenna: The Mosaics*, London, 1954, 22; B. Brenk, "Welchen Text illustrieren die Evangelisten in den Mosaiken von S. Vitale in Ravenna?" *Frühmittelalterliche Studien* 16 (1982), 19–24, esp. 23.

[34]*Epistula LXXIII*, 10; ed. G. Hartel, *Corpus scriptorum ecclesiasticorum Latinorum*, vol. 3, part 2, Vienna, 1871, 785.

[35]Jerome, *Prologue to Matthew*; ed. J.-P. Migne, Patrologiae cursus completus, Series Latina XXVI, cols. 17–18. Augustine, *De Civitate Dei*, 13.21; ed. E. Hoffmann, Corpus scriptorum ecclesiasticorum latinorum XL, part 1, Vienna, 1899, 646. See the discussions by P. A. Underwood, "The Fountain of Life in Manuscripts of the Gospels," *Dumbarton Oaks Papers* 5 (1950), 43–138, esp. 71; P.-A. Février, "Les quatres fleuves du Paradis," *Rivista di Archeologia Cristiana* 32 (1956), 179–199, esp. 194.

[36]*Epistula XXXII*, 10; text and translation in R. C. Goldschmidt, *Paulinus' Churches at Nola: Texts, Translations and Commentary*, Amsterdam, 1940, 39.

FIGURE 5.7. Kastoria, Church of the Hagioi Anargyroi, fresco. The Annunciation to the Virgin by the well.

FIGURE 5.8. Kastoria, Church of the Hagioi Anargyroi, fresco. The Annunciation to the Virgin.

At San Vitale, therefore, the river scenes beneath the four Evangelists probably represented the message of their Gospels flowing, in the same manner as the rivers of paradise, into the four corners of the earth, which is evoked through the plant and animal imagery in the vault above.

In Byzantine art after iconoclasm, we occasionally find the Evangelists accompanied by water and by flora, as at San Vitale. For example, a twelfth-century Gospel book now in the Pantocrator monastery on Mount Athos, MS. 234, includes portraits of St. Mark and St. Luke, who are both shown writing at their desks beside ornamental fountains.[37] The fountain beside St. Mark occupies a small a garden behind a white fence; it has a basin of green marble crowned by a pine cone and is flanked by two cypress trees. The one beside St. Luke is constructed of white marble and is covered by a pink marble canopy that carries a small roof garden of trees, also enclosed by a white fence. These fountains, with their enclosed gardens, represent a continuation of the old pre-iconoclastic imagery seen at San Vitale, although here nature is less wild; it has been tamed and confined within cultivated gardens. However, the miniatures in the Pantocrator manuscript are rarities. It is more common in posticonoclastic Byzantine art to find the Evangelists in architectural settings without fountains or even plants. The buildings that frame the Evangelists in medieval Byzantine art can be extremely elaborate, as seen, for example, at Lagoudera, where the four authors share the southwestern and southeastern pendentives under the dome (figure 5-9).[38] In these paintings the Evangelists write their books beside complex assemblages of doors, windows, columns, arches, pediments, domes, and courses of chevron in perspective, all wrapped around with crimson drapes. The rich architectures contrast with the much more austere presentations of the other saints in the church, who stand silhouetted against plain backgrounds. St. Panteleimon, for example, carries the box of medical instruments that identifies him as a doctor, but behind him there is no indication of any buildings where he might have practiced his craft (figure 5-10).[39]

A similar contrast can be seen, even more strikingly, in the paintings of the famous tenth-century illuminated Gospels in the Stauronikita Monastery on Mount Athos, MS. 43. In this manuscript four folios with painted portraits on their fronts and their backs precede the Gospels.[40] The design of one side of each sheet is elegant but relatively severe; much of the parchment is bare,

[37]Folios 23v. and 31; S. Pelekanidis, *Oi Thesauroi tou Agiou Orous*, vol. 3, Athens, 1979, 284, figs. 242–243; *Le Mont Athos et l'Empire byzantin: Trésors de la Sainte Montagne* (exhibition catalogue, Petit Palais), Paris, 2009, 188, no. 91.

[38]Nicolaïdès, "L'église de la Panagia Arakiotissa," 53–59, figs. 53, 55; Winfield and Winfield, *Church of the Panaghia tou Arakos*, 82–83, plate 1, figs. 78–81.

[39]Nicolaïdès, "L'église de la Panagia Arakiotissa," 126, fig. 96; Winfield and Winfield, *Church of the Panaghia tou Arakos*, fig. 258.

[40]Fols. 10–13; Ch. Mavropoulou-Tsioumi and G. Galavaris, *Holy Stavroniketa Monastery: Illustrated Manuscripts*, Mount Athos, 2007, 33–36, figs. 20–27.

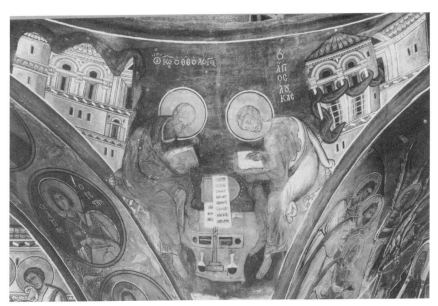

FIGURE 5.9. Lagoudera, Panagia tou Arakos, fresco. The Evangelists John and Luke framed by architecture.

but at the center there is a medallion enclosing a portrait of a saint silhouetted against a gold ground. By contrast, the other side is rich; it contains a full-page depiction of the Evangelist sitting at his lectern in front of an impressive architectural backdrop, which is rendered in perspective so as to create a strong impression of three-dimensional space. Thus, in front of the Gospel of St. John, we see the monastic Saint Euthymios presented frontally with his hands raised in a symmetrical pose of prayer. The plain gold background behind the ascetic saint contrasts with the impressive building painted behind St. John on the other side of the same leaf, where the saint sits in front of a great niche, or exedra, constructed of colored marbles (figure 5-11). This exedra is rendered in perspective, so that the scene creates an imposing physical space around the Evangelist. The impression of three-dimensional volume is enhanced by the furniture. The sloping tray that holds St. John's book is executed in oblique perspective, while the base of the lectern and the saint's footstool have solid block-like forms. It is possible to glimpse, in the far distance beyond the niche, a ghostly landscape of rocks and plants executed in grisaille, but there is no doubt that in this painting nature is completely upstaged by the architecture.

No less than the rivers and the birds that accompanied the Evangelists at San Vitale, the architectures of the Stauronikita Gospels created meaning. The purpose of the contrast between the presentation of the authors of the four Gospels with their buildings and the saints in the four medallions with their empty gold backgrounds was to emphasize the differing natures of these saints and to glorify the reality of the incarnation. In the four medallions we find two monks,

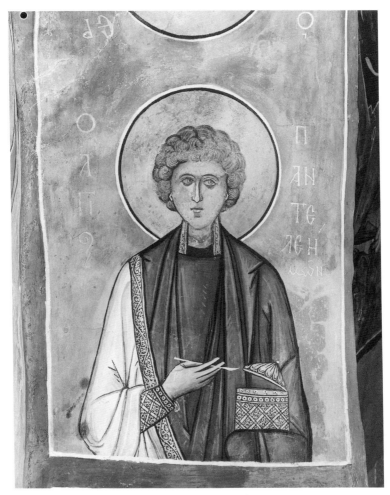

FIGURE 5.10. Lagoudera, Panagia tou Arakos, fresco. St. Panteleimon.

St. Euthymios and St. Anthony;[41] a female hermit, St. Mary of Egypt;[42] and a holy bishop, St. Gregory the Wonder Worker.[43] All of these saints were considered to be ascetics, who denied their flesh through fasting and self-denial to become closer to God. The aim of Byzantine monastic ascetics was to achieve a bodiless state, which was akin to the angels. The biographers of monastic saints likened them to shadows without physical substance.[44] The same qualities were shared by Mary of Egypt; a poem written by John Apokaukos at the

[41] Fols. 10 and 13v; ibid., figs. 20, 26.
[42] Fol. 11v.; ibid., fig. 23.
[43] Fol. 12; ibid., fig. 25.
[44] H. Maguire, *The Icons of Their Bodies: Saints and their Images in Byzantium*, Princeton, 1996, 66–74.

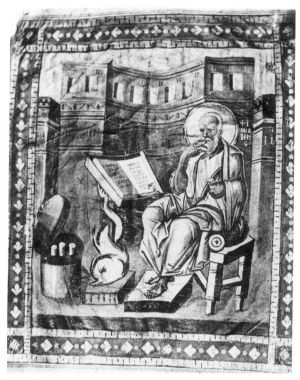

FIGURE 5.11. Mount Athos, Stauronikita Monastery, MS. 43, folio 13. St. John the Evangelist framed by architecture.

end of the twelfth or beginning of the thirteenth centuries described this saint as one who "had the fleshless quality of angels" and who "turns weight into shadow."[45] A similar language was used to describe holy bishops, who, like the monks and hermits, were expected to live lives of physical deprivation.[46] The poet Manuel Philes described an icon of St. John Chrysostom as portraying his body as a "shadow of a shadow" and as "thinned out from fasting as if it were fleshless."[47] In medieval Byzantine art, portraits of bishop saints corresponded to these concepts. As seen in the mosaic icon of John Chrysostom illustrated in plate XVIII,[48] their bodies tended to be flattened out and presented without an architectural background that would contribute to their physicality by positioning them in an illusionistic space.

[45]A. Papadopoulos-Kerameus, ed., "Epigrammata Ioannou tou Apokaukou," *Athena* 15 (1903), 476–477.

[46]Maguire, *Icons of Their Bodies*, 78–80.

[47]E. Miller, ed., *Manuelis Philae carmina*, vol. 1, Paris, 1855, 33.

[48]H. C. Evans, ed., *Byzantium: Faith and Power 1261–1557* (exhibition catalogue, Metropolitan Museum of Art), New York, 2004, 227–228, no. 135.

If ascetics were supposed to resemble shadows, this was certainly not true for the Evangelists, who were above all other saints the witnesses of the incarnation. Since they had recorded Christ's earthly life, they had the character of earthly authorities and were presented in art accordingly.[49] Manuel Philes addressed a portrait miniature of St. Matthew in a Gospel book with the following words: "You bear the form of a fleshly Evangelist . . . because you write for us the incarnate word."[50] It would not be appropriate for the corporeal life of Christ to be recorded by reporters who were shadows; the Evangelists had to have physical bodies also. Thus, the three-dimensional architecture behind their portraits carries the message of the physical authority of the Evangelists as those who bear witness to the incarnate life of Christ.

In summary, in Byzantine art after iconoclasm, the first role of architectural space was to indicate, by its relative presence or by its absence, the spiritual status of a portrait or a scene. Artists used the illusionistic construction of earthly space as one constituent in a discourse of oppositions; physical space was contrasted with its denial to suggest a hierarchy of subjects, some closer to material reality and some closer to the immaterial world. For the Byzantines, the creation of illusionistic physical space was not an end in itself to be applied in all contexts, as it was to become in the Renaissance, but was only one element in a more flexible language that encompassed both the material and the spiritual.

Stability and Mutability

The third type of architectural symbolism employed by medieval Byzantine artists is created by the contrast of stability with mutability. For an illustration, we can look once more at the miniatures depicting the Annunciation in the *Homilies of James of Kokkinobaphos* (figures 5-12 to 5-16). As we have seen, there are no less than five miniatures depicting the second Annunciation, the one that took place in the Virgin's house.[51] Each of the miniatures illustrates a different juncture in a long passage of the sermon, which is principally concerned with the causes of the Virgin's alarm and hesitations, the angel's efforts to allay her doubts, and her eventual acceptance and submission to the will of God. As was observed in chapter 2, the miniatures share a common feature in that they are deprived of any plant or animal motifs in contrast to the miniature showing the Annunciation to the Virgin's mother, St. Anne (figure 2-8).[52] Instead, there is only a plain gold ground behind the figures, in which there are representations of buildings.

[49]Maguire, *Icons of Their Bodies*, 80–87.
[50]Miller, ed., *Manuelis Philae carmina*, vol. 1, 19.
[51]Hutter and Canart, *Das Marienhomiliar*, fols. 118, 122, 124, 126, 127v.
[52]Ibid., fol. 16v.

FIGURE 5.12. Vatican Library, MS. Gr. 1162 (*Homilies of James of Kokkinobaphos*), folio 118. The Annunciation to the Virgin: "The salutation."

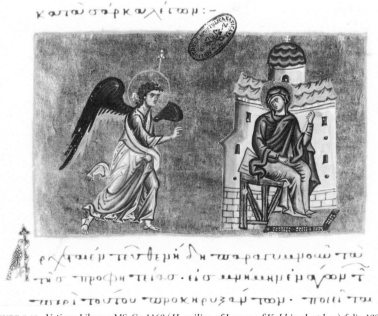

FIGURE 5.13. Vatican Library, MS. Gr. 1162 (*Homilies of James of Kokkinobaphos*), folio 122. The Annunciation to the Virgin: "Exposition of the truth of the Gospels."

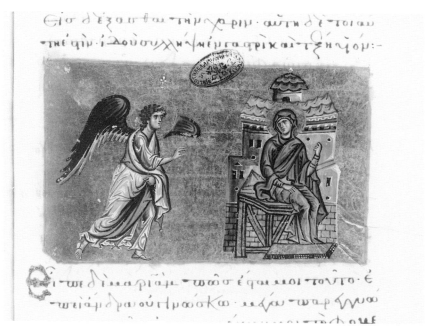

FIGURE 5.14. Vatican Library, MS. Gr. 1162 (*Homilies of James of Kokkinobaphos*), folio 124. The Annunciation to the Virgin: "The doubts of the Virgin as to how she is to conceive the Lord."

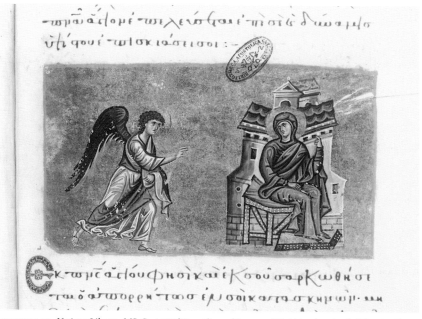

FIGURE 5.15. Vatican Library, MS. Gr. 1162 (*Homilies of James of Kokkinobaphos*), folio 126. The Annunciation to the Virgin: "The Virgin is released from her doubts."

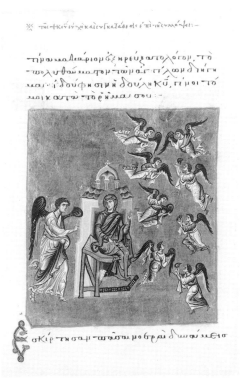

FIGURE 5.16. Vatican Library, MS. Gr. 1162 (*Homilies of James of Kokkinobaphos*), folio 127v. The Annunciation to the Virgin: joy in heaven.

The remarkable feature of the five miniatures is that they all show Gabriel and Mary in virtually identical poses, while behind them the design of the Virgin's house changes in each image. Thus, in the first painting of the series, which is labeled "The salutation," we see a somewhat complex architectural background, incorporating several structures with gabled roofs and with domes (figure 5-12). In the next miniature, labeled "Exposition of the truth of the Gospels," the architectural detail has been reduced to a single domed building, behind the Virgin (figure 5-13). A somewhat similar building, but with different fenestration, appears behind the Virgin in the third Annunciation scene, which is headed "The doubts of the Virgin as to how she is to conceive the Lord" (figure 5-14). In the fourth scene, titled "The Virgin is released from her doubts," the architecture changes again—now the dome on a drum that crowns the structure has been replaced by a gabled roof on a rectangular hall (figure 5-15). The fifth and last miniature in the series illustrates the Virgin finally accepting her role in the incarnation and the angels dancing for joy in heaven (figure 5-16). This time the architecture behind the Virgin changes completely. The building loses its lateral wings, and, as noted already, it is now crowned by an open structure consisting of a cupola supported on arches carried on slender columns.

What can be made of these truly paradoxical paintings, in which the actors seem to be frozen in time, maintaining exactly the same poses in each scene, while the architectural background behind them changes in every frame? We have proposed that, in the case of the last miniature, which illustrates the Virgin's final acceptance of her role, the ciborium on top of the Virgin's house is symbolic of her role as the "living temple." One could also see a metaphor in the prominent door that opens behind the Virgin in the scene of her final acceptance but that is absent in the four preceding miniatures, which illustrate her preparation. But more important than the metaphorical meanings suggested by these individual architectural elements are the changes themselves, that is, the mutability of the buildings in contrast to the immutability of the sacred actors. The artist juxtaposes the changeable nature of earthly structures with the stability and timelessness of heavenly command—the sacred drama, unlike its setting on Earth, is atemporal and not subject to alteration. A sermon by St. Neophytos makes a similar kind of distinction between earthly built architecture, the work of human hands, and the Virgin as the abode of the eternal God. In a lengthy passage in a sermon on the Feast of the Presentation of the Virgin, he compares the temple of Solomon with the Virgin's role as the living temple of God. Referring to Acts 7:47–50, he declares:

> Stephen, the first martyr, said that Solomon built for himself a house, a house, that is, for God. But the Highest One does not dwell in temples made by human hands, for, as the prophet says, heaven is my throne, and the earth my footstool. "What kind of house will you build for me," says the Lord, "or what will be the place of my rest? Did not my hand make all of this?" For this infinitely great God, who is absolutely uncontainable, who has the heaven for his throne and the earth for his footstool, who has brought all things into being from nothing, who holds the circle of the earth and all of its inhabitants in his hands like locusts, who fills the heaven and earth yet is uncontainable, he it is who consented to be contained in the holy temple that is "wonderful in righteousness."[53]

This passage follows an exegetical tradition of contrasting the Virgin as the "living temple" with the temple of Solomon, the "temple built by human hands." For example, the eighth-century sermon by John of Euboea on the conception of the Theotokos declares:

> O what a marvel! The living temple and cherubic throne is brought into a temple constructed from stones Behold a palace of the heavenly king is constructed without human hands This palace, which was prepared without earthly craftsmen, was shown to be higher than the heavens, and wider than the whole of creation, and no one dwelt in it

[53]Torniolo, ed., "Omelie," 214–215.

except the Craftsman and Creator and Maker of heavenly and earthly things.[54]

In the Annunciation miniatures of the *Homilies of James of Kokkinobaphos*, therefore, we see the Virgin as the house of an unchanging God who is outside of time, in contrast to the buildings behind her, which are the mutable works of human hands.

The complexity and ambiguity of architectural symbolism in Byzantium is well illustrated by a pair of mosaics of the late twelfth century in the Cathedral of Monreale in Sicily, in which we find a similar kind of symbolic juxtaposition of mutable buildings combined with metaphors created by specific architectural forms. The mosaics in question portray the disappearance of Christ in front of the disciples at Emmaus.[55] Although the Emmaus cycle at Monreale incorporates some Western elements,[56] the manner in which the background to these scenes is portrayed is Byzantine. In the first episode, portrayed on the left we see Christ sitting between the two disciples in the inn, which is portrayed by an architectural background containing three narrow openings between two towers (figure 5-17). Two projecting wings containing narrow, slit-like windows flank the central opening. This is the moment at which Christ breaks the bread and the disciples recognize the man who has joined them as the risen Lord. On the right, in the next scene, Christ has just disappeared, and the disciples sit with their heads downcast and wearing mournful expressions, as they contemplate the space where Christ has just been (figure 5-18). The disciple on the left grasps his cheek with his hand as a sign of his sorrow. Meanwhile, we see that the opening in the center of the architectural background has become wider. This is clearly an intentional change, for the two projecting wings on either side of the central opening have, as a consequence, become narrower and have lost their windows. So here, again, we have a mutable architecture, for which several explanations can be put forward.

In the first place, the widening of the central opening emphasizes the void left by the disappearance of Christ, which has caused the sorrow of the disciples. The south Italian Greek preacher Philagathos, in a sermon on the Emmaus story, which he preached a few decades before the mosaic in Monreale was made, describes the episode of Christ's disappearance as follows:

> If he was made manifest to the disciples, and then immediately became invisible, do not wonder at this. For such is the beauty of God. For at the

[54]*In conceptionem Sanctae Deiparae*, 14, 17; ed. Migne, *Patrologia Graeca* XCVI, cols. 1481, 1488; translation by M. B. Cunningham, *"Wider than Heaven": Eighth-Century Homilies on the Mother of God*, Crestwood, NY, 2008, 185, 188–189.

[55]O. Demus, *The Mosaics of Norman Sicily*, New York, 1950, 117–118, 289–290, pl. 73; E. Kitzinger, *I mosaici del periodo normanno in Sicilia*, fasc. 4, *Il duomo di Monreale: i mosaici del transetto*, Palermo, 1995, 11–13, figs. 131–132, 136–143.

[56]H. Maguire, "Medieval Art in Southern Italy: Latin Drama and the Greek Literary Imagination," in N. Oikonomides, ed., *L'ellenismo italiota dal VII al XII secolo*, Athens 2001, 219–239.

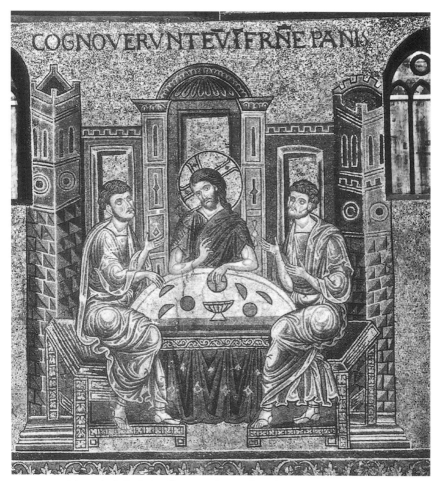

FIGURE 5.17. Monreale, Cathedral, wall mosaic. Christ and the disciples at Emmaus.

same time as it shines in the minds of the pure, like lightning, it quickly withdraws, becoming ungraspable, in order to implant the desire of apprehension and to encourage the fervent soul.[57]

The golden void at the center of the architectural background in the second scene, then, can be interpreted as a representation of the ungraspable nature of God. Second, the enlarged opening may be, once again, a reference to the gate of paradise, opened by Christ's resurrection. And, finally, the changing architecture emphasizes the mutable, temporal world that Christ has now left, where he is now present only in invisible form. The potential symbolism is complex and, as so often in the case of architectural symbolism, ambiguous. But it is present nonetheless.

[57] *Homilia XXXII, In quintum matutinum*; ed. Migne, Patrologia Graeca CXXXII, col. 657.

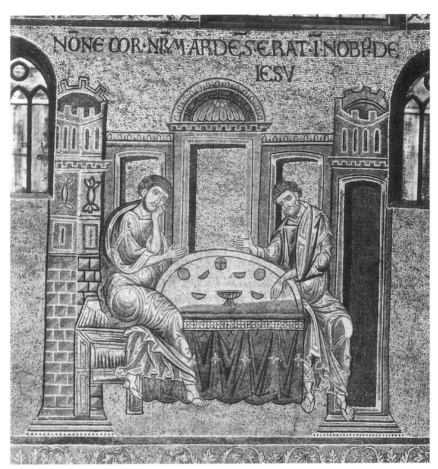

FIGURE 5.18. Monreale, Cathedral, wall mosaic. The disciples at Emmaus after the disappearance of Christ

Architecture and Its Absence

The association of space-creating built structures with earthly contexts in Byzantine art helps to explain why there was so little architecture in medieval depictions of the heavenly court. Portrayals of Christ in heaven showed him enthroned at the center of his retinue of angels and saints, as in the mosaics in the sanctuary of St. Mary Pammakaristos in Constantinople (plate XII), but typically there was no indication of an architectural setting, such as a city or a palace. The omission of such edifices from representations of the kingdom of heaven in posticonoclastic Byzantine art is all the more striking when the visual works are compared with works of literature, some of which contain rich and specific descriptions of the heavenly city and the palace of its ruler. Cyril Mango has drawn attention to the *Vision* of the tenth-century monk

Cosmas, which gives a detailed account of the heavenly city, with its walls of twelve courses, its gold and silver gates, its golden pavements, golden houses, and golden seats.[58] Its palace in many respects resembled the Great Palace of Constantinople.[59] It was at the edge of town, and it had a splendid dining hall with a long porphyry table at which favored guests reclined and with a balcony approached by a spiral staircase. Similar descriptions of the heavenly kingdom are found in other apocryphal texts. In the *Apocalypse of Anastasia* we are shown an immense hall lit by hanging lamps[60] and in the *Life of Andrew the Fool* a series of incredible chambers containing huge thrones that flashed with fire, the highest of which was that of the King. [61] In the tenth-century Life of St. Basil the Younger, we find the saints in heaven living in marvelous palaces, immaterial yet constructed of colored mosaics and variegated marbles. These dwellings, we are told, occupied an area that was one hundred times the size of Constantinople.[62]

This great wealth of heavenly architecture, however, went largely without illustration in medieval Byzantine art. In mosaics and paintings it is the *absence* of buildings that distinguishes heaven from earth, not, as in the texts, the evocation of structures that are larger or more splendid than those below. Once again we encounter fundamental differences between the vocabularies of literature and of the visual arts.

The origins of this visual distinction between a heaven without architecture and an earth with buildings are to be found in the preiconoclastic period. The contrast can be seen already in the mosaics of San Vitale in Ravenna, where the imperial courts of Justinian and Theodora, portrayed on the lower sidewalls of the apse, are juxtaposed with that of Christ in the vault above (figure Intro-1).[63] Here each of the earthly sovereigns is framed by an architectural setting, and in each case there has been much controversy about the precise reconstruction of the buildings portrayed. But what has not been in doubt is that the artists intended to show both rulers in actual physical locations, whether in a church or in a palace. Justinian's procession takes place in a space with a flat, coffered ceiling, which is supported at the front on two jeweled columns and the back on two shaded piers. As was customary, the coffers in the mosaic were decorated with stylized flowers. The Theodora mosaic has a more complex spatial setting than that of Justinian. It includes two green piers supporting a colorful red,

[58]*Synaxarium ecclesiae Constantinopolitanae*, ed. Delehaye, *Propylaeum ad Acta Sanctorum Novembris*, 112; paraphrase in C. Mango, *Byzantium, the Empire of New Rome*, New York, 1980, 152–153.

[59]Mango, *Byzantium*, 153.

[60]Homburg, ed., *Apocalypsis Anastasiae*, 22–24; Baun, *Tales from Another Byzantium*, 409.

[61]L. Rydén, ed. and trans., *The Life of St. Andrew the Fool*, vol. 2, Uppsala, 1995, 128–129.

[62]A. N. Veselovskij, ed., *Sbornik Otdelenija russkogo jazyka i slovesnosti Imperatorskoj Akademii nauk* 46 (1889–90), 39.

[63]Deichmann, *Frühchristliche Bauten*, plates 358–375; Deichmann, *Ravenna, Hauptstadt des spätantiken Abendlandes*, vol. 1, *Ravenna, Geschichte und Monumente*, 248; vol. 2, *Kommentar*, part 2, 180–187.

white, and blue awning that is draped between them and under which Theodora's retinue passes. At the far left of the scene, there is a small fountain in the form of a vase standing on a low pier.

Several authors who have written on these mosaics have understood Theodora as being shown in the atrium of a church,[64] while Justinian is within the church itself, possibly in the nave[65] or in the sanctuary, where he deposits his gift.[66] Some commentators have identified the church specifically with San Vitale,[67] while others have interpreted the mosaic by citing architectural details of Hagia Sophia in Constantinople, such as the fountain west of the narthex,[68] or by referring to liturgical ceremonies that took place in that church, such as imperial offerings,[69] or the First Entrance of the liturgy.[70] However, the portrayal of a flat and coffered ceiling in the mosaic of the emperor indicates that he cannot be situated literally in San Vitale or Hagia Sophia, as both churches were vaulted. Likewise, the empress is not in the atrium of a church, because awnings supported on piers were not usual features of the atria of churches but were associated with enclosed open-air spaces in houses and villas, such as courts or gardens.[71] It is more likely that Justinian and Theodora are depicted in palace settings, the emperor in a hall with a coffered ceiling, and the empress in an inner courtyard, provided with awnings and a fountain.

Whatever the identities of the buildings, however, there is no doubt that Justinian and Theodora are both portrayed in physical structures that belong to this world; their situation can be contrasted with that of the divine recipient of their gifts, who is portrayed in the vault of the apse above (figure Intro-1).[72] Here we see Christ enthroned on a blue globe between his angels, with the flowers of paradise at his feet, the pure gold of heaven behind him, and clouds over his head. There is no architectural setting to

[64]T. F. Mathews, *The Early Churches of Constantinople, Architecture and Liturgy*, University Park, 1971, 147; C. Barber, "The Imperial Panels at San Vitale: A Reconsideration," *Byzantine and Modern Greek Studies* 14 (1990), 19–42, esp. 21; J. Elsner, *Art and the Roman Viewer: The Transformation of Art from the Pagan World to Christianity*, Cambridge, 1995, 187; A. McClanan, *Representations of Early Byzantine Empresses, Image and Empire*, New York, 2002, 129.

[65]Elsner, *Art and the Roman Viewer*, 187.

[66]O. G. von Simson, *Sacred Fortress, Byzantine Art and Statecraft in Ravenna*, Princeton, 1987, 30.

[67]Ibid. See also J. R. Branham, "Bloody Women and Bloody Spaces," *Harvard Divinity Bulletin* 30, no. 4 (2002), 15–22, esp. 18.

[68]McClanan, *Representations of Early Byzantine Empresses*, 129.

[69]A. Grabar, *L'empereur dans l'art byzantin*, Strasbourg, 1936, 107; Grabar, "Quel est le sens de l'offrande de Justinien et de Théodora sur les mosaïques de Saint-Vital?" *Felix Ravenna* 81 (1960), 63–77.

[70]Mathews, *Early Churches*, 146–147; Elsner, *Art and the Roman Viewer*, 187.

[71]H. Maguire, "The Empress and the Virgin on Display in Sixth-Century Art," in E. Jeffreys, ed., *Proceedings of the 21st International Congress of Byzantine Studies, London, August 21–26, 2006*, vol. 1, London, 2006, 379–395, esp. 381–382.

[72]Deichmann, *Frühchristliche Bauten*, plates 351–357; Deichmann, *Ravenna, Hauptstadt*, vol. 1, 247–248, vol. 2, part 2, 178–180.

enclose the heavenly king.[73] Thus, we see that the earthly frames of the two
rulers below both exalt and confine them. They are promoted in this world
by their palatial settings, but the architecture also acts as a kind of trap that
confines the emperor and empress to an earthly, material context.

Eventually, the Byzantine rulers awarded themselves the same distinction as
Christ in his heavenly glory. That is, they had themselves also depicted against
plain gold backgrounds, with a minimum of architectural context. Such a por-
trayal of the emperor occurs in the frontispiece to the copy of John Chrysos-
tom's sermons on Matthew, which is preserved in the library at Mount Sinai
(figure 2-11).[74] In this illumination Constantine IX Monomachos, his empress
Zoe, and her sister Theodora stand silhouetted against a pure gold ground as
they receive the blessing of Christ above. There is no architectural setting for
either Christ or the earthly rulers. There is not even so much as a footstool
under their feet to support the emperor and empresses; the imperial trio is sim-
ply suspended in gold. A poem written around the miniature proclaims:

> Oh saviour, as the one Pantocrator of the Trinity, may you protect the ra-
> diant trinity of the rulers of the earth, the mightiest Lord Monomachos
> and the pair related by blood, the offshoot of the purple.[75]

In other words, the earthly rulers are seen to implicitly share in the divine radi-
ance of Christ.

In the light of the foregoing discussion, it is possible to speak of an elaborate
hierarchy of architectural symbolism in the art of medieval Byzantine churches,
which is well illustrated by the frescoes at Lagoudera. The sanctuary of the
church portrays the celestial vision of the Virgin and Christ Child enthroned
between the archangels Michael and Gabriel in the apse,[76] together with Christ
ascending to heaven in the barrel vault above[77] and holy bishops below (figure
5-19).[78] In this sacred space there is no depiction of architecture whatsoever. By
contrast, in the nave of the church architectural detail is prominent—in the Pre-
sentation of the Virgin on the north wall,[79] in the Dormition on the south wall
(figure 5-1), in the background to the Annunciation on the eastern pendentives

[73]The portrayal of Christ's court in the apse of San Vitale, with its abstract gold ground replacing
the more naturalistic depiction of an architectural setting or a blue sky, was an image of heavenly splen-
dor that was current by the end of the fourth century. Already in the apse mosaic of the Mausoleum of
St. Aquilino in Milan Christ sits between the twelve apostles against a golden ground: G. Mackie, *Early
Christian Chapels in the West: Decoration, Function, and Patronage*, Toronto, 2003, 158–163; B. Brenk,
The Apse, the Image and the Icon, Wiesbaden, 2010, 21, color fig. 7.
[74]Sinai, St. Catherine's Monastery, MS. Gr. 364, fol. 3.
[75]K. Weitzmann and G. Galavaris, *The Monastery of Saint Catherine at Mount Sinai, the Illuminated
Greek Manuscripts*, vol. 1, *From the Ninth to the Twelfth Century*, Princeton, NJ, 1990, 66, fig. 185.
[76]Winfield and Winfield, *Church of the Panaghia tou Arakos*, plate 5.
[77]Ibid., figs. 145–162.
[78]Ibid., figs. 23–26.
[79]Ibid., plate 3.

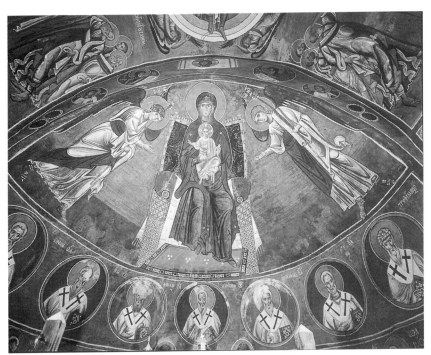

FIGURE 5.19. Lagoudera, Panagia tou Arakos, frescoes in the sanctuary. Virgin and Christ Child enthroned between archangels, part of the Ascension, and holy bishops.

(plate XIX), and behind the Evangelists in the western pendentives (figure 5-9). The Presentation of the Virgin, the Annunciation, and the Dormition were all scenes that proclaimed Christ's incarnation, as did the Evangelists through their writings. In these paintings, therefore, a setting evocative of earthly architecture was appropriate. But, conversely, we have seen that at Lagoudera saints who did not witness the earthly life of Christ were presented without any architectural context in order to convey their closeness to God (figure 5-10).

As in the case of depictions of animals and plants, medieval Byzantine portrayals of the heavenly kingdom can be contrasted with those in the West. We can take as an example the mosaic that was created in the apse of the church of S. Maria Nova in Rome, a few decades before the painting of the sanctuary at Lagoudera (plate XX).[80] In the Roman church we see the Virgin and Child enthroned at the center of an arcaded masonry structure, which is richly decorated with jewels and ornamental columns. This palace-like edifice also frames portraits of Saints John the Evangelist, James, Peter, and Andrew, who flank the Virgin on either side. Such an elaborate architectural setting in the vault was alien to the Byzantine concept of apse decoration, which preferred to place

[80]G. Matthiae, *Mosaici medioevali delle chiese di Roma*, Rome, 1967, 315–321, fig. 269.

the holy figures in a less determined space rather than to evoke heaven through buildings. A possible reason for this difference in approach is that Western artists, unlike their Byzantine counterparts, frequently illustrated the Apocalypse of St. John, including its description of the heavenly city.[81] Therefore, Western viewers were used to seeing the heavenly kingdom represented by architecture, whereas in Byzantium the spiritual realm was generally denoted through the diminution or absence of built structures.

Conclusion

In conclusion, we will return to the question posed at the beginning of this chapter: to what extent did architecture take on the function of conveying meaning in posticonoclastic Byzantine art, in place of the old organic imagery of animals and plants? The answer must be that, as images drawn from the natural world became more problematic, architecture did indeed assume a greater role in conveying symbolism in Byzantine religious art. The paintings of Lagoudera are a striking illustration of this change, but we have discovered that many other medieval works of art exploit the symbolic potential of architectural depictions in similar ways. The very depiction of physical space through architecture became symbolic of the earthly world; a space that was totally or relatively undefined became symbolic of the immaterial realm. Thus, architecture became a means of expressing the spiritual significance of an event, either through a greater or through a lesser incorporation of details suggestive of a material location. The contrast of the mundane with the sacred was also suggested through the mutability of architectural forms in contrast to the fixity of the holy icons. It is not true to say that medieval Byzantine artists were uninterested in the construction of pictorial space through architecture. However, for them the creation of spatial illusion was not an end in itself, to be applied in every context; it was only one option in a symbolic system that included both defined and undefined space together with the opposition of mutable and immutable forms.

It should be stressed that in this system of juxtapositions between physical space and its denial, the meaning depended in every case on the context. For example, in the case of the Annunciation to the Virgin, here was no absolute measure of two-dimensionality, or lack of mundane detail, that was applicable to all portrayals of the scene. The meaning in each individual instance was created only by contrast, as, for instance, when the Annunciation to the Virgin was given a less three-dimensional or picturesque treatment than the Annunciation

[81]For depictions of Christ enthroned surrounded by the Heavenly city, see, for example, O. Demus, *Romanesque Mural Painting*, New York, 1970, 292, fig. 13 (San Pietro al Monte, Civate), 97, 416 (Chapelle Conventuelle, Abbatiale Notre-Dame, Saint-Chef en Dauphiné).

to St. Anne in the same church or manuscript. This system of relativity allowed Byzantine artists freedom to shift the registers in which they created their scales. In the Evangelist portraits of the Stauronikita Gospels (figure 5-11), the architectural backgrounds are extremely solid and three-dimensional, whereas in the frescoes at Lagoudera they are relatively flat and without depth (figure 5-9). In both the tenth-century manuscript and the twelfth-century church, however, there is the same contrast between the rich architectural surrounds of the Evangelists as authorities who witnessed the life of Christ on earth and the plain, unadorned backgrounds behind the later saints, who did not bear direct witness to the incarnation but who demonstrated through their lives their special propinquity to God.

At the same time as they exploited the language of contrasts Byzantine artists manipulated the design of buildings portrayed in sacred scenes to reference architectural metaphors that were well-known from church literature. The use of architecture as metaphor, however, brought with it the dangers of ambiguity. A portrayal of a lamb with a nimbus in a church could be read only as a symbol of Christ, but it was, and is, uncertain whether a column incorporated into a painted building should be read simply as a column or as a symbol of the Virgin. However, such ambiguities aside, there is no doubt that architectural backgrounds played a major role in creating meaning in medieval Byzantine art. Just as much as a gold ground, architecture could express the transcendental values that were the principal concern of medieval Byzantine church art, and it could do so without the problematic recourse to metaphors and symbols derived from nature.

Conclusion

Ambivalence was at the core of Byzantine attitudes toward nature. The Byzantines took pleasure in its delights, even as they were aware of their corruptible and evanescent qualities. The Byzantine view of terrestrial creation vacillated between suspicion and acceptance, but they always felt that the terrestrial was less worthy, and less real, than the spiritual. They associated the bounty of the earth with the sanctification of material creation through the incarnation, but its fruits were emblematic of gluttony and the Fall of mankind. For the Byzantines, depictions of the natural world in art and in literature were rarely, if ever, pure decoration, devoid of meaning and significance. Portrayals from nature could serve as metaphors and symbols, but they also had the potential to become objects of worship in their own right. The danger that nature-derived images might be put to idolatrous use created a constant state of tension in Byzantine art between worldliness, represented by earthly creation, and otherworldliness, represented by the portrait icons of the saints. Although some medieval Byzantine writers protested that depictions of animals in churches were for ornamentation only[1] and that the worship of animal images was an error of the ancient Greeks, which no Byzantine would engage in unless he were led astray by demons,[2] the unease still lingered. The conflicting attitudes toward nature even affected paradise. Richly described in medieval texts, its gardens received a far more schematic treatment in art. For the Byzantines, the problem was: when does the depiction of spiritual delight become the portrayal of sensual pleasures? When do the wondrous fruits of paradise turn into the fruit that

[1] *Antirrheticus* III; ed. J.-P. Migne, Patrologiae cursus completus, Series Graeca C, col. 464; translation in M.-J. Mondzain-Baudinet, *Nicéphore, Discours contre les iconoclastes*, Paris, 1989, 249.

[2] So in the ninth-century *Life of the Patriarch Nikephoros I of Constantinople* by Ignatios the Deacon; ed. C. de Boor, *Nicephori archiepiscopi Constantinopolitani opuscula historica*, Leipzig, 1880, 178–179; translation by E. A. Fisher in A.-M. Talbot, ed., *Byzantine Defenders of Images: Eight Saints' Lives in English Translation*, Washington, DC, 1998, 91–92.

caused the Fall? This was the same conundrum that was later to be embodied in the famous triptych, the *Garden of Delights* by the Dutch artist Hieronymus Bosch.[3] In that painting, the vision of Adam and Eve in Eden, which is portrayed on the left-hand panel, turns into vivid scenes of gluttony and fleshly corruption in the center, which are both a celebration and a warning, since they are followed by the torments of Hell in the panel on the right.

Within the depictions of nature, there was a scale of acceptability. The most problematic were the personifications of entities such as the months, the seasons, and the rivers of paradise, which had been depicted often in floor mosaics before iconoclasm but virtually disappeared from churches after the ninth century. In posticonoclastic, as opposed to preiconoclastic, Byzantine art we find a kind of inversion. After iconoclasm artists were no longer encouraged to depict Christ symbolically as a lamb; henceforth, he was to be shown naturalistically in human form to stress his incarnation. At the same time, the human body was no longer appropriate for depicting the elements of nature. Less noxious than personifications, but still problematic, were portrayals of animals, which also had been ubiquitous in preiconoclastic church decoration but which appeared only sporadically in churches after iconoclasm. The most common place to encounter animals in medieval Byzantine churches is at liminal areas, such as doorways, windows, and chancel screens, where they were carved on jambs, lintels, and closure slabs. Here their function was more apotropaic than symbolic, as is demonstrated by a preponderance of fierce and noxious creatures, including dogs, lions, snakes, and birds of prey as well as sphinxes, centaurs, griffins, and other fearsome hybrids.[4] After iconoclasm, plant forms were the least problematic form of nature-derived decoration, but here, too, care was taken about their deployment. Many posticonoclastic churches received a much more restrained plant ornament than their preiconoclastic counterparts, and there was discrimination about where the plants were placed. Parts of the building that were more sacred than others, such as the sanctuary, might be deprived of vegetal motifs (plate XII), whereas foliage might be more abundant in other parts of the building (plate XIII).

Another factor that governed the acceptability of subjects drawn from nature was the context of viewing. Images on the walls and floors of churches were on permanent view and thus were more likely to attract criticism than portrayals that were tucked away in treasuries or in the pages of manuscripts. Hence we find a richer depiction of nature in small-scale objects, such as ivories, portable panel paintings, and especially books, than we do in mosaics and wall paintings. Images that could be controversial in a public location were less offensive in more discrete contexts. We never find in Byzantium, as we do in the West,

[3]H. Belting, *Hieronymus Bosch: Garden of Earthly Delights*, Munich, 2005.

[4]See A. Grabar, *Sculptures byzantines du moyen âge*, vol. 2, *XIe—XIVe siècle*, Paris, 1976, 59; E. D. Maguire and H. Maguire, *Other Icons: Art and Power in Byzantine Secular Culture*, Princeton, 2007, 69–73.

the principal apse of a church filled with plants, animals, and personifications drawn from nature (compare plate XII and figure 3-10). On the other hand, we can find flora and fauna, and even very occasionally a personification, in the pages of books, such as the illustrated copies of the *Homilies of James of Kokkinobaphos* (figures 2-3 and 3-2). We also find that the degree of license with respect to the depiction of nature depended on the tastes of particular patrons. For example, both the churches of Lagoudera and the Kariye Camii were monastic buildings, but nature plays a far larger role in the decoration of the latter (plates II and V). The prominence given to foliate ornament and even to animals in the mosaics and frescoes of the Kariye Camii can be attributed to the sophisticated literary tastes of its patron, Theodore Metochites.

Apart from these factors of visibility and individual preference, which affected the degree to which nature was welcomed into religious imagery, there was a succession of phases of austerity that affected the production of church art as a whole. The first of these relatively puritanical periods occurred at the turn of the fourth and fifth centuries and is exemplified not only by the purely geometric floors that were common at this period but also by the letter of St. Nilus of Sinai criticizing nature-derived images in churches. This was the time that witnessed the final stage of the struggle between paganism and Christianity, when there was a surge of legislation against pagan cults and images,[5] accompanied by a stricter enforcement of antipagan laws by Christian officials[6] as well as by vigilantes.[7] During this period tensions between Christians and pagans ran high, and it must have been more difficult for churchmen to sanction images from nature in the decoration of their churches.[8] After the crisis had passed and Christianity had firmly established itself as the official religion, attitudes could relax, and nature reappeared in all of its abundance on the floors, walls, and vaults of churches during the later fifth, the sixth, and the seventh centuries.

The next major phase of austerity came with the iconoclastic dispute, which saw both the defenders of Christian portrait icons and their opponents accusing each other of worshipping creation rather than the Creator. The result was the avoidance of nature-derived motifs in churches, and, in the case of the floor mosaics of Palestine, their destruction (figure 1-17). It appears that

[5]Codex Theodosianus, 16.10.7 (a. 381); 16.10.9 (a. 385); 16.10.10 (a. 391); 16.10.11 (a. 391); 16.10.12 (a. 392); 16.10.13 (a. 395); 16.10.14 (a. 396) 16.10.16 (a. 399); 16.10.17 (a. 399) 16 10.18 (a. 399).

[6]See G. Fowden, "Bishops and Temples in the Eastern Roman Empire A.D. 320–435," *Journal of Theological Studies*, New Series 29 (1978), 53–78; R. MacMullen, *Christianizing the Roman Empire*, New Haven, CT, 1984, 86–89, 98–99; R. Markus, *The End of Ancient Christianity*, Cambridge, UK, 1990, 112–114.

[7]See Libanius's protest at the destruction of pagan statues and temples by Christian gangs in Syria: *Oratio XXX*, 8–14.

[8]H. Maguire, "Christians, Pagans, and the Representation of Nature," *Begegnung von Heidentum und Christentum im spätantiken Ägypten* (*Riggisberger Berichte* 1), Riggisberg, 1993, 131–160, esp. 152.

at least some of the Christians who were erasing animals and nature personifications from their churches were, at the same time, venerating portrait icons (figure 1-19). However, in spite of the polemical statements of their opponents, it is likely that the iconoclasts also kept away from earthbound subjects that might attract charges of idolatry (figure 1-22). After iconoclasm, tesselated floor mosaics, with their depictions of plants, animals, and personifications, were abandoned, as were the lush portrayals of nature on the walls and vaults of churches, such as formerly had appeared at San Vitale in Ravenna (figures Intro-1 and Intro-2) and the Acheiropoietos in Thessaloniki (plate III). Instead, there was a preference for pavements displaying geometrical patterns in opus sectile, which were either completely or largely aniconic (plate XIV). These floors, however, continued to evoke the created world in the minds of Byzantine viewers. Thus, through a process of almost total abstraction the representation of nature was rendered safe, even while it could still impress through the gleaming colors of the marbles. In a sense, one can speak of two iconoclasms, the iconoclasm of portrait icons and the iconoclasm of images from nature. The first iconoclasm was transient, because portrait icons regained their place in Byzantine cult during the ninth century. But the effects of the second iconoclasm were permanent, for the world of nature was never celebrated in post-iconoclastic churches to the same extent as it had been before.

The twelfth century can be identified as a time in which there was an especially strong interest in portraying the natural world, as can be seen in the *Homilies of James of Kokkinobaphos* (figures 2-3, 2-8, and 3-2), in the Annunciation icon at Mount Sinai (figure 2-5), and even in an exceptional church pavement at the Pantocrator Monastery, which revived many of the motifs from preiconoclastic art (figure 2-4). However, in the final period of Byzantine art, during the Palaiologan period, we find a partial retreat. While there are some instances of continuing celebration of nature, such as the decoration of the Kariye Camii (plate V), in other cases there is a rigorous avoidance of organic imagery, as seen in the illustrations of the Akathistos Hymn (figure 3-3).

Not only did nature play a smaller role in the art of the Byzantine church after iconoclasm than it had before, but in those cases when it was explicitly portrayed, most often in the form of plants, it was depicted in a different way. Whereas in the early Byzantine period different species of plants and fruits frequently were carefully distinguished (figures 4-1 to 4-4), in the Middle Ages the vegetation that appeared in churches tended to become more schematic and hard to identify with specific plants in real life (plates V, X, and XIII). On the other hand, portraits of the saints were increasingly differentiated, through the creation of an extensive gallery of portrait types (figure 4-6). This decline of naturalism in the portrayal of nature can be linked, in part, to the decreasing importance of nature symbolism following the decree of the Quinisext council and in part to an association of differentiation with worship. In Byzantine art after iconoclasm, the features of Christ and of individual saints were accurately

described, so that their icons could be recognized for the purpose of adoration. In the case of portrayals from nature, on the other hand, accuracy of description was no longer necessary or desirable. If individual species were not recognizable, they could not be venerated.[9] Thus, in posticonoclastic Byzantine art, differentiation was associated with the spiritual, while a lack of differentiation was reserved for the terrestrial. Frequently modern commentators have linked abstraction with the spirituality of religious icons, but it is more true to say that in medieval Byzantine art the type of abstraction that was created by lack of discrimination between species denoted the terrestrial world.

At all periods in Byzantium, with the possible exception of the sixth century, the evocation of nature in literature was much richer than in art. Even in times of relative artistic austerity, such as the crisis of iconoclasm, nature continued to flourish in the hymns and sermons of the church. In part, this disjunction between texts and images may have been due to the more public nature of art. While mosaics and frescoes in churches could be seen all of the time, most sermons and hymns were recited relatively rarely in the liturgy, on the relevant feast day. But a more important factor was the problem of the reification of metaphor in images. A visual metaphor had to be embodied; if the metaphor was drawn from nature, it became a physical representation of an animal, a plant, or a human being personifying some element of creation. Such images, unlike their verbal counterparts, were potential idols. The cultic potential of visual images created a big divide between visual and verbal metaphor. This divide became all the greater as the Byzantines developed their own cult of sacred icons. The greater was the veneration of Christian portraits, the more the danger of venerating images from nature. This fundamental distinction between word and image in Byzantium is not so much rooted in theory as in practice, or, to be more specific, the fear of practice.

Depictions of architecture provided a less problematic source of metaphors and symbols in Byzantine iconography than the world of nature. Specific architectural forms, such as stairs or gates, which had been evoked frequently in sermons and hymns in connection with the incarnation, were exploited for their symbolic potential (plate XIX). In addition, medieval Byzantine artists used perspective in a new way, not to create an optical illusion in every scene, but to distinguish between scenes according to their spiritual significance, so that a dialogue of the earthly and the spiritual was created through the juxtaposition of space-creating and space-denying compositions. In some works of art the architectural backgrounds created symbolic meaning by changing from scene to scene, in contrast to the immutability of the sacred actors (figures 5-12 to 5-16). In portrayals of the court of Christ, and of its imperial counterpart on Earth,

[9]A similar argument can be made with respect to the figures evocative of pagan mythology carved on Byzantine bone and ivory caskets, which are invariably unlabeled and frequently hard to identify; see Maguire and Maguire, *Other Icons*, 162–167.

the withholding of an architectural setting became an indication of the heavenly realm (plate XII and figure 2-11). Here, too, there was a disjunction between art and literature, for in texts the palaces of heaven were richly described. Both the depiction of architecture and its denial, therefore, became ways of conveying spiritual meaning without recourse to images derived from nature.

A fundamental feature of Byzantine art is that its discourse is built on oppositions, in which the physical world appears as a foil to the true reality, which is spiritual. Byzantine artists defined the spiritual in contrast to the material, and they retained a sufficient interest in the world of nature to make such juxtapositions possible and effective. Thus, within one manuscript or cycle of mosaics, the Annunciation of the birth of Christ, which depicted the conception that was beyond nature (figures 2-6 and 5-12), was shorn of the earthbound vegetation that characterized the Annunciation of the birth of the Virgin, whose conception was beyond hope but not nature (figures 2-8 and 2-9). The depiction of Christ in his heavenly realm in the sanctuary of St. Mary Pammakaristos was deprived of the sprays of foliage that framed the earthly saints in the corner bays of the same church (plates XII and XIII). This language of oppositions in art provides a further explanation for the differences between the visual and the literary imaginations in Byzantium. In literature, heaven was evoked through images of the earthly world that were exaggerated in size and in splendor, such as nuts the size of barrels or buildings made of gold. But in art an imagery of this kind would only have seemed to glorify created things; it was better to convey the spiritual realm through the absence of the fruits and architecture of terrestrial existence.

It should also be noted that in every juxtaposition the symbolism is not absolute, with one fixed message like a traffic sign on a modern street, but it is flexible, changing its meaning according to the context of the opposition. For example, we have seen that in the mosaic of Christ in the principal apse of St. Mary Pammakaristos, a lack of plant ornament is a sign of higher spiritual status (plate XII). But in the contemporary mosaics of another church in Constantinople, the Kariye Camii, the same relative austerity accompanies the deaths of the Holy Innocents, in contrast to the garlands of vegetation that celebrate the infancy of the Virgin (plates V and XI).

The abstract tendencies that so many detractors and admirers have seen in Byzantine art, from the Renaissance writer Giorgio Vasari[10] to the modernist critic Clement Greenberg,[11] were only part of a more complex construct, in which earthly creation played a humble but necessary role as a foil to the spiritual. Thus, the colorful geometric floors of medieval churches represented the variety of plants in a nonfigurative manner, but they were contrasted with the

[10]G. Vasari, *Le Vite de' più eccellenti pittori, scultori ed architettori*; ed. G. Milanese, Florence, 1878, vol. 1, 250, vol. 2, 101.

[11]C. Greenberg, "Byzantine Parallels," in Greenberg, *Art and Culture: Critical Essays*, Boston, 1965, 169.

carefully distinguished portrait galleries of the saints above (compare plates XIV and II), while the plain grounds that surrounded images of Christ and his court in heaven were juxtaposed with terrestrial buildings in the scenes of his incarnation (compare figure 5-19 with plate XIX and figure 5-1). Byzantine painters did not pursue the development of realistic portraiture or the illusion of architectural space as ends in themselves, as did many later painters during and after the renaissance. Nor did they feel that it was necessary to push in these directions beyond what was necessary to set up the desired oppositions. Different painters, at different times and places, worked in different scales, some inclining to a more corporeal, illusionistic, or earthbound treatment than others. In each case, however, meaning was created by relativity within a single context, whether in a church or in a smaller work of art such as a manuscript.

Although the Byzantines were certainly open to artistic forms from both Islam and Western Europe, they were also resistant when they felt that the integrity of their cult was at stake. In the twelfth century, Byzantium to some extent resembled the West, in that there was an increasing acceptance of imagery from nature into religious art. In this respect, the opus sectile pavement of the Pantocrator Monastery in Constantinople can be seen as the equivalent of the apse of San Clemente in Rome, even if the Byzantine celebration of the natural world was on the floor and not in the main apse (figures 2-4 and 3-9). In the thirteenth century, however, the differences became much more pronounced. In France, Germany, and England there was the development of Gothic naturalism (plate XVI), which never had a counterpart in the East. In the West, the curtain that had divided nature from Christian art was eventually parted, but in Byzantium there was always resistance.

In part this divergence was due to differing conceptions of the ways images worked. In Byzantium the connection between images and their prototypes was generally more direct, and thus potentially more problematic, than in the West. By and large, the Byzantines did not see their icons as emblematic signs that merely symbolized individual holy figures or as distant reflections in a Neoplatonic hierarchy of access to the divine, but more as accurate portraits that provided direct avenues of communication. As we have seen, this view of the operation of sacred icons made depictions of imagery from nature, such as personifications, animals, or even plants, inherently more dangerous as they too could possibly become the focus of veneration in ways similar to portrait icons. Artists and viewers in the West, on the other hand, were content to see such depictions as Christian symbols, as they had been before iconoclasm, or else to interpret the elements of the terrestrial world in a Neoplatonic sense, following the theology of Pseudo-Dionysios. For them, the danger of the worship of creation was more remote, if not entirely absent.

In 1429 a prominent Byzantine churchman, Symeon of Thessaloniki, wrote a polemic against the Latins, in which he decisively rejected the Western curiosity about nature:

They [the Latins] desire the existence that is perceptible by the senses, and they take trouble in vain about the observation of visible phenomena and of created things that are subject to change. And they serve the created world instead of the creator, almost as the foolish [pagan] Greeks did . . . but they only put confidence in the knowledge of what is trifling, and they stupidly do not consider that there is anything above what is perceptible by the senses and the human mind But for us [Byzantines], the whole order of those who have lived in sanctity has been accomplished through faith.[12]

For this Byzantine archbishop, who was writing as the Renaissance was dawning in Italy, the observation of nature was at best useless and frivolous and at worst redolent of paganism. Yet in another context the same author was happy to sing the praises of a church by using nature as allegory. In a sermon on the Feast of Saint Demetrios, Symeon described the saint and his miraculous shrine in Thessaloniki through a rich series of metaphors. The saint, he declared, is a fragrant cypress tree endowed with lofty foliage and trickling with the nectar of heavenly gifts, an olive tree full of the divine fruits of mercy, a white lily of purity, a rose red with the martyr's blood, a fragrant herb that heals disease, a delightful paradise furnishing the fruits of grace, an enclosed garden offering various pleasing plants of life, and a divine meadow full of all the flowers of manifold virtues.[13] Thus, the late Byzantine writer, like many others before him, saw nature both as nectar, when it was the image of spiritual gifts, and as illusion, when it was the object of attention in its own right.

[12] *Dialogus contra haereses*; ed. Migne, Patrologia Graeca CLV, cols. 168–169. On this passage, see D. Pallas, "Ai aisthetikai ideai ton byzantinon pro tes aloseos (1453)," *Epeteris tes Etaireias Byzantinon Spoudon* 34 (1935), 313–331, esp. 328.

[13] *Oratio in Sanctum Demetrium*; Ed. D. Balfour, *Agiou Symeon Archiepiskopou Thessalonikes: Erga theologika*, Thessaloniki, 1981, 187–188. The passage is cited by H. G. Saradi, "Space in Byzantine Thought," in S. Ćurčić and E. Hadjitryphonos, eds., *Architecture as Icon: Perception and Representation of Architecture in Byzantine Art*, Princeton, NJ, 2010, 73–111, esp. 88.

BIBLIOGRAPHY

Alföldi-Rosenbaum, E., and J. Ward-Perkins. *Justinianic Mosaic Pavements in Cyrenaican Churches*, Monografie di Archeologia Libica XIV, Rome, 1980.

Anagnostakis, I., T.G. Kolias, and E. Papadopoulou., eds. *Animals and Environment in Byzantium*, Athens, 2011.

Anagnostakis, I., and T. Papamastorakis. "'And Radishes for Appetizers.' . .On Banquets, Radishes, and Wine," in D. Papanikola-Bakirtzi, ed., *Food and Cooking in Byzantium*, Athens, 2005, 147–172.

Andaloro, M., and S. Romano. "L'immagine nell'abside," in M. Andaloro and S. Romano, eds., *Arte e iconografia a Roma da Costantino a Cola di Rienzo*, Milan, 2000, 93–132.

Andreescu, I. "Torcello III: la chronologie relative des mosaïques pariétales," *Dumbarton Oaks Papers* 30 (1976), 247–341.

Antonopoulou, T., ed. *Leonis VI Sapientis Imperatoris Byzantini homiliae*, Corpus Christianorum, Series Graeca LXIII, Turnhout, 2008.

Antonova, C. *Space, Time, and Presence in the Icon: Seeing the World with the Eyes of God*, Farnham, 2010.

Aubineau, M., ed. *Les homélies festales d'Hésychius de Jérusalem*, 2 vols., Subsidia hagiographica LIX, Brussels, 1978.

Auzépy, M.-F., ed. *La vie d'Étienne le Jeune par Étienne le Diacre*, Aldershot, 1997.

Bakirtzi, O.-M. "Plants and Vegetation," in Ch. Bakirtzis, ed., *Ayios Nikolaos Orphanos: the Wall Paintings*, Nea Smirni, 2003, 130–133.

Bakirtzis, Ch. *The Basilica of St. Demetrius*, Thessaloniki, 1988.

Bakirtzis, Ch. "Byzantine Thrace (AD 330–1453)," in *Thrace*, Athens, 1994, 151–209.

Balfour, D. ed., *Agiou Symeon Archiepiskopou Thessalonikes: Erga theologika*, Thessaloniki, 1981.

Barber, C. "The Imperial Panels at San Vitale: a Reconsideration," *Byzantine and Modern Greek Studies* 14 (1990), 19–42.

Barber, C. "The Truth in Panting: Iconoclasm and Identity in Early-Medieval Art," *Speculum* 72 (1997), 1019–1036.

Barry, F. "Walking on Water: Cosmic Floors in Antiquity and the Middle Ages," *Art Bulletin* 89 (2007), 627–656.

Bashear, S. "Qibla Musharriqa and Early Muslim Prayer in Churches," *The Muslim World* 81 (1991), 267–282.

Baun, J. *Tales from Another Byzantium: Celestial Journey and Local Community in the Medieval Greek Apocrypha*, New York, 2007.

Bekker, I., ed. *Michaelis Glycae annales*, Corpus scriptorum historiae byzantinae, Bonn, 1836.

Belting, H. *Likeness and Presence: a History of the Image before the Era of Art*, Chicago, 1994.

Belting, H. *Hieronymus Bosch: Garden of Earthly Delights*, Munich, 2005.

Belting, H., C. Mango, and D. Mouriki. *The Mosaics and Frescoes of St. Mary Pammakaristos (Fethiye Camii) at Istanbul*, Washington, DC, 1978.

Bisheh, G. "An Iconographic Detail from Khirbet al-Mafjar: the Fruit and Knife Motif," in L.E. Stager, J.A. Greene, and M.D. Coogan, eds., *The Archaeology of Jordan and Beyond: Essays in Honor of James A. Sauer*, Cambridge, MA, 2000, 59–66.

Bitrakova-Grozdanova, V. *Monuments paléochrétiens de la région d'Ohrid*, Ohrid, 1975.

Boissonade, J.F. *Anecdota graeca*, Hildesheim, 1962.

Bollig, J., ed., and P. de Lagarde. *Iohannis Euchaitorum Metropolitae quae in codice vaticano graeco 676 supersunt*, Göttingen, 1882.

Bowersock, G. *Mosaics as History: The Near East from Late Antiquity to Islam*, Cambridge, MA, 2006.

Branham, J.R. "Bloody Women and Bloody Spaces," *Harvard Divinity Bulletin* 30, no. 4 (2002), 15–22.

Brenk, B. "Welchen Text illustrieren die Evangelisten in den Mosaiken von S. Vitale in Ravenna?" *Frühmittelalterliche Studien* 16 (1982), 19–24.

Brenk, B. *The Apse, the Image and the Icon: An Historical Perspective of the Apse as a Space for Images*, Wiesbaden, 2010.

Brubaker, L. *Vision and Meaning in Ninth-Century Byzantium: Image as Exegesis in the Homilies of Gregory of Nazianzus*, Cambridge, UK, 1999.

Brubaker, L. "The Vienna Dioskorides and Anicia Juliana," in A. Littlewood, H. Maguire, and J. Wolschke-Bulmahn, eds., *Byzantine Garden Culture*, Washington, DC, 2002, 189–214.

Brubaker, L. "Aniconic Decoration in the Christian World (6th-11th Century): East and West," in *Cristianità d'occidente e cristianità d'oriente (secoli VI-XI)*, Settimane di Studio della Fondazione Centro Italiano di Studi sull'Alto Medioevo LI, Spoleto, 2004, 573–590.

Brubaker, L. "Eighth-Century Iconoclasms: Arab, Byzantine, Carolingian, and Palestinian," in J.D. Alchermes, ed., *ΑΝΑΘΗΜΑΤΑ EOPTIKA: Studies in Honor of Thomas F. Mathews*, Mainz am Rhein, 2009, 73–81.

Brubaker L., and J. Haldon. *Byzantium in the Iconoclast Era (ca. 680–850): the Sources. An Annotated Survey*, Aldershot, 2001.

Brusin, G., and P. Zovatto. *Monumenti Paleocristiani di Aquileia e di Grado*, Udine, 1957.

Buckton, D., ed. *Byzantium, Treasures of Byzantine Art and Culture* (exhibition catalogue, British Museum), London, 1994.

Byzance (exhibition catalogue, Musée du Louvre), Paris, 1992.

Byzanz: Pracht und Alltag, exhibition catalogue, Kunst- und Ausstellungshalle der Bundesrepublik Deutschland, Bonn, 2010.

Caillet, J.-P. *L'Evergétisme monumental chrétien en Italie et à ses marges d'après l'épigraphie des pavements de mosaïque (IVe-VIIe s.)*, Rome, 1993.

Canivet, P., and M.T. Canivet. *Huarte, sanctuaire chrétien d'Apamène (IVe-VIe s.)*, Paris, 1987.

Chatziioannou, I. Ch., ed. *Historia kai erga Neophytou presbyterou monachou kai enkleistou*, Alexandria, 1914.

Constas, N.P. "Weaving the Body of God: Proclus of Constantinople, the Theotokos and the Loom of the Flesh," *Journal of Early Christian Studies* 3, no. 2 (1995), 169–194.

Constas, N.P. *Proclus of Constantinople and the Cult of the Virgin in Late Antiquity: Homilies 1–5, Texts and Translations*, Leiden, 2003.

Cormack, R. "The Apse Mosaics of S Sophia at Thessaloniki," Deltion tes Christianikes Archaiologikes Etaireias 10 (1980–1981), 111–135.

Cormack, R. *Writing in Gold: Byzantine Society and its Icons*, London, 1985.

Corpus scriptorum ecclesiasticorum latinorum, 125 vols., Vienna, 1866–2011.

Cramer, J., ed. *Anecdota graeca e codd. manuscriptis Bibliothecae Regiae Parisiensis*, 4 vols., Oxford, 1839–41.

Creswell, K.A.C. *Early Muslim Architecture*, Oxford, 1940.

Creswell, K.A.C., and J.W. Allan. *A Short Account of Early Muslim Architecture*, Aldershot, 1989.

Cunningham, M.B. "The Meeting of the Old and the New: the Typology of Mary the Theotokos in Byzantine Homilies and Hymns," in R.N. Swanson, ed., *The Church and Mary*, Woodbridge, 2004, 52–62.

Cunningham, M.B. "Divine Banquet: The Theotokos as a Source of Spiritual Nourishment," in L. Brubaker and K. Linardou, eds., *Eat, Drink, and Be Merry (Luke 12:19)—Food and Wine in Byzantium*, Aldershot, 2007, 235–246.

Cunningham, M.B., trans. *"Wider than Heaven": Eighth-century Homilies on the Mother of God*, Crestwood, NY, 2008.

Ćurčić, S. *Some Observations and Questions Regarding Early Christian Architecture in Thessaloniki*, Thessaloniki, 2000.

Daley, B.E. *Gregory of Nazianzus*, Abingdon, 2006.

Darrouzès, J. "Le mémoire de Constantin Stilbès contre les Latins," *Revue des études byzantines* 21 (1963), 50–100.

Darrouzès, J., ed. and trans. *Opuscules et lettres par Nicétas Stéthatos*, Paris, 1961.

Davis-Weyer, C. *Early Medieval Art 300–1150: Sources and Documents*, Toronto, 1986.

De Boor, C., ed. *Nicephori archiepiscopi Constantinopolitani opuscula historica*, Leipzig, 1880.

Decker, M. *Tilling the Hateful Earth: Agricultural Production and Trade in the Late Antique East*, Oxford, 2009.

Deferrari, R.J. *St Basil, The Letters*, 4 vols., London, 1926–1934.

Deichmann, F.W. *Frühchristliche Bauten und Mosaiken von Ravenna*, Baden-Baden, 1958.

Deichmann, F.W. *Ravenna, Hauptstadt des spätantiken Abendlandes*, vol. I, *Geschichte und Monumente*, vol. II, *Kommentar*, parts 1–3, Wiesbaden, 1969–89.

Delehaye, H., ed. *Synaxarium ecclesiae Constantinopolitanae, Propylaeum ad Acta Sanctorum Novembris*, Brussels, 1902.

Demiriz, Y. *Interlaced Byzantine Mosaic Pavements*, Istanbul, 2002.

Demus, O. *The Mosaics of Norman Sicily*, New York, 1950.

Demus, O. *Romanesque Mural Painting*, New York, 1970.

Dewing H.B., and G. Downey. *Procopius*, 7 vols., London, 1953–1961.

Di Segni, L. "Varia Arabica. Greek Inscriptions from Jordan," *Liber Annuus* 56 (2006), 578–592.

Djourova, A., and G. Guerov. *Les trésors des icônes bulgares (exhibition catalogue, Château de Vincennes)*, Paris, 2009.

Dolezal, M.-L., and M. Mavroudi. "Theodore Hyrtakenos' *Description of the Garden of St. Anna* and the Ekphraseis of Gardens," in A. Littlewood, H. Maguire, and J. Wolschke-Bulmahn, eds., *Byzantine Garden Culture*, Washington, DC, 2002, 105–158.

Donceel-Voûte, P. *Les pavements des églises byzantines de Syrie et du Liban: décor, archéologie et liturgie*, Louvain -la-Neuve, 1988.

Downey, G. "Nikolaos Mesarites, *Description of the Church of the Holy Apostles at Constantinople*," *Transactions of the American Philosophical Society, n.s.* 47:6 (1957), 855–924.

Dunbabin, K.M.D. *The Mosaics of Roman North Africa*, Oxford, 1978.

Elsner, J. *Art and the Roman Viewer: the Transformation of Art from the Pagan World to Christianity*, Cambridge, UK, 1995.

Eustratiades, S. *Theotokarion*, Chennevières-sur-Marne, 1931.

Evangelatou, M. "The Purple Thread of the Flesh; the Theological Connotations of a Narrative Iconographic Element in Byzantine Images of the Annunciation," in A. Eastmond and L. James, eds., *Icon and Word: the Power of Images in Byzantium. Studies Presented to Robin Cormack*, Aldershot, 2003, 261–279.

Evangelatou, M. "The Symbolism of the Censer in Byzantine Representations of the Dormition of the Virgin," in M. Vassilaki, ed., *Images of the Mother of God: Perceptions of the Theotokos in Byzantium*, Aldershot, 2004, 117–131.

Evangelatou, M. "Pursuing Salvation through a Body of Parchment: Books and their Significance in the Illustrated Homilies of Iakobos of Kokkinobaphos," *Mediaeval Studies* 68 (2006), 239–284.

Evans, H.C., ed. *Byzantium: Faith and Power 1261–1557* (exhibition catalogue, Metropolitan Museum of Art), New York, 2004.

Evans H.C., and W.D. Wixom. *The Glory of Byzantium. Art and Culture of the Middle Byzantine Era,* a.d. *843–1261* (exhibition catalogue, Metropolitan Museum of Art), New York, 1997.

Février, P.-A. "Les quatres fleuves du Paradis," *Rivista di Archeologia Cristiana* 32 (1956), 179–199.

Fine, S. "Iconoclasm and the Art of Late-Antique Palestinian Synagogues," in L.I. Levine and Z. Weiss, eds., *From Dura to Sepphoris, Studies in Jewish Art and Society in Late Antiquity*, Portsmouth, RI, 2000.

Fine, S. *Art and Judaism in the Greco-Roman World: toward a New Jewish Archaeology*, Cambridge, UK, 2010.

Foerster, R., and E. Richsteig. *Choricii Gazaei opera*, Leipzig, 1929.

Forsyth G.H., and K. Weitzmann. *The Monastery of Saint Catherine at Mount Sinai: the Church and Fortress of Justinian*, Ann Arbor, MI, 1965.

Fourmy, M.H., and M. Leroy, eds. "La vie de S. Philarète," *Byzantion* 9 (1934), 85–170.

Fowden, G. "Bishops and Temples in the Eastern Roman Empire A.D. 320–435," *The Journal of Theological Studies, New Series* 29 (1978), 53–78.

Franses, R. "When All that Is Gold Does Not Glitter," in A. Eastmond and L. James, eds., *Icon and Word: The Power of Images in Byzantium. Studies Presented to Robin Cormack*, Aldershot, 2003, 13–23.

Freeman, A., ed. *Monumenta Germaniae historica, Concilia*, vol. II, Supplement, I, *Opus Caroli regis contra synodum*, Hannover, 1998.

Friedländer, P. ed. *Johannes von Gaza und Paulus Silentiarius*, Leipzig-Berlin, 1912.

Frolow, A. "Deux églises byzantines," *Etudes Byzantines* 3 (1945), 43–54.

From Byzantion to Istanbul: 8000 Years of a Capital (exhibition catalogue, Sakıp Sabancı Museum), Istanbul, 2010.

Gallay P., and M. Jourjon. *Grégoire de Nazianze, Discours 27–31* (Discours Théologiques), Paris, 1978.

George, W.S. *The Church of Saint Eirene at Constantinople*, Oxford, 1912.

Gero, S. *Byzantine Iconoclasm during the Reign of Constantine V*, Louvain, 1977.

Gigante, M. ed. *Versus iambici*, Palermo, 1964.

Gilhus, I.S. *Animals, Gods and Humans: Changing Attitudes to Animals in Greek, Roman, and Early Christian Ideas*, London, 2006.

Gilliard, F.D. "Notes on the Coinage of Julian the Apostate," *Journal of Roman Studies* 54 (1964), 135–141.

Givens, J.A. *Observation and Image-Making in Gothic Art*, Cambridge, UK, 2005

Goldschmidt, A., and K. Weitzmann. *Die byzantinischen Elfenbeinskulpturen des X.-XIII. Jahrhunderts*, 2 vols., Berlin, 1930–34.

Goldschmidt, R.C. *Paulinus' Churches at Nola: Texts, Translations and Commentary*, Amsterdam, 1940.

Grabar, A. *L'empereur dans l'art byzantin*, Strasbourg, 1936.

Grabar, A. *Byzantine Painting*, Geneva, 1953.

Grabar, A. "Quel est le sens de l'offrande de Justinien et de Théodora sur les mosaïques de Saint-Vital?" *Felix Ravenna* 81 (1960), 63–77.

Grabar, A. *Sculptures byzantines du moyen âge*, vol. II, *XIe—XIVe siècle*, Paris, 1976.

Grabar, A. *L'iconoclasme byzantin: le dossier archéologique*, 2d ed., Paris, 1984.

Grabar, O. *The Shape of the Holy: Early Islamic Jerusalem*, Princeton, NJ, 1996.

Greenberg, C. *Art and Culture: Critical Essays*, Boston, 1965.

Griffith, S.H. "Theodore Abu Qurrah's 'On the Veneration of the Holy Icons': Orthodoxy in the World of Islam," *Sacred Art Journal* 13 (1992), 3–19.

Griffith, S.H. *A Treatise on the Veneration of the Holy Icons Written in Arabic by Theodore Abu Qurrah, Bishop of Harran (C.755–C.830 a.d.)*, Louvain, 1997.

Griffith, S.H. "Crosses, Icons and the Image of Christ in Edessa: The Place of Iconophobia in the Christian-Muslim Controversies of Early Islamic Times," in P. Rousseau and M. Papoutsakis, eds., *Transformations of Late Antiquity: Essays for Peter Brown*, Aldershot, 2009, 63–83.

Grosdidier de Matons, J. *Romanos le Mélode, Hymnes*, 5 vols., Sources chrétiennes, Paris, 1964–1981.

Guidobaldi, A.G. "L'opus sectile pavimentale in area bizantina," *Atti del I Colloquio dell' Associazione Italiana per lo Studio e la Conservazione del Mosaico*, Ravenna, 1993, 643–663.

Hachlili, R. *Ancient Mosaic Pavements*, Leiden, 2009.

Hadermann-Misguich, L. *Kurbinovo: les fresques de Saint-Georges et la peinture byzantine du XII siècle*, Brussels, 1975.

Hahnloser, H.R., and R. Polacco. *La Pala d'oro*, Venice, 1994.

Halkin, F., ed. *Euphémie de Chalcédoine*, Brussels, 1965.

Hanfmann, G.M.A. *The Season Sarcophagus in Dumbarton Oaks*, Cambridge, MA, 1951.

Harmon, A.M., K. Kilburn and M.D. Macleod. *Lucian*, 8 vols., London, 1968–1991.

Harrazi, N. *Chapiteaux de la grande Mosquée de Kairouan*, Tunis, 1982.

Harrison, R.M. *Excavations at Saraçhane in Istanbul*, Princeton, NJ, 1986.

Hawkins, E., and M. Mundell. "The Mosaics of the Monastery of Mar Samuel, Mar Simeon, and Mar Gabriel near Kartmin," *Dumbarton Oaks Papers* 27 (1973), 279–296.

Hercher, R. *Erotici scriptores graeci*, 2 vols., Leipzig, 1858–1859.

Hergenroether, J., ed. *Monumenta graeca ad Photium eiusque historiam pertinentia*, Rattisbon, 1869.

Hermann, A. "Der Nil und die Christen," *Jahrbuch für Antike und Christentum* 2 (1959), 30–69.

Homburg, R., ed. *Apocalypsis Anastasiae*, Leipzig, 1903.

Hörandner, W. *Theodoros Prodromos, historische Gedichte*, Vienna, 1974.

Hutter, I., and P. Canart. *Das Marienhomiliar des Mönchs Jakobos von Kokkinobaphos, Codex Vaticanus Graecus 1162*, Codices e vaticanis selecti LXXIX, Zurich, 1991.

James, L. *Light and Colour in Byzantine Art*, Oxford, 1996.

Jeffreys, E. "Mimesis in an Ecclesiastical Context: the Case of Iakovos Monachos," in A. Rhoby and E. Schiffer, eds., *Imitatio—Aemulatio—Variatio*, Vienna, 2010, 153–164.

Jensen, R.M. *Living Water: Images, Symbols, and Settings of Early Christian Baptism*, Leiden, 2011.

Jolivet-Lévy, C. "Le canon 82 du Concile Quinisexte et l'image de l'Agneau: à propos d'une église inédite de Cappadoce," *Deltion tes Christianikes Archaiologikes Etaireias* 17(1993–1994), 45–52.

Jolivet-Lévy, C. "The Bahattin samanlığı kilisesi at Belisırma (Cappadocia) Revisited," in C. Hourihane, ed., *Byzantine Art: Recent Studies*, Princeton, NJ, 2009, 81–110.

Kähler, H. *Hagia Sophia*, New York, 1967.

Kalavrezou-Maxeiner, I., *Byzantine Icons in Steatite*, Vienna, 1985.

Kartsonis, A.D. *Anastasis: the Making of an Image*, Princeton, NJ, 1986.

Kazhdan, A.P. *Studies on Byzantine Literature of the Eleventh and Twelfth Centuries*, Cambridge, UK, 1984.

Kazhdan, A.P. *A History of Byzantine Literature (650–850)*, Athens, 1999.

Kazhdan, A.P., A.-M. Talbot, A. Cutler, T.E. Gregory, and N. P. Ševčenko, eds. *The Oxford Dictionary of Byzantium*, 3 vols., Oxford, 1991.

Kessler, H. L. *Spiritual Seeing: Picturing God's Invisibility in Medieval Art*, Philadelphia, 2000.

Kiss, E. "The State of Research on the Monomachos Crown and Some Further Thoughts," in O.Z. Pevny, ed., *Perceptions of Byzantium and its Neighbors (843–1261)*, New York, 2000, 60–83.

Kitzinger, E. "Studies on Late Antique and Early Byzantine Floor Mosaics, I: Mosaics at Nikopolis," *Dumbarton Oaks Papers* 6 (1951), 83–122.

Kitzinger, E. *I mosaici del periodo normanno in Sicilia, fasc. 4, Il duomo di Monreale: i mosaici del transetto*, Palermo, 1995.

Kolarik, R.E. "The Floor Mosaics of Eastern Illyricum," *Hellenika* 26 (1980) (Proceedings of the Tenth International Congress of Christian Archaeology), 173–203.

Kolbaba, T.M. *The Byzantine Lists: Errors of the Latins*, Urbana, 2000.

Kotter, P.B., ed. *Die Schriften des Johannes von Damaskos*, 7 vols., Berlin, 1969–1988.

Kraeling, C.H. *Gerasa, City of the Decapolis*, New Haven, CT, 1938.

Kurtz, E., ed. *Michaelis Pselli Scripta minora*, 2 vols., Milan, 1936–1941.

Lampsidis, O., ed. *Constantini Manassis Breviarium chronicum*, Corpus fontium Historiae Byzantinae XXXVI, Athens, 1996.

Leib, B. ed. *Alexiade*, 3 vols., Paris, 1937–1945.

Levi, D. *Antioch Mosaic Pavements*, Princeton, NJ, 1947.

Littlewood, A., H. Maguire, and J. Wolschke-Bulmahn, eds. *Byzantine Garden Culture*, Washington, DC, 2002.

Luibhéid, C. *Pseudo-Dionysius: The Complete Works*, New York, 1987.

Mac Coull, L.S.B. *Dioscorus of Aphrodito: His Work and His World*, Berkeley, CA, 1988.

Mackie, G. *Early Christian Chapels in the West: Decoration, Function, and Patronage*, Toronto, 2003.

MacMullen, R. *Christianizing the Roman Empire*, New Haven, CT, 1984.

Maguire, E.D. *The Capitals and Other Granite Carvings at Justinian's Church on Mount Sinai*, Ph.D. dissertation, Harvard University, 1986.

Maguire, E.D., and H. Maguire. *Other Icons: Art and Power in Byzantine Secular Culture*, Princeton, NJ, 2007.

Maguire, H. *Art and Eloquence in Byzantium*, Princeton, NJ, 1981.

Maguire, H. *Earth and Ocean: the Terrestrial World in Early Byzantine Art* (Monographs on the Fine Arts Sponsored by the College Art Association of America XLIII), University Park, 1987.

Maguire, H. "An Early Christian Marble Relief at Kavala," *Deltion tes Christianikes Archaiologikes Etaireias* 16 (1991–92), 283–295.

Maguire, H. "Christians, Pagans, and the Representation of Nature," *Begegnung von Heidentum und Christentum im spätantiken Ägypten* (Riggisberger Berichte 1), Riggisberg, 1993, 131–160.

Maguire, H. "Imperial Gardens and the Rhetoric of Renewal," in P. Magdalino, ed., *New Constantines: the Rhythm of Imperial Renewal in Byzantium, 4th–13th Centuries*, Aldershot, 1994, 181–197.

Maguire, H. "Originality in Byzantine Art Criticism," in A.R. Littlewood, ed., *Originality in Byzantine Literature, Art, and Music*, Oxford, 1995, 101–114.

Maguire, H. *The Icons of their Bodies: Saints and their Images in Byzantium*, Princeton, NJ, 1996.

Maguire, H. "The Good Life," in G.W. Bowersock, P. Brown, and O. Grabar, eds., *Late Antiquity: A Guide to the Postclassical World*, Cambridge, MA, 1999, 238–257.

Maguire, H. "The Nile and the Rivers of Paradise," in *The Madaba Map Centenary, 1897–1997*, M. Piccirillo and E. Alliata, eds., Jerusalem, 1999, 179–184.

Maguire, H. "Medieval Art in Southern Italy: Latin Drama and the Greek Literary Imagination," in N. Oikonomides, ed., *L'ellenismo italiota dal VII al XII secolo*, Athens 2001, 219–239.

Maguire, H. "The Medieval floors of the Great Palace," in N. Necipoğlu, ed., *Byzantine Constantinople, Monuments, Topography and Everyday Life*, Leiden, 2001, 153–174.

Maguire, H. "Paradise Withdrawn," in A. Littlewood, H. Maguire, and J. Wolschke-Bulmahn eds., *Byzantine Garden Culture*, Washington, DC, 2002, 23–35.

Maguire, H. "A Fruit Store and an Aviary": Images of Food in House, Palace, and Church," in D. Papanikola-Bakirtzi, ed., *Food and Cooking in Byzantium*, Athens, 2005, 133–145.

Maguire, H. "The Empress and the Virgin on Display in Sixth-Century Art," in E. Jeffreys, ed., *Proceedings of the 21st International Congress of Byzantine Studies, London, August 21–26, 2006*, vol. I, London, 2006, 379–395.

Maguire, H. "Ivories as Pilgrimage Art: A New Frame for the 'Frame Group,'" *Dumbarton Oaks Papers* 63 (2009), 117–146.

Maguire, H. "Moslems, Christians, and Iconoclasm: Erasures from Church Floor Mosaics during the Early Islamic Period," in C. Hourihane, ed., *Byzantine Art: Recent Studies*, Princeton, NJ, 2009, 111–119.

Manafis, K.A., ed. *Sinai: Treasures of the Monastery of Saint Catherine*, Athens, 1990.

Manfredi, M. "Inno cristiano al Nilo," in P.J. Parsons and J.R. Rea, eds., *Papyri Greek and Egyptian Edited by Various Hands in Honour of Eric Gardner Turner*, London, 1981, 49–69.

Mango, C. *Materials for the Study of the Mosaics of St. Sophia at Istanbul*, Washington, DC, 1962.

Mango, C. *The Art of the Byzantine Empire, 312–1453*, Englewood Cliffs, NJ, 1972.

Mango, C. *Byzantium, the Empire of New Rome*, New York, 1980.

Mango, C., and J. Parker. "A Twelfth-Century Description of St. Sophia," *Dumbarton Oaks Papers* 14 (1960), 233–245.

Mango, C., and E.J.W. Hawkins. "The Hermitage of St. Neophytos and Its Wall Paintings," *Dumbarton Oaks Papers* 20 (1966), 136–206.

Mango, C., and E.J.W. Hawkins. "The Mosaics of St. Sophia at Istanbul: the Church Fathers in the North Tympanum," *Dumbarton Oaks Papers* 26 (1972), 1–41.

Mansi, G. *Sacrorum conciliorum nova et amplissima collectio*, 53 vols., Florence, Venice, 1759–98.

Marki, E. *E Nekropole tes Thessalonikes*, Athens, 2006.

Markus, R. *The End of Ancient Christianity*, Cambridge, UK, 1990.

Martin, J.R. *The Illustration of the Heavenly Ladder of John Climacus*, Princeton, NJ, 1954.

Martindale, A. *Gothic Art*, New York, 1985.

Maskarinec, M. "Hagia Sophia's Marble Meadows and the Marble Imperial Presence in Constantinople," Thirty-sixth Annual Byzantine Studies Conference, Abstracts of Papers, Philadelphia, 2010, 11–12.

Mathews, T.F. *The Early Churches of Constantinople: Architecture and Liturgy*, University Park, 1971.

Matthiae, G. *Mosaici medioevali delle chiese di Roma*, Rome, 1967.

Mavropoulou-Tsioumi, Ch., and G. Galavaris. *Holy Stavroniketa Monastery: Illustrated Manuscripts*, Mount Athos, 2007.

McClanan, A. *Representations of Early Byzantine Empresses, Image and Empire*, New York, 2002.

Megaw, A.H.S. "Notes on Recent Work of the Byzantine Institute in Istanbul," *Dumbarton Oaks Papers* 17 (1963), 333–371.

Megaw, A.H.S. "Background Architecture in the Lagoudera Frescoes," *Jahrbuch der Öster-reichischen Byzantinistik* 21 (1972), 195–201.

Megaw, A.H.S., and E.J.W. Hawkins. *The Church of the Panagia Kanakaria at Lythrankomi in Cyprus*, Washington, DC, 1977.

Michaelides, D. *Cypriot Mosaics*, Nicosia, 1987.

Migne, J.-P., ed. *Patrologiae cursus completus, Series Graeca*, 161 vols., Paris, 1857-1866.

Migne, J.-P., ed. *Patrologiae cursus completus, Series Latina*, 221 vols., Paris, 1844-1880.

Miller, E. *Manuelis Philae carmina*, 2 vols., Paris, 1855–1857.

Mondzain-Baudinet, M.-J. *Nicéphore, Discours contre les iconoclastes*, Paris, 1989.

Le Mont Athos et l'Empire byzantin: Trésors de la Sainte Montagne (exhibition catalogue, Petit Palais), Paris, 2009.

Muthmann, F. *Der Granatapfel: Symbol des Lebens in der alten Welt*, Fribourg, 1982.

Necipoğlu, N., ed. *Byzantine Constantinople, Monuments, Topography and Everyday Life*, Leiden, 2001.

Nicolaïdès, A. "L'église de la Panagia Arakiotissa à Lagoudéra, Chypre: Étude iconographique des fresques de 1192," *Dumbarton Oaks Papers* 50 (1996), 1–137.

Nilsson, I. "Narrating Images in Byzantine Literature: the Ekphraseis of Konstantinos Manasses," *Jahrbuch der Österreichischen Byzantinistik* 55 (2005), 121–146.

Norman, A.F. *Libanius, Selected Works*, 2 vols., Cambridge, MA, 1969–1977.

Ognibene, S. "The Iconophobic Dossier," in M. Piccirillo and E. Alliata, *Mount Nebo. New Archaeological Excavations 1967–1997*, Jerusalem, 1998, 373–389.

O'Meara, J. *Eriugena, Periphyseon*, Montreal, 1987.

Onians, J. "Abstraction and Imagination in Late Antiquity," *Art History* 3, no. 1 (1980), 1–23.

Orlandos, A.K. "E para ten Artan mone ton Blachernon," *Archeion ton Byzantinon Mnemeion tes Hellados* 2 (1936), 1–56.

Orlandos, A.K. "Palaiochristianika kai byzantina mnemeia Tegeas-Nykliou," *Archeion ton Byzantinon Mnemeion tes Hellados*, 12 (1973), 12–81.

Ousterhout, R. *Master Builders of Byzantium*, Princeton, NJ, 1999.

Ousterhout, R. "Architecture, Art, and Komnenian Ideology at the Pantokrator Monastery," in N. Necipoğlu, ed., *Byzantine Constantinople: Monuments, Topography and Everyday Life*, Leiden, 2001, 133–150.

Pallas, D. "Ai aisthetikai ideai ton byzantinon pro tes aloseos (1453)," *Epeteris tes Etaireias Byzantinon Spoudon* 34 (1935), 313–331.

Panofsky, E. *Abbot Suger on the Abbey Church of St.-Denis and its Art Treasures*, Princeton, NJ, 1979.

Papadopoulos-Kerameus, A., ed. "Epigrammata Ioannou tou Apokaukou," *Athena* 15 (1903), 476–477.

Papadopoulou, B.N. *H Byzantine Arta kai ta mnemeia tes*, Athens, 2002.

Papageorgiou, A. *Eikones tes Kyprou*, Nicosia, 1991.

Papastavrou, H. "Le symbolisme de la colonne dans la scène de l'Annonciation," *Deltion tes Christianikes Archaiologikes Etaireias* 15 (1989–90), 145–160.

Papastavrou, H. "Le voile, symbole de l'Incarnation, contribution à une étude sémantique," *Cahiers archéologiques* 41 (1993), 141–168.

Papastavrou, H. *Recherche iconographique dans l'art byzantin et occidental du XIe au XVe siècle. L'Annonciation*, Venice, 2007.

Paschalides, S.A., ed. *O Bios tes osiomyroblytidos Theodoras tes en Thessalonike*, Thessaloniki, 1991.

Patlagean, E. "Byzance et son autre monde. Observations sur quelques récits," in *Faire croire, Collection de l'École Française de Rome LI*, Rome, 1981, 201–221.

Pelekanidis, S.M. *Palaiochristianika mnemeia Thessalonikes. Acheiropoietos, Mone Latomou*, Thessaloniki, 1949.

Pelekanidis, S.M. *Kastoria*, vol. I, *Byzantinai toichographiai*, Thessaloniki, 1953.

Pelekanidis, S.M. *Gli affreschi paleocristiani ed i più antichi mosaici parietali di Salonicco*, Ravenna, 1963.

Pelekanidis, S.M. *The Treasures of Mount Athos. Illuminated Manuscripts*, 4 vols., Athens, 1974–91.

Pelekanidis, S.M., and M. Chatzidakis. *Kastoria*, Athens, 1985.

Peltomaa, L.M. *The Image of the Virgin Mary in the Akathistos Hymn*, Leiden, 2001.

Pentcheva, B.V. *The Sensual Icon: Space, Ritual, and the Senses in Byzantium*, University Park, 2010.

Peschlow, U. "Zum byzantinischen opus sectile-Boden," in R. Boehmer and H. Hauptmann, eds., *Beiträge zur Altertumskunde Kleinasiens, Festschrift für Kurt Bittel*, Mainz, 1983, 435–447.

Petit, L., ed. "Typikon du monastère de la Kosmosotira près d'Aenos (1152)," *Izvestiia Russkago Archeologicheskago Instituta v Konstantinople* 13 (1908), 17–75.

Pevsner, N. *The Leaves of Southwell*, London, 1945.

Piatnitsky, Y. "The *Panagiarion* of Alexios Komnenos Angelos and Middle Byzantine Painting," in O.Z. Pevny, ed., *Perceptions of Byzantium and its Neighbors (843–1261)*, New York, 2000, 40–55.

Piccirillo, M. *Madaba, le chiese e i mosaici*, Milan, 1989.

Piccirillo, M. *The Mosaics of Jordan*, Amman, 1993.

Piccirillo, M., and E. Alliata. *Umm al-Rasas/Mayfa'ah*, vol. I, *Gli scavi del complesso di Santo Stefano*, Jerusalem, 1994.

Poinssot, L. "Mosaïques d'El-Haouria," *Revue Africaine* 76 (1935), 183–206.

Preger, Th., ed. *Scriptores originum Constantinopolitanarum*, 2 vols., Leipzig, 1901.

Quasten, J. *Patrology*, 4 vols., Westminster, MD, 1986–1988.

Renauld, E., ed. *Michel Psellos, Chronographie*, 2 vols., Paris, 1926–1928.

Rhoby, A., ed. *Byzantinische Epigramme in inschriftlicher Überlieferung*, vol. I, *Byzantinische Epigramme auf Fresken und Mosaiken*, vol. II, *Byzantinische Epigramme auf Ikonen und Objekten der Kleinkunst*, Vienna, 2009–2010.

Rizzardi, C. "La basilica di Santa Maria Assunta di Torcello fra Ravenna e Bisanzio: note sui mosaici dell' abside destra," in G. Trovabene, ed., *Florilegium artium: scritti in memoria di Renato Polacco*, Padua, 2006, 153–160.

Roberti, M.M. "Osservazioni sulla basilica postteodoriana settentrionale di Aquileia," *Studi in onore di Aristide Calderini e Roberto Paribene, III*, Milan, 1956, 863–875.

Romano, R., ed. *Nicola Callicle, carmi*, Naples, 1980.

Rossi Taibbi, G., ed. *Filagato da Cerami, Omelie per i vangeli domenicali e le feste di tutto l'anno*, Palermo, 1969.

Russell, D.A., and N.G. Wilson, eds. and trans. *Menander Rhetor*, Oxford, 1981.

Rydén, L., ed. and trans. *The Life of St. Andrew the Fool*, Uppsala, 1995.

Safran, L., ed. *Heaven on Earth: Art and the Church in Byzantium*, University Park, 1998.

Sahas, D. *Icon and Logos: Sources in Eighth-Century Iconoclasm*, Toronto, 1986.

Sande, S. "Egyptian and Other Elements in the Fifth-Century Mosaics of S. Maria Maggiore, *Acta ad archaeologiam et artium historiam pertinentia* 21 (2008), 65–94.

Saradi, H.G. "Space in Byzantine Thought," in S. Ćurčić and E. Hadjitryphonos, eds., *Architecture as Icon: Perception and Representation of Architecture in Byzantine Art*, Princeton, 2010, 73–111.

Sathas, K. ed. *Mesaionike bibliotheke*, Paris, 1872–94.

Scarborough, J., ed. *Symposium on Byzantine Medicine (Dumbarton Oaks Papers, 38)*, Washington, DC, 1984.

Schick, R. *The Christian Communities of Palestine from Byzantine to Islamic Rule: A Historical and Archaeological Study*, Princeton, NJ, 1995.

Schick, R. "Archaeological Sources for the History of Palestine: Palestine in the Early Islamic Period: Luxuriant Legacy," *Near Eastern Archaeology* 61–62 (1998), 74–108.

Schultz, R., and S. Barnsley. *The Monastery of Saint Luke of Stiris in Phocis*, London, 1901.

Sewter, E.R.A. *Fourteen Byzantine Rulers: The Chronographia of Michael Psellos*, Harmondsworth, 1966.

Sewter, E.R.A. *The Alexiad of Anna Comnena*, Harmondsworth, 1969.

Sinkević, I. *The Church of St. Panteleimon at Nerezi: Architecture, Programme, Patronage*, Wiesbaden, 2000.

Sodini, J.-P. "Marble and Stoneworking in Byzantium, Seventh –Fifteenth Centuries," in A.E. Laiou, ed., *The Economic History of Byzantium*, vol. I, Washington, DC, 2002, 129–146.

Soteriou, G.A., and M.G. Soteriou. *H Basilike tou Agiou Demetriou Thessalonikes*, Athens, 1952.

Soteriou, G.A., and M.G. Soteriou. *Eikones tes Mones Sina*, Athens, 1956.

Spatharakis, I. *The Pictorial Cycles of the Akathistos Hymn for the Virgin*, Leiden, 2005.

Spieser, J.-M. *Thessalonique et ses monuments du IVe au VIe siècle: contribution à l'étude d'une ville paléochrétienne*, Paris, 1984.

Spieser, J.-M. "Remarques complémentaires sur la mosaïque de Osios David," *Hetaireia Makedonikon Spoudon, Makedonike Bibliotheke* 82 (1995), 295–306.

Stokstad, M. *Art History*, 3d ed., Upper Saddle River, NJ, 2008.

Stucchi, S. *Architettura cirenaica, Monografie di Archeologia Libica XI*, Rome, 1975.

Stylianou, A., and J.A. Stylianou. *The Painted Churches of Cyprus, Treasures of Byzantine Art*, London, 1985.

Suchla, B.R., ed. *Corpus Dionysiacum*, vol. I, *Pseudo-Dionysius Areopagita: De divinis nominibus*, Berlin, 1990.

Talbot, A.-M., ed. *Byzantine Defenders of Images: Eight Saints' Lives in English Translation*, Washington, DC, 1998.

Talbot, A.-M. "The Death and Commemoration of Byzantine Children," in A. Papaconstantinou and A.-M. Talbot, eds., *Becoming Byzantine: Children and Childhood in Byzantium*, Washington, DC, 2009, 283–308.

Talbot, A.-M., ed. *Holy Women of Byzantium: Ten Saints' Lives in English Translation*, Washington, DC, 1996.

Terry, A., and H. Maguire. *Dynamic Splendor: the Wall Mosaics in the Cathedral of Eufrasius at Poreč*, University Park, 2007.

Thessalonike, Istoria kai Techne (exhibition catalogue, White Tower, Thessaloniki), Athens, 1986.

Thomas J., and A.C. Hero. *Byzantine Monastic Foundation Documents*, 5 vols., Washington, DC, 2000.

Thümmel, H.G. "Neilos von Ankyra über die Bilder," *Byzantinische Zeitschrift* 71 (1978), 10–21.

Toesca, P. *San Vitale of Ravenna: the Mosaics*, London, 1954.

Torniolo, M., ed. "*Omelie e catechesi mariane inedite di Neofito il Recluso (1134–1220c.)*," *Marianum* 36 (1974), 184–315.

Tronzo, W. *The Cultures of his Kingdom*, Princeton, NJ, 1997.

Tronzo, W. "Shield, Cross, and Meadow in the Opus Sectile Pavements of Byzantium, Southern Italy, Rome and Sicily," in N. Oikonomides, ed., *L'ellenismo italiota dal VII al XII secolo*, Athens, 2001, 241–260.

Trypanis, C.A. *The Penguin Book of Greek Verse*, Harmondsworth, 1971.

Tsigaridas, E.N. *Ta psephidota kai oi byzantines toichographies, in Iera Megiste Mone Vatopaidiou: Paradose-Istoria-Techne*, Mount Athos, 1996.

Tsironis, N. "The Mother of God in the Iconoclastic controversy," in M. Vassilaki, ed., *Mother of God: Representations of the Virgin in Byzantine Art* (exhibition catalogue, Benaki Museum, Athens), Milan, 2000, 27–39.

Underwood, P.A. "The Fountain of Life in Manuscripts of the Gospels," *Dumbarton Oaks Papers* 5 (1950), 43–138.

Underwood, P.A. *The Kariye Djami*, London, 1967.

Vasari, G. *Le Vite de' più eccellenti pittori, scultori ed architettori*, G. Milanese, ed., Florence, 1878.

Vassiliev, A., ed. *Anecdota graeco-byzantina*, Moscow, 1893.

Volbach. W. F. *Early Christian Art*, New York, n.d.

Von Simson, O.G. *Sacred Fortress, Byzantine Art and Statecraft in Ravenna*, Princeton, NJ, 1987.

Voulet, P., ed. *S. Jean Damascène: Homélies sur la Nativité et la Dormition*, Sources Chrétiennes LXXX, Paris, 1961.

Webb, R. *Ekphraseis, Imagination and Persuasion in Ancient Rhetorical Theory and Practice*, Farnham, 2009.

Weiss, Z., and R. Talgam. "The Nile Festival Building and Its Mosaics: Mythological Representations in Early Byzantine Sepphoris," in J.H. Humphrey, ed., *The Roman and Byzantine Near East*, vol. III, Portsmouth, 2002, 55–90.

Weitzmann, K., ed. *The Age of Spirituality: Late Antique and Early Christian Art, Third to Seventh Century* (exhibition catalogue, the Metropolitan Museum of Art), New York, 1979.

Weitzmann, K., and G. Galavaris. *The Monastery of Saint Catherine at Mount Sinai: The Illuminated Greek Manuscripts*, vol. I, *From the Ninth to the Twelfth Century*, Princeton, NJ, 1990.

Wenger, A. "Ciel ou Paradis," *Byzantinische Zeitschrift* 44 (1951), 560–569.

Williamson, P. *Medieval Ivory Carvings: Early Christian to Romanesque*, London, 2010.

Winfield, D., and J. Winfield. *The Church of the Panaghia tou Arakos at Lagoudhera, Cyprus: The Paintings and Their Painterly Significance*. Washington, DC, 2003.

Woodfin, W.T. "A Majestas Domini in Middle-Byzantine Constantinople," *Cahiers archéologiques* 51(2003–4), 45–53.

Woodfin, W.T. "Wall, Veil, and Body: Textiles and Architecture in the Late Byzantine Church," in H.A. Klein, R.G. Ousterhout, and B. Pitarakis, eds., *The Kariye Camii Reconsidered*, Istanbul, 2011, 371–385.

Xyngopoulos, A. *E Psephidote diakosmesis tou naou ton Agion Apostolon Thessalonikes*, Thessaloniki, 1953.

INDEX

Abstraction, 8–9, 106–134, 170. *See also* plants
Adam
 fall of, 112
 in paradise, 55, 167
Agriculture, 3, 35, 42
Ainos, River, 61
Ain Témouchent, mosaic of ocean, 17, 26, fig. 1.8
Akathistos Hymn, 9, 79–80, 91–92, 105, 135–136, 138, 169
Alexandria, 29
Alexiad, 48
Altar, 34, 87, 144
Ammon, 23, 79
Amnos. See lamb
Amulets, 26
Ananeosis, 30–32, 34
Anastasius of Antioch, *In Annuntiationem*, 80
Andrew of Crete
 encomium of St. Patapios, 59–60
 sermon on Nativity, 62
 sermon on Nativity of the Virgin, 138
Andrew the Fool, *Life* of, 93, 160
Angels, images of destroyed, 33. *See also* cherubim and seraphim, Gabriel, Michael
Aniconic images
 of the divinity, 129
 of earthly creation, 111, 122–123, 125–130, 133, 169, 171
 See also iconoclasm, marbles, opus sectile, pavements
Animals, as apotropaic images, 167. *See also* beasts, birds, paganism, sanctuary screen, sculptures
Anna Comnena, *Alexiad*, 48
Anne, saint, 71, 82. See also Annunciation to St. Anne
Annunciation to St. Anne, 65–66, 67, 70–74, 152, 164–165, 171
Annunciation to the Virgin, 65, 67–74, 83–85, 88, 171
 and architectural metaphor, 136–137, 139, 142–146, 152–157, 162–164

on sanctuary arch, 137, 140
on sanctuary screen, 140
Annunciation by the Well, 74, 144–146
Ant, 53
Anthony, saint, 117, 150
Anthropomorphic images, 4, 6–7, 9–11, 92, 97, 110, 128–129, 134–135, 167. *See also* icons of Christ and the saints
Antioch, 32
 House of the Sea Goddess, 30–35, figs. 1.13–1.14
Anubis, 28
Aphrodisias, marble of, 133
Apis, 23
Apocalypse of Anastasia, 93, 141, 160
Apocalypse, of St. John, 164
Apollo, 133
Apostles, 78–79
Apple, 6, 107, 110, 112
Apses, decoration of, 20–21, 39, 46, 80, 90–91, 126–127, 161–164, 167–168
 in the medieval West, 99–102
Aquileia, double basilica, 11–12, 14, 23, fig. 1.1
Arabs, invasion of, 32, 36
Architecture
 ambiguities in interpretation of 137–138, 144, 157–158, 165
 avoidance of in art, 148, 151–152, 159–165, 170–172
 and depiction of space, 135, 144–152, 164–165
 and disjunction between art and literature, 159–160, 171
 heavenly, 159–165, 170–171
 as metaphor, 135–143, 156, 165
 as substitute for organic imagery, 135, 141, 148, 164, 170
 symbolism of, 8, 10, 83–84, 135–165
 in western medieval art, 163–164
 See also apses, bridge, ciborium, city, column, door, gate, key, ladder, palace, pyramid, sanctuary screen, stairs, temple, tower
Aristotle, 48
Ark of Noah, 79–80
Arsenios, 117

187